Complete Guide to Watercolor Painting

NEW, ENLARGED EDITION

Complete Guide to Watercolor Painting

by Edgar A. Whitney A.N.A., A.W.S.

WATSON-GUPTILL PUBLICATIONS/NEW YORK

PITMAN PUBLISHING/LONDON

Copyright © 1974 by Watson-Guptill Publications

First published in 1974 in the United States and Canada by Watson-Guptill Publications,
a division of Billboard Publications, Inc.,
1515 Broadway, New York, N.Y. 10036

Published simultaneously in Great Britain by Pitman Publishing Ltd.,
39 Parker Street, Kingsway, London WC2B 5PB
ISBN 0-273-00843-9

Library of Congress Cataloging in Publication Data
Whitney, Edgar A.
 Complete guide to watercolor painting.
 First ed. published in 1958 under title: Watercolor:
the hows and whys.
 Bibliography: p.
 1. Water color painting—Technique. I. Title.
ND2420.W45 1974 751.4'22 74-4330.
ISBN 0-8230-0851-7

Manufactured in U.S.A.

First Printing, 1974
Second Printing, 1975
Third Printing, 1976
Fourth Printing, 1977

Contents

*. . . for love of anything is the offspring
of knowledge, love being more fervent
in proportion as knowledge is more certain.*

LEONARDO DA VINCI

Introduction

ALL KNOWLEDGE ESSENTIAL to the painting of a fine watercolor can be obtained from books, many books; teachers, many teachers; and subscription to the truth of the pragmatic theory that doing is part of the knowing.

There is no one volume purporting to present all, or even a resumé of all the contributing factors inherent in a watercolor. Most books give superficial information on such subjects as wash techniques and the use of tools; they make no pretense of helping the artist to understand himself, the creative act, design principles, or recent findings in the study of aesthetics. They do not supply definitions of artists' and critics' vernacular—so important to the student in shaping his thinking. This book has those additional objectives. It is conceived as a working tool to be kept in studio and sketchbox. It is to be glanced at frequently to keep the mind from digressions, and to keep the artist concerned with significant word sequences. It is a reference book.

Throughout the book and particularly in the chapter, *Notes*, you will find "capsule" precepts or comments. Some are quotes, others originals. There is evidence that certain authors have better minds than ours and these "seeings" —well expressed by our superiors—can sustain, encourage, and edify us when our lesser understanding and vision engender doubts. Man must have a faith to live by—something to believe in. These men have found an unassailable faith in the validity of creative activity.

I teach about two hundred students weekly in eight different classes. A large percentage of them are professional artists. I repeatedly admonish them, "If you will own and read this selected list of authors—Maitland Graves, Suzanne Langer, Louis Arnoud Reid, Jacques Barzun—to name four of the many—there will be no need for coming to me as students." They continue to come. Some for as long as eight years. Why? Well, I don't know. It might be sloth, "leaving seatprints on the sands of time," or just the fact that they like their edification sugar coated with entertainment—all good teachers are fifty percent ham. It may also be that some of the three-syllable words in Langer, Reid, Barzun, *et al*, frighten them. The word *philosophy*, for instance, creates tension in many students, yet Webster defines it as "love of wisdom or knowledge," and William James as "man thinking." What's frightening about that?

One sees the same aversion to scholarship in contemplating the contemporary professional painters. Men with national reputations reflect discredit upon themselves and the organizations that honor them by indicating in their paintings and their books a lack of interest in penetrating the design barrier, and in the contriving of aesthetic fusion. Their deficiencies are mostly in the areas they refuse to think about—design and aesthetic theory. If you spend a few hours in a social group, you will have evidence as to which man in the group is most interested in women, which in liquor, which in conversation, and which in himself. By the same token, your picture will fool no sophisticated eye. It will report precisely your interests and state of being when you painted it. If, confronted with the vital problems of fine color, value chords, and distinguished space divisions, your answers are an evasive brush-off, your concern being largely with making a tree look like a tree and contriving a slick, glib wash, you must accept qualified appraisal of your status as an artist.

After many years of commercial art experience and teaching, I am required in daily demonstrations to show how the character of all component parts of a painting are reported literally. Escape from realism only, concerns me very much. I expound upon design principles and they are embodied in my paintings, but the *emphasis* is heavier on the illustrative than I like to have it. I still make too low a bow to nature, but the bow is more perfunctory each year, so I am encouraged, but still impatient of slow growth. A fine picture is a fusion of plastic and psychological values—psychological values plastically apprehended. Without this fusion, we have illustration or decoration. There is nothing wrong with either except that, being fragmentary, they lack importance as works of art. Art is significant when it is the result of a fusion of both these components. This is very important for the student to remember.

So, perhaps there is a need for a simply written book which neglects none of the essentials found in a wide student-reading-painting experience. Inasmuch as precise thinking presupposes precise language, the *best* word will always be chosen, and watercolorists, interested in maximum information with minimum effort, should find this book a practical tool.

The author of a textbook, in his desire to be thorough, could write forever in the peripheries of his subject and never finish his book. He must, therefore, accept the limitations of any one book and be selective. Eager to be helpful, and to do the most good, such an author will direct his research and efforts to supplying the greatest need of his readers.

The bookshelves are so filled with watercolor textbooks dealing with techniques and tools, that these subjects are assumed to be not unfamiliar to readers. While in the interest of thoroughness they are adequately dealt with, they are not the only subject matter of this book. Emphasis is placed upon what must be an artist's greatest single concern every time his brush touches paper—*design*. Growth in taste is contingent upon never ending preoccupation with design principles.

Other than books which are watercolor symposiums, most certainly valuable, I have found but one watercolor textbook making any appreciable gesture in this direction, and the author apologizes for that. I have told hundreds of students to buy his books, because his design precepts are sound and practical. His design precepts, however, are not basic, and significantly the word design does not appear in his index.

The ability to run the different washes and paint in wet areas with some control, the capacity to "draw" without design conditioning, a knowledge of the potentials of different tools—these skills can be acquired by any person with an I.Q. of, say, seventy; but a masterly, powerful stature as a designer can be acquired only by a fairly normal mind plus scholarship. Watercolorists who believe this, and have been unable to find a textbook on watercolor which puts emphasis on *basic design principles*, are those for whom this book is written.

The design principles presented in this book have been tested daily since the first edition was written. To pragmatists asking their inevitable question, "Do they work?" I answer: "Students conditioned by these principles have in the past four years been awarded, by the juries of the American Watercolor Society, ten percent of the wall space in their Annual Exhibitions."

This book is original in that it is my personal synthesis and manner of statement. However, the ideas and principles discussed, weighed, and appraised are too important to be new. Like the wheel, they are included among man's oldest ideas. Automobiles of the future will either have wheels or they will not be good automobiles; the pictures painted in the future will have design principles evident in them—arrived at through cognition or the trial-and-error method—or they will not be good pictures.

This is as good a place as any for me to apologize for, or at least explain, a sort of *ex cathedra* manner of declamation born perhaps of wide teaching experience (you get no credence if you state without conviction), or it may be an excited enthusiasm for current findings. These are not regarded as conclusions. I know that the only absolute is, there will be change, and that all other truths are partial truths. The physicist's sign \rightleftarrows for the inescapable paradox is understood.

I am not naïve enough to imagine myself impartial. I will argue with reckless bias for and against, and then, when possible, quote the most authoritative bias against and for. This appoints you as judge of the merits of the case, and gives us both a variety of culture.

There are too many students who do not know that competence can be learned and taste can be educated into us. My objective is to acquaint them with those two facts. I want my book to be inspirational.

The watercolorist's problem is a rectangle of watercolor paper. What it takes to solve that problem is precisely what it takes to solve *any* problem—information. That information is implicit in this book. Those wishing to be more explicitly edified need only consult the bibliography.

1

Tools for Watercolor

THERE ARE two reasons for putting paint on paper. One is to communicate an idea or an emotion. The other is to decorate a surface. Either objective, or the more interesting and more important one of contriving a synthesis of both, has as a prerequisite a knowledge of and facility with the tools used. These are our concern in this chapter.

THE VIRTUES OF WATERCOLOR

Watercolor has three glories or virtues: (1) Faster rhythms—one stroke three-feet long if you wish. (2) Lovelier precipitations, the truth involved here being that substances obeying their own laws do beautiful things. Look at tide marks on a beach, or auto tire marks in snow. Coil two ropes and cast one on the floor, then you arrange the other. A glance at them proves my contention. Look at a Rorschach ink blot. This is the truth Jackson Pollock added nothing to. He poured enamel or paint on the floor and framed the area that pleased him most. Watercolor is trying to help you every stroke you make. (3) Its white paper showing through a transparent wash is the closest approximation to light in all the media, and light is the loveliest thing that exists. All of these virtues have to do with the nature of watercolor, which is that it is wet.

WATERCOLOR'S NATURE

The nature and essence of watercolor is its spontaneity, the swift seizure of a single impression, not the careful building up of design and inclusion of carefully defined detail. That is oil, gouache, or casein painting. Taste is questionable when there is a too arbitrary extension of the natural province of the medium.

In the first edition of my book on a page in this chapter, expressing enthusiasm for aquarelle with my penchant for dramatics, I contrived a very stupid word sequence that read as an indictment of gouache, casein, and tempera. I did not mean it the way it read. I greatly respect the work of many men painting in these media. Aron Bohrod, Arnold Blanche, John Pellew, Hardie Gramatky, Warren Baumgartner, and Joseph Di Martini come to mind. As a matter of fact, I have a Pellew and Di Martini in my private collection.

"Art is emphasis on essence" is a precept to be aware of when being selective as to subject matter. A portrait of Cyrano de Bergerac with a small nose would not be a portrait of Cyrano. This truth is relevant to any medium. A so-called watercolor which does not emphasize, make capital of, its *wetness*, is not an artful *water*color.

A liquid quality in watercolor is important. Understanding of this is your first long step in the direction of facility with watercolor, which is mostly control of washes. Abstract lessons—similar to chromatic scales for the piano student—together with suggested tools and the *reasons* for their use, follow.

THE TOOLS

I feel silly writing about tools. Hundreds of pages in watercolor books have already advised you on this subject; furthermore, the tools used by the best watercolorists have little to do with the qualities in their works. The color and value chords of each painter, the way he divides space, where his interest lies in the gamut between illustration and decoration, would be his own even if he painted with a sponge and a shaving brush.

I work on the ground, seated on a small folding stool. I have reasons for doing so. It gives the same free arm swing the Orientals get painting on their knees, and the angle of vision at that distance encompasses all of my watercolor, so colors and thrusts can be related. But, no matter how much you like my pictures, if you have a big stomach, or are rather broad astern, you will not work on the ground from a small folding stool.

When I use a pencil, a 2-B makes a mark dark enough to be seen under a wash without furrowing the paper. You may prefer a harder or softer pencil. I frequently draw directly with a goose quill, with a ballpoint pen, or with a brush. Marin used charcoal. A few times on location will enable you to make your own decisions. I have reasons, however, for using the tools I do. I will give you my reasons.

PAPER AND COLORS

There is no argument here. Tube colors are best. Anything but one hundred percent all-rag paper makes a tough job tougher. 140 lb. is a good all-around weight —heavy enough to permit corrections—and it can be used on the other side when

you get a "stinker." I no longer mount paper, though I will tell you how to do it. The cost in time and effort, and loss of paper at the edge is not compensated for by the elimination of an occasional bulge—which experience enables you to handle anyway—and if you are fussy, use 300- or 400-lb. stock. I clip 140-lb. paper to a piece of Masonite, one strong clip at each corner. A bulge can be pressed out and the clips readjusted in a second.

STRETCHING PAPER

Here is a stretching procedure for the half-size imperial sheet. Soak 140-lb. paper (completely immersed) in cold water for one-half hour; hold it perpendicular until most of the water has run off; lay paper on board one end down first, so that no air bubbles are underneath; take strips of gummed paper previously cut to the right length and measuring from two and one-half to three inches in width. Fasten paper to board—about two inches on the board and one inch on the paper. The two inches on the board should be dampened with a sponge; the remaining one inch should go on paper dry—there is enough water on the wet paper. Now, with a hard, smooth tool (the back of a comb or a toothbrush) squeegee the water from under the gummed paper; then, with an *absolutely clean* sponge, absorb all the excess moisture from the paper, including the squeegeed gummed paper. This cuts drying time in half. For a full-size sheet, which has much greater drying tensions, reinforce first gummed paper with a second strip on all four sides, overlapping on the paper by about a half inch more. Keep paper horizontal while it is drying.

COLD PRESS PAPER

More experienced watercolorists usually prefer cold press paper because subtler nuances of color can be obtained. The rough paper granulations being higher, they cast more shadow on colors, but make rough brushing on surf and close-up foliage a much simpler technical problem.

SMOOTH PAPER

There are gains and losses involved in the use of any paper. Smooth paper has virtues, but its use requires greater technical ability. The novice will lose control of washes, and get dry edges where he does not want them, because he does not work fast enough. Brilliancy and subtlety of color, impossible on rougher paper, are two of the merits of cold press and hot press, there being none of the shadows cast by the rougher stock. If you want more "tooth" to the hot press paper, wet it to raise the fiber, then let it dry. Re-wet to work. A good time to start painting is when it begins to lose its glisten. "Lifts" on smooth stock are very successful. Use a clean, damp brush. Effects can be obtained by tilting the paper. For a real dark, use thick body color. Clean water in still moist areas gives a nice, textured watermark.

The papers I prefer are Arches, Crisbrook, R.W.S., Fabriano, and A.W.S. The imperial size, 22½ x 30½ inches, divides into two or four nice proportions.

14

Why manufacturers continue to make sketch blocks or pads, I do not understand. Glued on four edges, the wet, expanding paper has nowhere to go but up, creating undulations in which control of washes is lost.

PALETTE

I use an O'Hara palette, upon which the color is a mound on a flat surface. The reason for this is that sullied color runs off and leaves pure color available on the top of the mound. A dinner plate or enameled tray has the same advantage. Any palette with color in a depression is mechanically inferior. Contaminated color becomes a *constant* problem. Water stays in declivities and when paper is wet you cannot get dry color to put into wet areas. Masterpieces have been painted with color in little holes, but they were made in spite of this handicap.

BRUSHES

Eighty percent of my painting is done with a two-inch camel's-hair flat brush and a one-inch red sable flat. In many pictures no other brushes were used. This may be because demonstrating to classes everyday—committed to one hour of drawing and painting, and talking while I paint (students cannot sit still longer)—I find these brushes faster. The large flat brush, however, has the following undeniable virtues: (1) A ready-made straight edge—most expedient; (2) it holds more color and covers areas faster; (3) it is an infinitely better "lifting" tool, because its thousands of hairs at the end, squeezed dry, are "thirstier"; (4) it is the best known antidote for "hemstitching," breadth of effect being aided mechanically; (5) holding the brush perpendicular to the plane of the paper, with its end touching the paper, gives to small parts the beauty of a "tool mark." Any calligrapher knows what I mean. In elementary school art exhibitions, the graphic arts are always superior to the paintings, because the dig of a tool in linoleum blocks or the scratch on scratchboard contains the beauty of the unmolested mark.

There are fine watercolorists who paint with very few brushes but, confronted with specific problems in specific areas, I prefer having available the one best tool for the solution. What other brush can do certain jobs as well as a number 4 rigger, for instance? Its long hairs hold enough water to complete the stroke of rigging on ships, cables on derricks, or branches in foliage; they also absorb the trembles of a hand and make easy the essence of a rope or cable—its absolutely smooth curve. So, I have a two-inch "silvering brush" of camel's-hair and a rigger as help. I want all the help I can get.

Standard equipment would include red sable round brushes. I have numbers 14, 10, 6, 3, and 2 (the big brushes lose their points), and a one-inch red sable, flat. My students and I find my "Whitney Rotary" brush of value—a double-ended brush. With water in one brush and color in the other, an edge can be treated or softened instantly by a flip of the hand, then back to the color-filled brush; this method is used as opposed to that of a stroke, shaking the brush clean

in the water, softening the edge, then picking up more color with the brush. To construct this double-ended brush, join the two brushes where the diameters are equal—a wedge on one and a "V" that fits the wedge in the other—bind with fine thread, a little Duco cement, and cover with waterproof adhesive.

Before leaving the subject of brushes, I want to agree with George Ennis who said "one brush only is *necessary*" (the italics are mine, and I would add the word "absolutely" before "necessary"). He suggested a number 12 round red sable.

COLOR PALETTE

To students who are concerned with costs, I say, "It takes a specific quantity of paint to paint a given picture or get a required effect. The quantity of paint you have in your box has nothing to do with the cost of the picture." In fact, if you have a large palette, you can mix your paint with less waste. As to the phrase "disciplined palette," the discipline should be in the artist, not the palette. Arranging them from hot to cold, I use vermilion, cadmium orange, cadmium yellow deep, strontium, viridian, phthalo green, Prussian blue, cobalt, ultramarine blue, alizarin crimson. Those are my brights, kept at the top of my slightly tilted palette, so that the sullied color does not run into them. In a lower row I have Indian red, burnt sienna, yellow ochre, raw umber, burnt umber, Payne's gray, and ivory black. All these colors are reasonably permanent. With them any color can be obtained. I know their characteristics. I use strontium in preference to cadmium pale *because* it is more opaque, and yellow ochre instead of raw sienna for the same reason. Sufficiently diluted, they are not obvious between you and the paper, and when in small areas you need a light over, or in, a dark, you have it. Incidentally, opacity *in small areas* does not seriously compromise transparency, in fact, it complements it—keying the large areas and making them look more transparent by contrast.

Indian red, another opaque color, is splendid with Prussian blue for dark grays. Ivory black makes the most glorious silvery neutral washes in high key. It is sooty and should not be used for middle or low values. However, if you do use it, flavor it with a color put on top of it.

WATER CAN

A flat water can is preferable to a deep one, so that *all* the color can be rinsed from the brush by banging it against the bottom. It is also a smaller bulge in your bag or tool kit.

KNIFE

The knife is a splendid tool but use it with restraint, especially in first washes where it is apt to have a raw, monotonous aspect. In second washes, the knife mark or mutilation of too pure areas is less dangerous.

I find a large synthetic sponge adjacent to my palette helps me maintain a precise degree of wetness in my brushes, wiping the too wet brush on the sponge. A *natural* sponge has many uses. It is invaluable for wetting paper, for instance.

Someone has said that an artist is a craftsman in love with his tools. I go along with this to the extent of being frequently called a gadgeteer. I have a rubber *sink scraper* that with one stroke (remember the toolmark eulogy?) makes very finely lit planes on rocks. A *rubber heel,* cut at different angles, makes smaller rocks and mutilating marks in too pure areas. By too pure, I mean too pure texturally, or with too little interest in them—dead areas. A *kitchen knife* with its curved sharp-edge squeegees marks of varying widths.

A *carpenter's pencil,* 6-B, used in wet areas does not shine. It helps definition and textural reports.

I watched Dong Kingman, a virtuoso, condition values and textures with *Kleenex* always in his left hand. It is a very useful tool. It picks up color faster when squeezed dryish after wetting. However, wet or dry, it helps vary edges in cumulus clouds and surf. An infinite number of textures can be obtained on other surfaces by creasing, folding, crinkling in different ways, and by tamping and dragging. It can change a value readily, easily, with just a touch.

Rubber cement is used (never by me) to block out areas (in a large wash) that are to be treated or painted later. It has a function but you are stuck with the edge which usually has a hard quality. A *razor blade* used as a flat scraper removes paint from the tops of the grain for snow effects, sun "bead" on water, etc. *Sandpaper* has a few uses. It creates a snow effect on dried washes by taking the tops off the paper's high spots; or rain, when dragged on wet areas. *Crayon and pastel* can add interest to "dead" darks. A *toothbrush* is good for textural spatter. A *small bristle brush* is useful for cleaning and dislodging paint from areas: (1) wet scrub; (2) tamp with tissue repeatedly until the paper is clean again or is the lighter value you desire. *Eraser*—unless you are deliberately molesting the paper's surface, use only Artgum. I rarely use a tube of *Chinese white.* I am an aquarellist —a purist, but I have sometimes saved "stinkers" by a thin wash of opaque white and then rearranging my value and color chord. A *piece of shoemaker's leather* cut so that different size marks can be made, and with one edge nicked, is helpful in order to obtain old board and tree textures with one or two strokes.

Tricks? Of course they are tricks—found in all trades. The result is what you will be judged by. How you get the results is your business. And these "tricks" all subscribe to the nature of watercolor—its immediacy—its partial-statement character—its demand that you think in simplest terms.

Watercolor is the witty medium. I know of no *thing* that cannot be used to create textural effects. I drop sand in sandy foregrounds, use twigs and stones I find

at my feet with which to mark too pure areas. I use indelible, graphite, grease and wax pencils, pieces of wax, chalks, fingers and finger nails, and several times have spit into areas (and successfully) to drive the truth home to students, that *any* cause creates an effect.

CARRYING THE TOOLS

I carry all of my tools in a strong canvas bag with a zipper top and two handles which my arm can go through, slinging the bag from my shoulder. One compact unit contains everything, including plenty of half-sheets of imperial size watercolor paper.

2

The Drills

EXERCISES for the beginner in watercolor have been described so often and with so few variations that I am reluctant to include them, but do so in order to be thorough.

The virtue of the abstract exercise is that it allows one hundred units of attention to be focused upon one subdivision of the total problem at one time. For instance, eliminate consideration of color, drawing, and design. Take just black paint and several brushes and experiment, mixing water and paint in the brush and pushing the brush around on paper, acquiring information about different values, how to change them, effects obtained with different degrees of wetness, qualities of strokes and textural effects. Make small rectangles, say two-inches high and six-inches wide of ten different values graded from black to white, with equal value intervals or differences between each.

Discover how to get the three different qualities of edge: (1) Rough brush via the hairs flat on the paper or moved very fast so that color is deposited *only* on the tops of the tiny mounds on the paper; (2) blended edge, softened by water either before or after the brush stroke is made; (3) hard edge with sharp definition.

It has been said that the ability to lay a wash is seventy-five percent of watercolor technique. Practice the five basic washes in six-inch squares using a No. 8 sable brush and ivory black pigment.

FLAT WASH ON DRY PAPER

This requires a puddle of even color—no lumps—in the palette, and always have a slightly tilted paper, about a 15-degree angle. Start at the top with a fully charged brush. Carry a beaded wet edge down the paper by stroking it back and forth, drinking up surplus color at the bottom with a thirsty (squeezed out) brush.

FLAT WASH ON WET PAPER

Wet the area with water *slightly* tinted with color, so that the wetted area can be seen; then distribute color in the area, stroking darker areas into lighter areas until it is approximately even in value. Next "iron it out" with horizontal strokes, working from top to bottom. If the area has a correct degree of wetness, gravitation helps deposit color evenly. If strokes show, the area is too dry and a little water should be added.

GRADED WASH ON WET PAPER

Wet paper in the manner described above. Deposit most color at the top with a diminishing amount toward the bottom. Brushing horizontally, try to get an even gradation from black at top to white at bottom. Do not be satisfied if gradation is uneven. If streaks appear, add water and try again. You will find that you will have to use a thirsty brush, drinking color, stroked from the bottom up to get an even gradation. A thirsty brush is a cleaned brush with the moisture squeezed out by pulling it through the fingers. The brush then sucks color from the paper back into itself very easily.

GRADED WASH ON DRY PAPER

Load brush with color. Paint top of rectangle about brush width. Dip brush partly in water to dilute. Carry first horizontal stroke a little lower. Dip in water to dilute again. Continue this to bottom of rectangle.

GRANULATED WASH

With the area quite wet, flood in plenty of color. Tilt paper back and forth until pigment settles in the small basins in the paper, giving a granular aspect to the wash. Use the colors with body, not the staining colors.

THE "LIFT"

You should be familiar with the "lift." Paint a rectangle of dark, and at different times during its drying, drag a brush (preferably a flat) *slowly* through the area, pressing firmly. Note the different results in the varying degrees of wetness. In a similar area, squeegee a knife (at butter-spreading angle), changing the knife angle so as to make the marks of differing widths. With discretion and experience this becomes a very valuable tool. The knife's sharp edge should have a graded curve so that the various widths of marks can be made.

With any brush, flat or round, *push* brush at a low angle so that the hairs turned back against the paper are spread apart; then whisk brush from paper so that hairs or bristles remain spread when they leave the paper. This is a swift and efficient way to make a grass textured edge.

Play with the brushes. Note results of fast and slow brush strokes in dry and in wet. Push, pull, drag, twist your brushes. Use the other end of them as a mutilating tool in the too pure areas; employ them to suggest textures. Paint small houses and barns with flat brushes, one stroke for each side, plus perhaps a "lift" or two. Suggest clapboards by a series of touches with a flat brush. Make every conceivable kind of mark.

WET IN WET DIFFUSIONS

You must, through experience, acquire knowledge of the degree of diffusion you will get with different degrees of wetness on the paper and in the brush. When a darkish wash begins to lose its glisten, make marks with pure water in a small brush, spatter pure water on the same area, and spatter darker colors. You will be experimenting with an eye for future textural needs. You should become so familiar with the brush that it functions as an extension of yourself, and you cease being aware of it, conscious only of a result you want, as you are unconscious of your hand when you scratch, or pick something up.

COLOR DRILL

Whether you paint illustratively, striving for naturalistic color or selectively, creating color schemes without reference to nature, painting will mean frustration if you cannot get the hue, value, and intensity you want.

I strongly recommend a color-mixing drill O'Hara taught, which I place here with the other technical drills, rather than with the color subdivision of the chapter on design. Using *only* alizarin crimson, cadmium yellow medium, and cobalt blue (these three pigments being close to a true red, yellow, blue primary concept), paint six rectangles, say six-inches wide and two-inches deep, the hues of which will be red, orange, yellow, green, blue, and purple. Each rectangle will have about a fifty percent intensity or be halfway between full intensity and a neutral gray, and each will process a value of about fifty percent or be halfway between white and black. After each set is finished (do many), judge them, one component at a time—first hue, then value, then intensity. You should not paint until you can be reasonably successful every time, the hues being true and all rectangles being alike in intensity and value, looking like blood brothers.

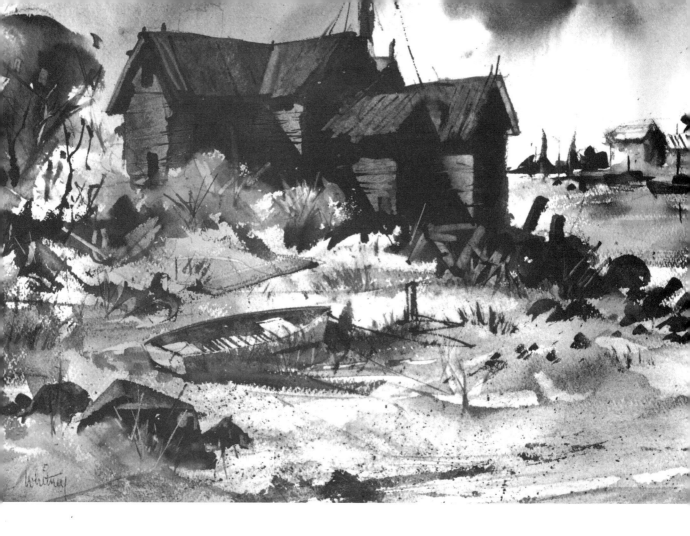

LOBSTERMAN'S SHACKS

The dark shape, very aggressive visually, obeys the law for a fine shape, "a dynamic oblique, length and breadth materially different in measure, and interlocking incident at edges." The optical center of that dark piece is a different measure from each edge of the paper, as it should be. The *large piece* of neutral gray beach makes the muted colors in grass, house, sky, water and tree, "sing".

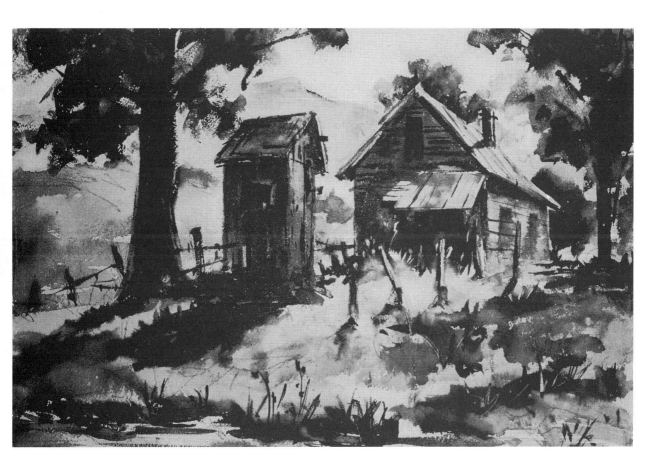

ABANDONED SCHOOL HOUSE

The pattern scheme is an interlocking dark against lighter values. This is a middle major key, and an analogous color scheme (yellow and green). It was painted dry on 300-lb. Arches paper. The subject was largely textures in the school, outhouse, and bank of grass. There are two best times to express or report textures: (1) when the area is wet, use mutilating tools, and (2) when it is bone dry, use brushes, knife, sandpaper, or eraser. The brush-off given the "backdrop," establishing third dimension, was a bit darker in the painting. Three third-dimensional steps back are usually pleasant: foreground, mid-distance, and distance. Vary the intervals between them. Here the first step between foreground (the brook) and mid-distance (the house) is very short, and the step back to the mountain, very long.

23

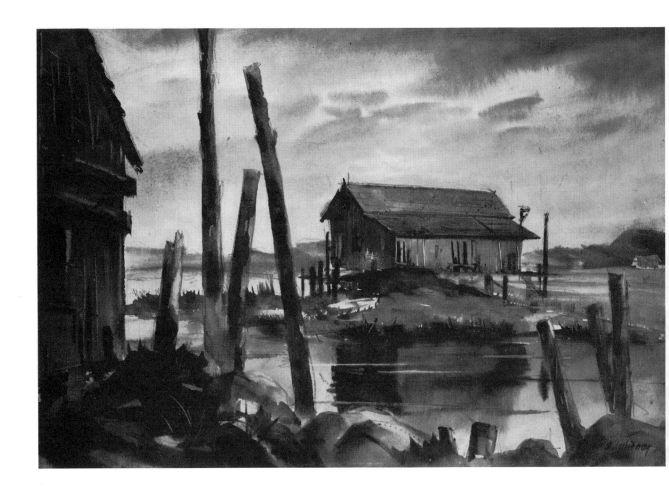

TURBOTTS CREEK—CLEARING

Chamberlain, the etcher and photographer, calls Turbotts Creek the Stonehenge of New England. The hundreds of tall poles in the area qualify the remark and gave me a chance to use them decoratively. The pattern scheme is a piece of dark against lighter values. The sky was a flat wash on dry paper. I wet the sky with pure water and then worked elsewhere until the glisten was almost gone. Again I judged the diffusion in an area that was to be dark— the upper right corner. When diffusion was just right, I dappled in the small spots of blue sky showing through the clearing skies.

I want to describe the way I do poles or trunks of bare trees. When they are dry (this was a saturated job), I flood a pale neutral color into their tops, guiding the wet down their length (paper tilted about 15 degrees). Then going back, I flood slightly different colors into them, usually warms at the bottoms for the light bounce from earth, and cools at the top for sky reflections. Then I describe the cylindrical form by a plane change accent: let the first value read as reflected light, and knife out the plane receiving light, changing the knife angle so as to avoid marks of precisely the same width. This procedure gives the medium a chance to achieve accidentals en route up the pole or tree. If you have the same value or color en route, the piece will be uninteresting. Note, no two poles are the same length, or the same oblique, and the intervals between them are all different.

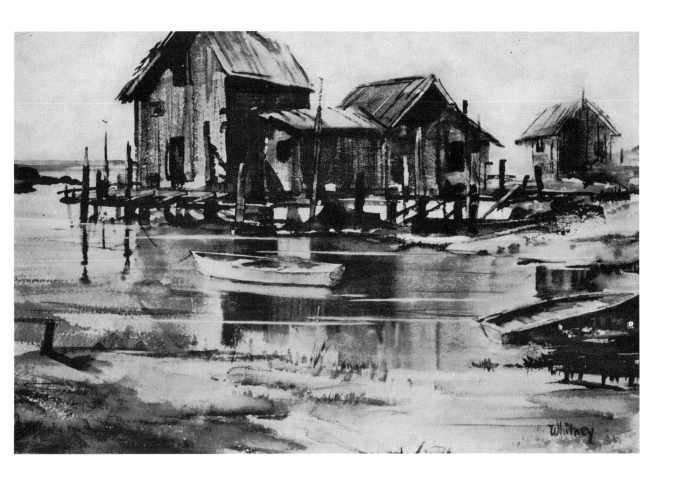

TURBOTTS CREEK, MAINE

The broad pattern scheme is pieces of dark against lighter values. It is a complementary color scheme, red purple (neutralized) and green yellow. It has a high major key. Use was made of the piles under the houses as a decorative motif. There is a recurrent motif in nature (I call it "a piece of lace"). Its decorative potentials can be seen looking at twigs against a sky; trunks and branches against sunlit fields; cables and derricks against sky; human legs, table legs, and chair legs. A recurrent motif occurs whenever a value silhouettes against different directions, different girths, different colors, and different size and shape interstices. Any of these are a motif with decorative potentials.

I worked fast and dry with a 2-inch brush. First, the sky and the two pieces of beach, then the houses (not drawn, painted directly), getting textures with mutilating tools: knife, brush handle, etc. Next the water, including reflections and the horizontals which are the symbol for inland water. Next I "lifted" the small boat in the reflections with a damp flat brush, added some brush calligraphy for textures in the shacks, and *described* the planes in light and shade in the boats.

The picture's most successful component is color. The transition in the water came just right and has attention called to it by the visually strong "piece of lace" under the shacks. The point of interest is established there by conflict. Darkest dark, lightest light; hottest hot, coldest cold; sharpest edges; shapes silhouetted and "framed"; all in that area—the "shout" right there, whispers elsewhere. *That is* organization in a rectangle.

3

Painting the Picture

HAVING SERVED some technical apprenticeship with wash, brush, and color drills, now comes the complex problem of a painting. Confronting your subject, you observe that it is composed of leaves, wood, grass, earth, air, rocks, flesh, hair, or whatever. Your palette has only paint in it. Your subject is bathed in the most beautiful thing that exists—light. Your subject has three dimensions. Your paper has two dimensions.

THE CREATIVE CONCEPT

Now, heaven help you if you cannot see that the concept of your activity must not be transcription. It *must* be translation. *It is a different language with its own idiom and syntax,* and the rights of the picture always come first. To try to *transcribe* color, value, or textures is fatal. When Rimski-Korsakov composed *The Bee* did he put a tape recorder in a hive? An artist does not report the fact of a thing, he expresses the truth of it in whatever language he is using. Failure to see this simple truth keeps amateurs amateurs, and dwarfs the stature of too many professionals.

The next complexity you observe is that there is no frame around nature, and the instant you allocate a positive shape in your rectangle, you create negative shapes and find them just as important in the frame as the positive shapes. You are now up to your neck in *design* which has its own chapter, following this one. Design principles must guide every thought and mood *while* your subject is being smelled, tasted, touched, listened to, and looked at. You paint with all five senses. You must be emotionally and sensually involved with your subject.

EMOTIONAL INVOLVEMENT

A fine watercolor is a by-product. The objective is a state of being. This state of being, degree of concentration, forgetfulness of self, is perhaps best exemplified by the word empathy. Empathy is a one-word definition of what an artist is, his essence. Empathy is the projection of one's consciousness into another person or object in order to understand him or it better. More than sympathy, empathy is knowing how the other person or object feels.

Make no mistake about this. Every brush stroke will record inevitably your state of being the instant you make the stroke. The best access to this state of being, your objective, is through intellectual identification with the subject matter; that is, curiosity about it as natural phenomena, with the same intensity of interest that a child has touching an object for the first time. You do not have to fall in love with subject matter at first sight. Scholarly investigation of it will prove it worthy.

So step one is emotional involvement with the subject. This objective, by the way, bypasses a great pitfall, coercive anxiety. Some tensions and concerns are perhaps unavoidable, but the tight-jawed ego—involved and frantically grabbing for paint—is fatal. Hurried gestures are usually inept. Tension is cumulative. When you sense it, move more slowly. Refuse to hurry. Discipline yourself back into the "state" by thinking with significant words. Force meaningful words and principles through your mind. Think their values into your picture. This makes you less self-conscious and puts your attention into the rectangle where it should be. The answer "none" to the question "What words have I been thinking with?" means you are making a thoughtless painting.

BEING SELECTIVE

Your paint having only a small fraction of the power of light, and your vision encompassing the infinite variety of textures, colors, objects, and natural phenomena in *any* subject, there is the inescapable necessity for eliminations and simplification imposed upon you. You *must* be selective. First fix the characteristics—the essences of the subject—in the fewest possible words. Seven or eight should be plenty. When thinking of subject matter do not neglect the less trite concepts.

SUBJECT MATTER

A subject may be superficially seen as "boat houses by inland water" when the better concept might be deep space or a fine color harmony, or a beautiful pattern, and *incidentally* "boat houses by inland water." Light, movement, and power, none of which are tangible things, are all important, interesting *subject matter* for pictures. Having decided what the subject matter is, be selective. Ruthlessly eliminate any color, line, value, texture, shape, size, or direction that does not express the subject. Emphasize those that do. Art is emphasis on essence.

SYMBOLS

Invent *symbols* with which to express that essence. Your inland water, for instance, would have two essences: It is wet; it is the flattest thing in all nature. These essences would be symbolized by (1) wet marks in wet areas (avoiding dry brush to any great extent) and (2) horizontals to express the flattest thing in nature.

You are communicating your ideas and feelings about the subject. *No communication, no art.* Let us explain that italicized statement. You have a *feeling* about a place or a thing or a person. You have had the feeling. No art, yet! The feeling is a symptom. But the moment you try to communicate this to someone else, to tell them about it, or how it moved you, art raises its lovely head. You express, you communicate with symbols, and any symbol must be logically formulated. You select the few essences of the complex subject and express them in the different language of paint, especially in the watercolor medium, the natural province of which is partial statement, relying heavily on the power of suggestion. Know that in each area you have only three "labels": (1) Color; (2) texture in the area; (3) silhouette at the edge of that piece of value meeting a different value. This last is a much more powerful "label," reading faster than the other two.

SIGNIFICANT DESIGN

The design should express subject matter or you start with two strikes against you. I recall a Pratt student submitting a weekly illustrative assignment. The subject was an Irish wake. The mourning figures and the interior were beautifully painted, but the picture was in high key, which utterly negated any hope of expressing the mood. The subject demanded a low-keyed illustration. The inexperienced student had not thought in terms of significant design—his first problem. A portrait painter who would paint a great scientist with a dominance of warm colors and diagonals, and use cool colors and perpendiculars and horizontals when the subject was a soubretteer would not be a good painter however clever his brushwork and draughtsmanship might be.

The importance of significant design cannot be overestimated, and it is your concern while making the very small rough pattern scheme. The shape of the picture is a first decision. Is your subject essentially square, perpendicular, horizontal? In a perpendicular picture, a quiet ocean with a flat beach and a few low rocks would look pretty silly. Even when the choice is not so obvious, this first challenge to your taste must be seen as just that. Give it full consideration.

SHAPES

Design the *shapes* first, fitting nature or objects into them. A synthesis occurs in the mind while thinking shapes. An awareness of the matter to be fitted is requisite, but shapes, space divisions, value, and color chords are your concern when creating pattern.

28

A brief reminder or digest of design principles might be advisable here.

Your picture must be an interesting unit. Variety in action or content and in the design elements creates this interest. A dominance in idea or action and in each of the design elements—line, value, color, texture, shape, size, and direction— creates unity.

Variety or contrast of content or action must be present, disciplined by the dominance of one action or idea: Variety of elements disciplined by a dominance; *lines* curved and straight, but one dominant; *directions* horizontal, oblique and vertical, but one direction dominant. *Sizes* may be small or large, but one size dominant; *shapes* curved and angular, but one shape dominant; *textures* rough and smooth, but one texture dominant; *values* dark, midtone, and light, but one value dominant. *Colors* of different values, intensities, and hues, but one hue dominant.

Rhythm should be contrived by a variety in the intervals between elements. There must be major intervals and lesser or minor intervals, with one major interval stronger—dominating other intervals. If a characteristic motif, one putting emphasis on essence, can be found, that is your clue to the *building* of the composition. Try it.

The above constitutes the review of design principles which will be found in the chapters on design. Now back to watercolor techniques.

Prolixity, in paint, is to be avoided. A few fine shapes and a few fine angles can suffice for most subjects. Any shape having visual identity must be a good shape, and here, also, taste being involved, principles obtain. A shape having variety in its length and breadth dimensions, its directional thrust being a dynamic oblique, and with incident at its edges, interlocking with negative areas, will be a more interesting shape than one which has few or none of these attributes.

Two simple rules obtain in placing the point of interest in the rectangle. It should not be so close to any edge that it is difficult to qualify the large area of the rest of the picture. The optical center of the interesting area should be a different measure from the four edges of the picture.

Linear subordination to a center or radiation is an excellent device to help establish a center of interest. Contrive lines, volumes, thrusts, shadows, a series of spots or things, that carry the eye from any edge of the paper into the approximate area where the center of interest is to be established.

PATTERNS

Design values are going to be thought into your paintings or you will be rolling dice in the rectangle. A first consideration is *pattern*. If you buy a coat do you examine the stitching of the buttonholes and, if you find them acceptable, say, "I'll take this one"? Or do you first appraise its shape in the mirror? Pattern is even more important in your watercolor. *Nothing is more important.* You may be the greatest

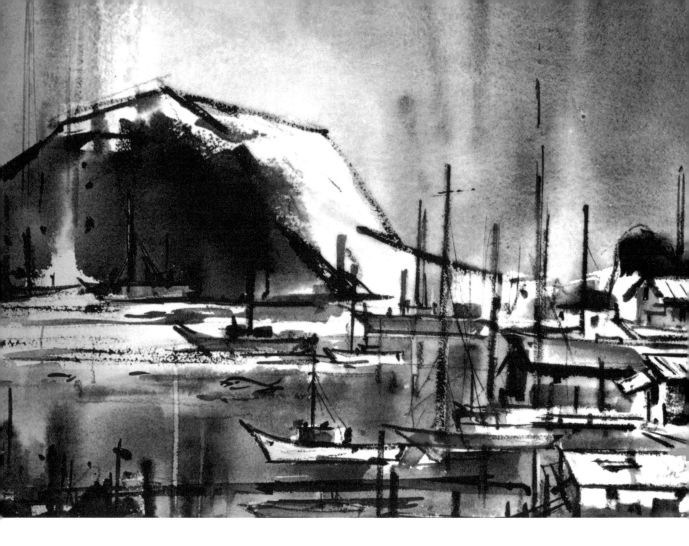

WEST-COAST HARBOR

This watercolor has character, achieved through dominance in color
(blue); in line (straights); in direction (perpendicular); and because of
its spottiness. The whites, instead of being a shape or two, well placed and
good shapes, are sprinkled over the paper. This is a line and wash job.
A line and wash watercolor should be two partial statements, one
of them dominant.

The white piece on the monolith, an oblique (being larger than other
whites), and the oblique lines in the same area (being longer), challenge
the more numerous perpendiculars. They shouldn't. Most of the
dominant straight lines were made with pieces of plastic which had
been rubbed in the pigment on the palette. I was amused, teaching in
Carmel, California, finding students using what they called their YIP sticks,
in the same way. Richard Yip who teaches them, pulls the stick out of
a popsickle and with it gets the same "mark" quality.

30

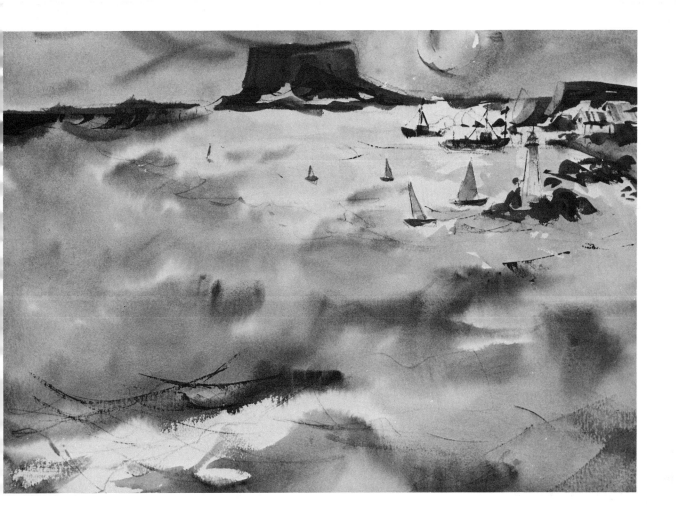

MORRO ROCK, CALIFORNIA COAST

This full sheet watercolor was painted from the top of a cliff on the California coast. The famous *Morro Rock* is shown at the top of the painting.

Observance of design laws is apparent here. There is *dominance* in size in the piece of ocean. There is *interlocking* of land and sea in the shoreline. Expression of the sea's freshness was insured by finishing the full sheet in twenty minutes. *Gradation* is seen in the large piece. (The greater the difference in size of the pieces that have visual identity in a painting, the more distinguished become the space divisions.) The blue color *dominance* cannot be seen in this black and white reproduction. This painting won first honorable mention in an American Watercolor Society Annual.

virtuoso, technically, but if your painting does not have a distinguished pattern, your painting will be mediocre.

SIX PATTERN SCHEMES

There are six broad value pattern schemes, tried, tested, and proven to be successful which make for readability, lucidity of statement, and breadth of effect: (1) A piece of darker value in lighter values; (2) a piece of lighter value in darker values; (3) a small light area and a large dark area in midtones; (4) a small dark area and a large light area in midtones; (5) gradation, in any direction, up, down, or across; (6) "all-over pattern" as in textile design—an equal surface tension or visual strength throughout the rectangle.

These six basic pattern schemes are in no way constrictive. The possibilities for variety within their gamut are *infinite*. Do you know there are only seven basic plots in all fiction?

PATTERN-VALUE SCHEMES
These sketches show how successful pictures painted by well known artists fall into the six pattern-value schemes I have discussed in this chapter:

1-A EDWARD HOPPER

1-B WINSLOW HOMER

1-C EMIL KOSA, JR.

1-D WINSLOW HOMER

1-A, 1-B, 1-C, and 1-D are all "a piece of dark value in lighter values."

2-A JOHN COSTIGAN

2-B VICTOR SCHRECHENGOST

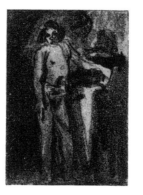

2-C REMBRANDT

2-A, 2-B, and 2-C are all "a piece of lighter value in darker values."

32

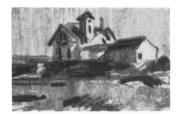

3-A EDWARD HOPPER

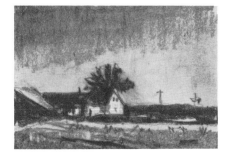

3-B ANDREW WYETH

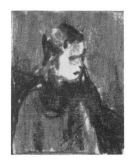

3-C SIDNEY DICKENSEN

3-A, 3-B, 3-C, and 3-D are all "a large dark and a small light in midtones."

3-D MILLARD SHEETS

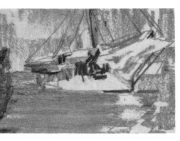

WINSLOW HOMER

4-B JAMES BECKWITH

4-A and 4-B are both "a large light and small dark in midtones."

5-A LOREN BARTON

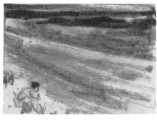

5-B RUSSELL FLINT

5-A and 5-B are both "gradation" composition.

6-A, 6-B, and 6-C are all "all-over patterns."

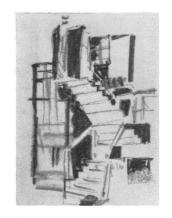

6-A CHARLES DEMUTH

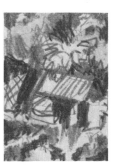

6-B GEORGE HARDING

6-C HARDIE GRAMATKY

CONTRIVING THE DESIGN

Your first step after contriving an emotional involvement with your subject is to make a wise choice as to which of these six pattern schemes is best for the expression of your subject matter. There are several ways to contrive—to emphasize—fine pattern in watercolors. I will first list the different ways and then discuss the advantages and disadvantages of each: (1) The small rough; (2) designing the middle tones with a large brush directly on the paper, palely, (either on wet or dry paper) (3) "seeing" a valid design concept so clearly on the blank paper that you practically trace it; (4) designing with a pencil—outlining directly on the paper—and making the necessary changes.

The professional or very experienced amateur possessing knowledge that enables him to see a mistake before he makes it can, and purposefully does, use all of the above methods of imprinting design values and getting fine pattern into his works. For the benefit of the less experienced, and for those interested in greater emphasis on design, I offer this appraisal of the merits of the different ways listed above.

THE SMALL ROUGH

The small rough functions as a compass throughout the "voyage" but never negates improvisation or the flash of insight. It is used by most careful designers in the fine arts and by all fine illustrators. The only concerns of the small rough are allocation of the three broad values—lights, midtones, and darks and a decision as to design significance—which *key* and which *shape* best express the subject. This concentration eliminates consideration of drawing and texture and commits *all* of your attention to the pattern.

The small roughs are made so quickly—a few minutes for each—that many can be made and a best selection made from the many used. It is a consensus among the best artists that when a good small sketch is achieved, the picture is half finished. You will learn that the creation of a reasonable lighting on a human situation or landscape is not too difficult; nor is the designing of an acceptable abstract pattern. But to combine the two successfully calls for experience. This fusion takes place in the mind as the small pattern rough is designed.

When scribbling values into areas on small roughs, make the scribbled lines perpendicular. They seem to be less aggressive texturally. An oblique scribble subtracts from your concentration on pattern.

DESIGNING ON THE PAPER WITH A LARGE BRUSH

Many artists are afraid of this method, and without reason. The large chunk of pale value or pale line can be changed at will while still wet, with a sponge or, if you dislike the design, wipe out the whole thing with the damp sponge and redesign. This method is absolutely plastic. Pieces of value can be judged better as to shape

34

than outlines, and you are not irrevocably committed to any mark or piece. The very pale design can be ignored or corrected by the subsequent heavier washes. The pale wash, not coincident with the heavier wash, creates a nice vibration and varies edges.

"SEEING" A VALID DESIGN ON THE BLANK PAPER

Only artists of real stature and great experience can immediately see a design on the blank paper. Geniuses can, also. Its virtue lies in its freshness and the emotional content of those first groping—drawing—empathetic touchings of the paper.

DESIGNING WITH THE PENCIL DIRECTLY ON THE PAPER

I repeat, an expert can achieve creditable results with *any* method, but *without the help of the small preliminary rough* this method has disadvantages. Changing penciled lines with an eraser dirties the paper and molests the surface. Incidentally, there are two reasons for using a fairly heavy pencil line: (1) You can relate nearby directional thrusts and shapes better if you can see both at one time, and (2) if your first light washes cover pencil lines that are too light, you have to design and draw twice. If you object to pencil marks after the painting is bone dry, you may erase them easily with Artgum, especially when you are painting with staining colors. Be careful in areas of sediment colors.

No one can judge pattern as well from penciled outlines as when *pieces* of value are appraised. When trying to design, full size, attention is inevitably divided by textural qualities and drawing. This means lessening the intensity of the appraisal of the all-important pattern.

NOTATED SKETCHES

About three of every hundred exhibited pictures are painted on location. Most of the other ninety-seven were painted in the studio from small notated sketches, which subscribe in varying degrees to a standard procedure, which O'Hara taught me at his school in Maine.

A small pencil sketch is made, say, five-inches wide, concerned with *pattern only*, allocating the lights, light midtones, dark midtones, and darks. From each "piece" or area, sky, water, land, etc., a line is drawn to a rough circle outside of the sketch, in which is recorded the color and the value of that area. Colors are designated as R-O-Y-G-B-P—Gr for gray, W for white, Br for brown, and Bk for black. If a color is intense it is underlined. The value is fixed by its position in a gamut from 1 white to 10 black.

This shorthand recording method is also used for third dimensional relationship of things or areas, zero being the immediate foreground and 100 the most remote thing in the picture (excepting sky); anything halfway between zero and

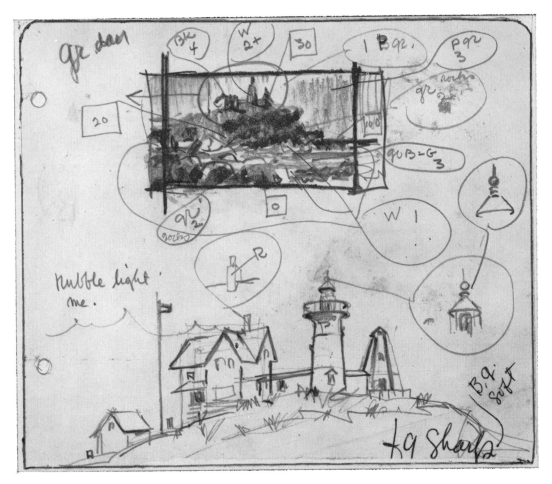

NOTATED SKETCH This notated sketch, seven inches wide, is concerned with pattern only. The letters represent color and the numbers represent value.

100, would be labeled 50, etc. This third dimensional memo is enclosed by a rough square outside of the pattern sketch with a line running to where its position is *in* the pattern, the square making it distinct from the circle containing the color and value notation. The pattern and color, value and third dimensional note is now augmented by a *diagrammatic* drawing of structures, shapes, etc., too complex to remember.

Make these drawings small, too, just a record of structure. If a part of this diagram is too small to explain detail, make an enlarged explanation of detail. Add then a written description of everything that might help you recall, back in the studio, what you saw, felt, heard, and smelled on location. Burchfield even recorded the name of an insect he heard singing.

36

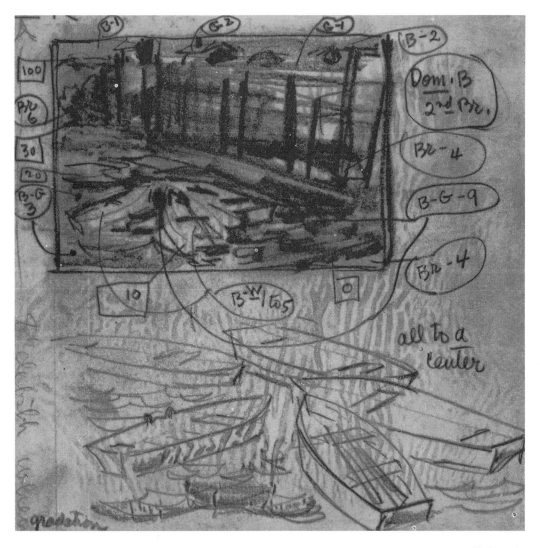

If you make this notated sketch conscientiously, you will be amazed to find, back home, that you make small use of it. You remember everything. Working on location, you do not look that carefully.

The great virtue of the notated sketch is that it frees the artist from subservience to nature. He is obliged to be more selective and more creative.

Artists who never work on location and artists who never work from notated sketches greatly limit their experience.

QUICKIES

Students and professional painters alike will profit by frequently painting "quickies." One-eighth the size of an imperial sheet ($22\frac{1}{4}$ x $30\frac{1}{2}$) is a practical size for a five to ten minute quickie. The quickie is a freeing experience, teaching the importance of freshness and partial statement. Many of your quickies will put more

37

labored pictures to shame. Work fast, dryer than usual, and deliberately aim at a less reportorial result. Say this "could be" the sky, this "could be" the distant headland, etc.

The quickie also serves as experience in the *necessary modus operandi* for such subjects as rocks, clouds, and wood interiors, and as the basis of notated sketches.

CHOOSING THE TECHNIQUE

With an emotional involvement achieved, and a pattern selected, now decide which mechanical procedure or step sequence is to be used: working light to dark or vice versa; pencil drawing first; direct painting in wet; brush drawing in wet; ink quill or ball-point, dry, or in wet; big washes plus brush line; big washes plus quill line; or any combination of these. *Paint—think—feel—*into your pictures as many of the truths, stated first in this chapter and appended hereafter, as possible.

This capsule form has been adopted for the following reason: So many of the principles are of equal importance that an emphasis on some, suggested by putting them first in sequence, would be misleading. Also, it is practically impossible to list all pertinent thoughts and findings—and, at the same time, maintain a smooth easy reading continuity. The isolation of each thought seems to aid the digestion of it, and a sort of "one-mouthful-chewed-at-a-time" theory seems advisable.

ORGANIZING YOUR PICTURE

The moment you put some objective in life first and relate all other interests and activities to that objective, your life is organized, *designed.* The moment you make some area in your rectangle *first* in visual strength, your rectangle is to a degree organized, designed. You contrive visual strength by "shouting" there—greater contrasts there—especially in value—and "whispering" elsewhere.

EXPRESSION IN LOWEST POSSIBLE TERMS

Eliminate, eliminate, think and see in the most basic possible terms. Fix your subject verbally in a telegram, and tell that story with the simplest possible pattern. Never forget, be eternally concerned about the rights of the picture. The frequency of the "looks at" the subject indicates the maturity of an artist. The professional artist looks longer, more intently and much less often. He looks in order to relegate nature's forms into their simplest geometric equivalents. (There are only four: cubes, cones, cylinders, and spheres.) He raises his eyes for a suggestion from nature when he has aesthetic need, in a too pure area, for a texture, detail, or value. There is constant interaction between two functionings: (1) Selecting a bit of natural phenomena that has decorative possibilities and using it in the picture; (2) feeling a need in a too pure area and looking up to nature for a clue.

Always think and work from the whole to the parts. Unless you are a master, do not "draw" in any area until you have indicated *all* areas and like their relationships. Have big things right first, and you will then question the need of details.

RESTRICTING YOUR VALUES

Strength, clarity of statement, and *breadth of effect* are of great importance. Vivacity and sparkle will result if you restrict yourself to, say, four values—light, light-midtone, dark-midtone, and dark. Color and texture are of secondary importance. They augment and embellish value organization, but can never successfully supersede it. Greatest contrasts between the values place the emphasis at the point of interest. An excellent way to discipline yourself to achieve *identity* for each of the four values is to paint a watercolor in successive washes: A light-middle tone enclosing or establishing the light areas; when dry, a dark-midtone in the light-midtone; when dry the darks painted where they occur. A happier result can be obtained when the midtones cover fifty percent or more of the rectangle; the darks and lights (never equal in area) being used for emphasis.

SEEING VALUE DIFFERENCES

Students who see casually will not perceive the color and value transitions in "pieces" of value and color. They will be informed if they will punch two holes, say ¼-inch in diameter, about four inches apart in a piece of black cardboard and, focusing the two holes on an area, with one eye closed, observe the difference in value and color in one area.

A painting half warm and half cool, or with half soft diffusions and half hard edges, or a half light area and an equal dark area, or with perpendicular thrusts equalling horizontal thrusts, or areas equal in size, is not nearly as good a painting as it would have been if the design principle of dominance had been reasoned into it, thereby achieving unity.

If you want a light area of value or color diffusing in part of a dark piece, lift some of the dark with a thirsty brush, so that the lighter color, touched in, will not be too compromised.

BEST VALUE SEQUENCE

There is an advantage in working light to dark because you are not committed to first decisions. It is easy to put darks over lights, and when the darks are put in last you can "relate" them to the lights and midtones. Also, when working wet, putting darks first means bleeding edges. You can get a kind of glitter by working dark to light, but the darks frequently look "hard"—not nicely related to the lights and midtones.

'KEYING''

"Keying" is a valuable tool. You can make an area seem darker, lighter, warmer, cooler, by keying it with its opposite or complement put close to the area, or in it. In a low key picture, avoid the small, rough-brushed whites. "Key" colors and values very carefully. The shapes of lights or light middle tones will make or break your picture for, keyed by the darks, they will have great force. Make color "sing,"

by keeping your brush very clean when going to the palette for a different color. Plan transitions and put them in freshly. Soften too hard edges with wet. Save your darkest value till the last. Remember, use heavy body color only in deeply wet areas.

THE VISUAL STRENGTH OF WHITE

The whites or the very light areas have great visual attractiveness. White has greater visual strength than the other values. It has a spotlight quality increasing in strength as the key of a picture is lowered. Place whites importantly and in most compositions when a white or a light occurs at the edge of your painting, slightly modify it at the edge or it will contend with your center of interest. Design the whites well, beautifully related to each other. The intervals between them should vary, they should have variety in size, and each spot should be a good shape in itself.

The optical illusion of two equal-sized spots, one white on a black field, one black on a white field, is commonly known. The white, *enclosed* piece always seems larger, more prepossessing, more interesting. Lettering "in reverse" is a case in point. The white or light in a picture can be utilized as a spotlight to designate the principal actor or area in your picture, precisely as in the theater. Caution: Do not make the "spotlight" too obvious—an almost circular bull's-eye, for instance. Remember that after making me look at one area first, by the use of conflicts you have an obligation to provide me with visual entertainment at that spot. Never allow a less interesting place in the picture to have greater visual attractiveness than the *most* interesting place.

An analogy here would be the bore at the party, talking so loudly that you could not hear the guest you preferred listening to. All shapes and all edges are more interesting and help integration or unity in the rectangle if they interlock, tie into each other. Stand beside a friend, "consider" your "oneness." Now embrace each other. Are you more of a unit? That illustrates the principle, the best concept, for "pieces" of value and color in your picture. Bear in mind this principle whenever you are composing the picture.

MIX COLOR ON THE PAPER

I find students afraid to slap a brushful of color into an area. They try to mix carefully in the palette a value and color that will be right on the paper. Take a chance. In the center of the area put *any* guess; you can then judge color and value (and the degree of diffusion if the area is wet) in relation to adjacent areas. Then question it, using the word "too." Is it too dark? Too light? Too warm? Too cool? In the next few minutes you key it—relate it to the other colors and values in the painting.

There are two reasons for mixing color on the paper and not in the box: (1) Colors can more readily be keyed or related to each other if they are closely juxtaposed on the paper; (2) accidentals, lovely precipitations of one value and

40

color into another occur with much greater frequency mixing on the paper. Do not be afraid of putting color or value into an area, especially while it is wet. The area—wet while you are working in it—is as plastic as a piece of putty. You can change color, value, and texture at will.

WATERCOLOR METHODS

(1) The oldest English method is one wash over another with a drying period between.

(2) Painting on very smooth "slippery" paper requires great facility in preserving the identity of different washes; great subtlety in washes and nuances of color is possible.

(3) When we use the sewing-up technique, a loaded brush is flooded into areas kept apart by a narrow thread of untouched paper between them. As the areas lose their glisten, color changes can be flooded in. When dry, these are "stitched" together.

(4) The dry brush or direct method uses little water except in large wash areas. It is a deliberate "playing it safe" method—perhaps the simplest; but it is a dangerous one in that a hairy, dryish feeling can be the result of so dry a method.

(5) The wet method is the most forthright subscription to the nature of watercolor. It gives the medium a greater chance to obey its own laws, achieving lovelier effects than you can paint. Endlessly, on my New England tours, students will gripe about a preference we have for the wet method, though I insist upon experience with every method. Repeatedly I see the griper, along in the middle of the second week, looking delightedly, and with mouth and eyes open in amazement, at what he recognizes as his handsomest watercolor, done wet in wet. This is the general method combined with wash, pattern and line, and dry brush, used by the current California watercolorists—Brandt, Post, Dike, and others.

First qualify light areas, getting transitions (gradation) of both value and color in large areas, then—designing with a large brush—mid values, establishing the pattern in the rectangle. The third step is the use of line as an additional, partial statement, helping definition, and used decoratively; then very little dry brush to help describe form and add textural interest.

The early mistakes, the initial lack of control working wet in wet, are: Improper, inadequate wetting of the paper; losing control by automatically and absentmindedly taking more water in the brush every time color is picked up; being too impatient and forgetting to test an area before working in it.

WETTING THE PAPER

Two steps are involved in properly wetting the paper: (1) In order to have it lie *flat*, it must be equally wet all over. If one area is dryer than another the paper cockles. The only way to be sure that every area is equally wet is to have every

thread of the paper thoroughly saturated. Wet the back (a soft sponge is best), turn it over and wet the front where the drawing is and then wet the board on which the paper is clipped. Pour water via the squeezed sponge, between the board and the paper. When each corner of the paper lifted and released falls back with a wet smack and the entire paper is saturated, step one has been taken care of. (2) Now tilt the board and paper so that water runs off the low corner into your water pan. When this has diminished to a trickle, use a squeezed sponge to absorb the excess moisture on the top of the paper.

This method will bring about the desired degree of wetness, resulting in the proper extent of diffusion. Experience will help here but the beginner has no alibi if his paint bleeds beyond the boundaries within which he wished to contain it. Simply *touch* the loaded brush *in the center* of an area, and watch; in five seconds you see *precisely* the degree of diffusion which will result from the brush's contact with the paper. If diffusion is too great, dry the paper either with a squeezed "thirsty" brush, the squeezed sponge, or a bit of Kleenex; or you can reduce the amount of water in the brush—more paint, less water.

When an area with color in it is too wet, and you are impatient to work in that area, expedite drying by taking several Kleenex tissues between the fingers so the ends stick out above and below the horizontal hand. Then pass the hand back and forth between the board and the paper, so the tissue dries both areas at the same time. *Never* carry the color to the edge of the area until you know exactly the degree of diffusion and like the value and color. Work in large "backdrop" areas first. Sequence will be dictated to some extent by the drying. Save sharp calligraphic and positive shapes until paper is dryer and bone dry.

KEEPING THE PAPER WET

There are ways to keep paper wet while working wet in wet. Glass under the paper, a wet blanket or blotter under the paper, or glycerin in the water. There is one best way. With your paper on a Masonite or enameled board, at about a fifteen-degree angle, lift paper at the top edge and drop water between paper and board by squeezing a sponge. The damp paper distributes this water. The trick is to do this *before you have to.* If your corners are dried and curled up from the board it is too late and you have difficulty re-wetting.

RE-WETTING

There are ways to re-wet a dry watercolor so as to work wet in wet again. (1) Submerge in water for say 10 minutes and then clip it back on your board. (2) Atomize water on the horizontal painting. (3) With a large flat two-inch brush lay a fast wash over the back of the painting; next put it on the board and run a *fast* wash over the painting, overlapping the brush strokes as you go down and never going back; finally, lift the painting at the top and drop water squeezed from sponge between the board and the paper.

DRYING

When working in the studio expedite drying with an electric hair dryer. Outdoors, turn the picture into sun or wind and hold it perpendicular.

DRY BRUSH

Dry brush on a wash creates an illusion of transparency because you see the wash through the dry brush marks. It is used to model forms via linear description of form. Caress the form in a manner the English call swirling. Dry brush can create deep darks that are not as opaque as many successive washes. An area can be darkened without muddiness if opacity is desired. Dry brush results when color is deposited only on the tops of the paper's granulations, which happens when (1) the hairs of the brush are moved on the paper parallel to it; (2) when a stroke is made so fast that the hairs never get into the "valleys."

Another quality of dry brush is achieved by use of color too dry to flow into valleys and by spreading the hairs so that individual hairs make marks with spaces between the marks, as in swirling.

Dry brush is preferable to many washes for the building up of dark darks. Fine transparent darks can also be obtained by using body color, *provided* the paper is saturated. The color being sucked down into the wet paper, makes the paper visible, because the color is in the paper rather than on top of it, between you and the paper.

CORRECTIONS

Though the chances are about even that corrections will hurt a good watercolor—freshness being too frequently lost—many papers with one or two unsuccessful areas can be saved if you have learned how to make changes. Time spent in learning how to make such corrections is a profitable investment. In one of my watercolors an area five by seven inches was very badly painted. On a piece of good bond paper I drew entirely different subject matter, a dock, two figures, and a boat, so planned as to be larger in size than the bad area. With a razor blade I cut around the outside edge of the drawing, laid the stencil over the part to be removed and, by brushing vigorously with a *damp* sponge, *away* from all edges of the stencil, regained white paper, let it dry and painted in the changes. That picture was exhibited in an A.W.S. Annual.

A bone-dry watercolor can be submerged in four or five inches of clear water in the bathtub and a large area removed with a sponge, *tamping*, not rubbing, the color out. (Rubbing destroys the surface.) An area may be lightened this way with a brush. Strangely, the areas not molested by the sponge or brush are not disturbed by the water even after being submerged for an hour. Try it and see what results you get.

The value of areas may be lightened with an ordinary eraser, or by repeated wetting with clean water and tamping with tissue. Stubborn paint can be removed

with an oil painter's bristle brush. Sandpaper is dangerously violent but I have successfully used it many times.

A fixative blower saved a picture for me. I had a goose-quill line drawing of surf and rocks at Bald Cliff, Maine, that I liked. When I painted the color in, I got a nasty iridescent, cheap lack of color dominance. I mixed a small quantity of cadmium orange and blew it through a fixative blower so that it fell evenly on the horizontal paper. This established a color dominance and got an afterglow lighting effect that was unique.

Chalk and colored pencils can get effects, burnishing opaque darks into luminosity, etc., but mixed media is beyond the province of this book because I am an aquarellist.

A pen knife or razor blade can trim a bad edge or establish a highlight.

RECLAIMING LOST WHITES

White paper may be reclaimed by wetting an area carefully with a brush and clear water. Do not let it bleed into adjacent areas. Allow the wetness to sink into the paper for a minute or two, keeping the area uniformly wet with the brush. Now tamp lightly with blotting paper or tissue, leaving area damp but not wet. Briskly burnish the area and adjacent areas with a piece of clean cloth—only two or three strokes, then immediately rub with Artgum. A little practice on unsuccessful jobs will improve results.

USING UNSUCCESSFUL PAINTINGS

Save your less successful pictures for practicing the above correction techniques. You can usually find a piece of value and color in them similar to the part of the picture you wish to change and, trying the change on the poor picture first, tackle the important change with more knowledge and assurance of success.

In my palette I have three staining colors, alizarin crimson, phthalocyanine green, and Prussian blue. Other colors, more opaque with more body used in thin washes, act as a glaze, and can impose an over-all relationship upon colors which are not very happy together. A glaze can also create an optical effect not to be obtained in any other way. Both washes seem to retain a degree of visual identity, yet the eye synthesizes them.

Try to visualize your painting. The more clearly you "see" it in the rectangle, the better. Then almost trace the concept or vision. Never, however, exclude improvisation, but do try to envision the finished job before starting and while painting.

Provide an easy way into your picture—a discernible entrance, an invitation. This entry can be made through a foreground, or what might be called a "trap" for the eye in the top of the picture, that leads into the picture and starts you toward the point of interest.

44

Demonstration Paintings

BRONX RIVER

This watercolor's chief virtue is the white shape, which obeys the law
for good shapes. There is also clarity of pattern statement, the lights,
midtones and darks being readily found. The figures are right in scale,
the gestures expressed and their degree of finish is consistent with the
landscape. It is a mistake to have figures look superimposed, appearing to
be several inches in front of the picture plane. This results from a
different degree of finish in the figures and not losing and finding
the edge.

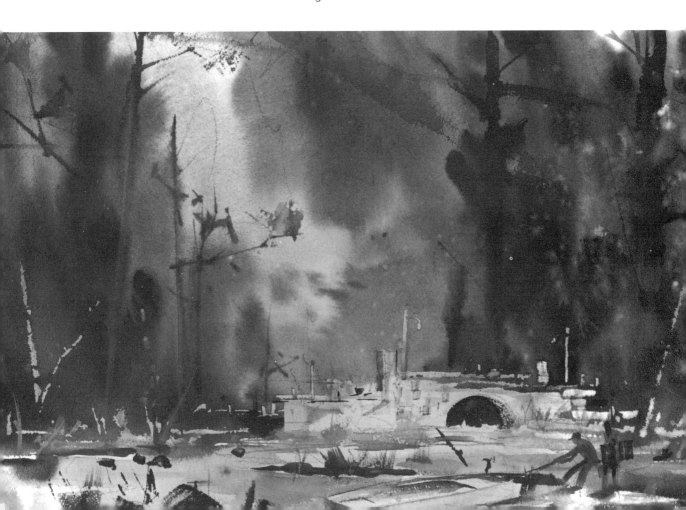

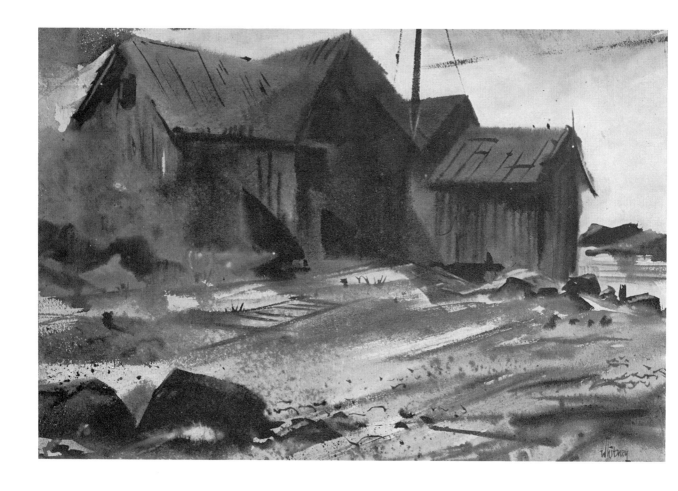

BIDDEFORD POOL SHACKS

The broad pattern scheme in this painting is a dark shape and a repeat in midtones; the three values read broadly and *intervals* between them vary: there is a large dark and a repeat, there is a large light and a repeat. There are well established dominances: in direction, horizontal with diagonals as a secondary; in texture, soft, wet in wet; in lines, straight; in color, purple.

I used the following procedure: (1) I saturated the paper, removing surface water with natural sponge then, with a 2-inch camel's hair brush, (2) I qualified lights (3) I established pattern with midtones (4) I added darks, spatter and textures, on beach and in shacks (5) I made two strokes with a rigger for the lines near the mast, otherwise only the 2-inch brush was used. Usually better pattern is achieved this way because it is easier to judge shapes when seen as *pieces of value* than when outlined. When you paint in this way, areas have an emotional charge, seldom achieved when painting is committed to fixed outlines. Also, this method of groping for fine pattern is much more plastic than pencil lines. A shape can be changed, or drawing corrected instantly with a damp sponge.

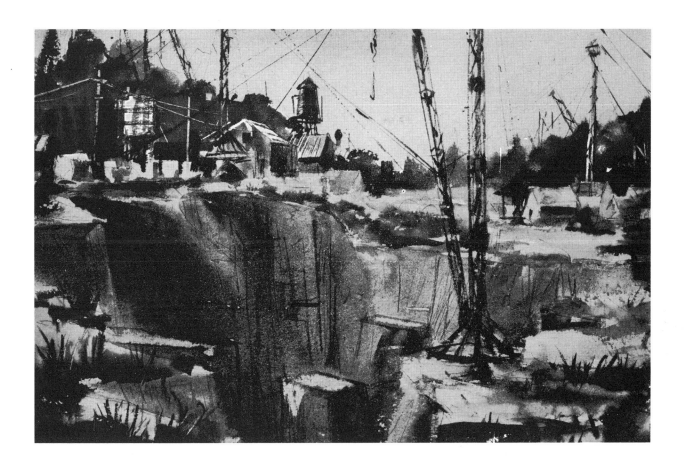

QUARRY IN MAINE

The broad pattern scheme is here an all-over pattern, expressing the clamor and busyness of this industrial area. As with all industrials in watercolor, the trick was to *suggest* the mechanical repeats of derricks, etc. The cables to the top of the derricks (many of them lost in the reproduction) show the use of the No. 4 rigger brush. Though these could be made with almost any brush, by able technicians, their smooth hang becomes a simple stroke, even for the novice, with this brush. The color scheme also expressed the clamor of the place—gray sky, but the rest of the painting uses hots and colds in equal intensity.

47

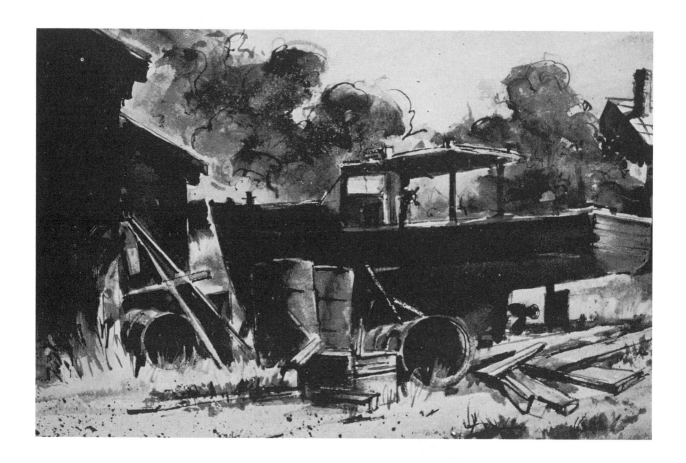

KENNEBUNKPORT BOAT YARD

Here the broad pattern scheme is a piece of dark against lighter values, the shapes interlocking very successfully. The painting has a very decided warm dominance, the large dark piece, house, boat and cans are all reds of varied hue, intensity, and value. The foreground is yellow and the vegetation a very warm yellow green. I drew first directly with a goose quill dipped in black India ink. Line and wash watercolors must have a dominance of one of the media; either a drawing, tinted, or a watercolor with definition helped by line, are the two concepts to choose from. Always consider them as two partial statements. Do not have washes and lines precisely "fit" each other. Have them "out of register." This creates vibration and avoids a tight, prim feeling not compatible with watercolors.

My demonstration failed. The piece of dark, though well designed, had no gradation in color and precisely equalled the visual strength of the ink lines. I told my class to go to work and I "fought" it for another half-hour. I first darkened the dark piece, overpowering the lines there. When that dried, I rough-brushed pure vermilion over the shed at left, the first wash *showing through*, creating the illusion of transparency. I put a brown *ink* wash over the boat to give it a different color quality. It is a very strong watercolor now.

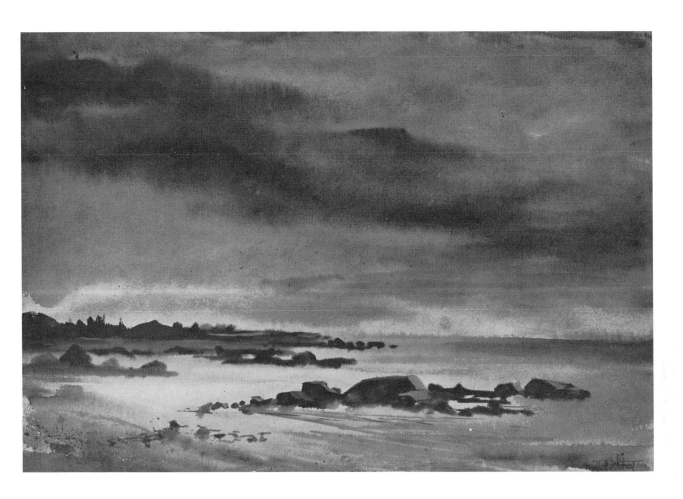

CLEAVES COVE

I didn't draw in this painting before I applied the watercolor. I used cold press, 140-lb paper, thoroughly saturated, diminishing the surface wetness with a sponge. I ran a gray graded wash from the upper right to the lower left, leaving the "spotlight" in which I planned to put the peninsula with its typical Maine vegetation. When the wash was starting to lose its glisten, I touched a 2-inch brush, loaded with color, *into the center of the area I knew was to be darker, and watched the degree of diffusion.* It was almost right but did not diffuse quite enough, so, *I changed the angle of the paper* from 15 to 45 degrees —*insuring the nice drool.* I then slapped in the strong oblique thrust, swung it back towards the center of interest, changed the color slightly, en route, and that was the sky.

Next, the neutral gray (ivory black) beach, an oblique repeat of the sky oblique, was added. Then a touch with a loaded brush in the middle of where the dark sky oblique was planned, to test color, value and diffusion . . . color and value were right, there was a

bit too much diffusion, so I decreased the angle of the paper to almost horizontal and put in the dark oblique, swinging it back towards the center of interest in the low sky . . . next the peninsula *interlocking* all edges, using the typical rocky shore in Maine decoratively and describing form, which was the plane change to the horizontal grass plane . . . then the near rocks again, being careful to interlock edges, to have rocks *different sizes* and to have color changes in that piece . . . the lit planes were squeegeed out with a piece of rubber heel . . . then spattered texture (an extra dimension) on the beach, which with a touch of burnt sienna, brought it forward. Only the 2-inch and 1-inch flats were used. The painting was completed in 25 minutes. Regarding these fast pictures, once again I state that the nature of watercolor, its bloom, its immediacy, the glory of tool *marks*, the precipitations of color and value can create beauty *provided the artist has created fine value and color chords and distinguished space divisions.*

49

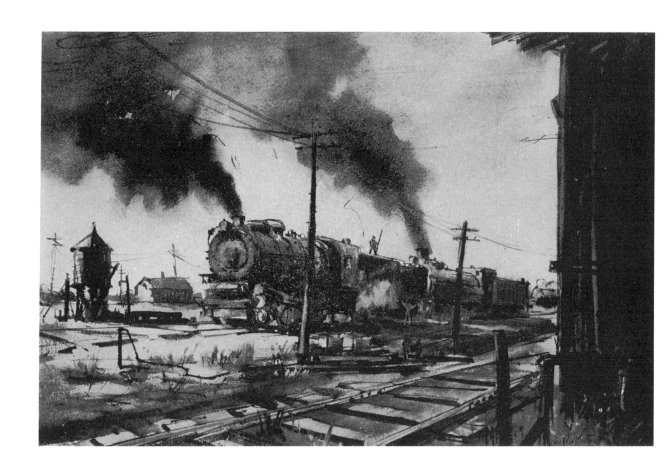

OYSTER BAY FREIGHT YARD

The broad pattern scheme here is a piece of dark against lighter values. Color scheme was almost a gray monochrome (significant design); a few warm spots in the foreground for aggression were the only colors of any intensity.

In spite of the complicated subject, I drew directly in ink with a quill. As a matter of fact, if you've drawn enough, you rarely change a pencil line anyway, so why fear the other drawing tools?

This watercolor demonstration failed miserably, so I told the class to start working, and spending another half-hour, I saved it. The failure was in the value chord. I laid a thin wash of opaque white over the entire paper and then changed values and the intervals between them, precisely as you would grope for a chord that "sounded good" on a piano. This value chord is very difficult to appraise in watercolor inasmuch as when values look right when wet, they are wrong. The values change. Yet, their relationship is second in importance only to pattern.

The industrial sky was a flat wash of pale ivory black. A loaded brush was tried in the center of the smoke area until the diffusion, value, and color was just right. I then shaped the smoke diffusions, adding drier color and changing the colors, varying warms and cools as I got nearer to the engines, being careful to have the nearer smoke darker and warmer. I am sure this is what Charles W. Hawthorne had in mind when he said "A good watercolor is an accident."

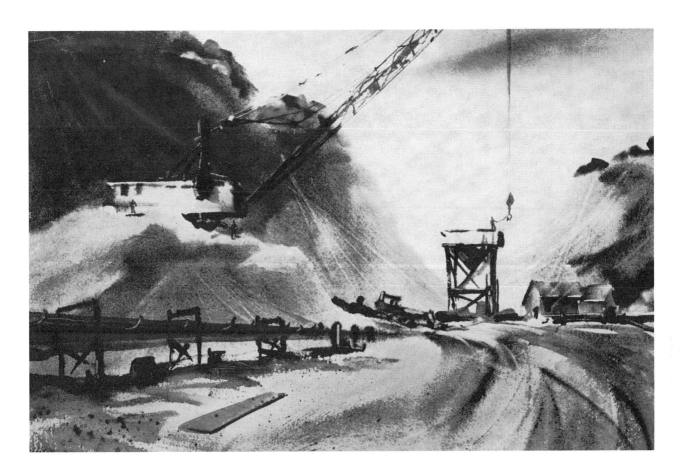

LONG ISLAND SAND PITS

In this reproduction the piece of dark upper left is utterly wrong value. I cannot understand why. It is supposed to be an orthochromatic print. The color scheme was complementary (orange and blue). The center of interest was well established in the area of the derrick cab, it being an intensely cold yellow (strontium), and the darks of the derrick support and under the cab were the most intense darks in the painting. There is also a linear subordination to that center, in the rhythms of the road. The two buildings and the bulldozers create a line pointing to the center of interest, as does the derrick. Everything except the derrick and cables was painted with the 2-inch brush, the end of which, touched to the paper, created "marks" clearly seen in the structure of the hopper and the conveyor belt.

The danger in industrials is to report too much. Make partial statements, enlisting collaboration of those who look; they "finish" the picture with you.

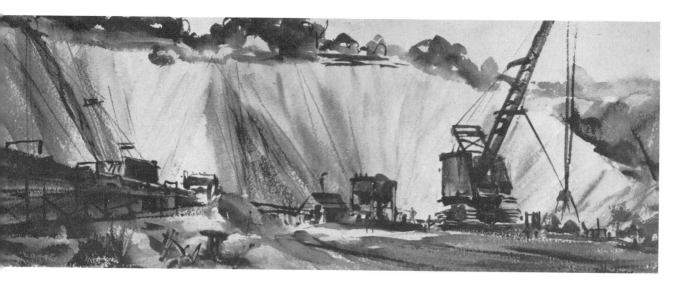

OPERATION—SAND PITS

The broad pattern scheme here is large light and small darks in midtones. This is a middle major key picture. The color scheme was analogous: yellow, brown, and orange. Greens at the top and the red cabs of the derricks were too small and neutralized to count coloristically. Form description in the pits was important (two basins), and the linear marks made by the handle of the brush while the area was wet helped describe these forms. The 2-inch brush did the entire job except for the two very small figures and the cables on the derricks. Again center of interest or principality or organization, whichever you choose to call it, was established by having major conflicts at one well-placed spot. The darkest dark, the lightest light, the hottest hot, the coolest cool, and the sharpest edges all occur where the cab and derrick are framed and silhouetted. I did not draw, but painted directly. The calligraphic quality of the brush end touched to the paper is apparent in many places. Again, in an industrial, the chief pitfall—belaboring detail, or "hemstitching"—was avoided.

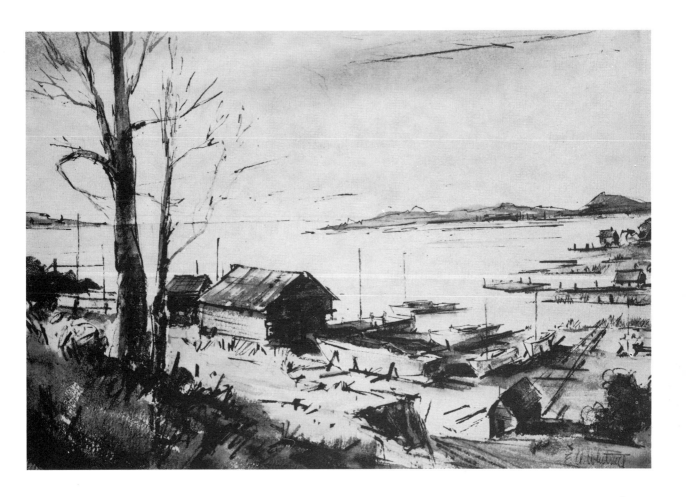

SAMMY'S BOAT YARD

The broad pattern scheme is darks against lighter values. The washes came much darker in the reproduction, losing all of the detail in the shadow sides of houses and destroying carefully contrived value relationships. The reproduction becomes an arrangement of two values which the painting certainly was not. The bad reproduction also compromises the line dominance which was so important. Perhaps the only function the reproduction can have is to show the variety of weight of line possible with a quill pen.

This was a direct quill-ink drawing, making capital of the variety in weight of line possible with that tool. Note that the ink line had to be run into the sky, so that the line convention used anywhere would be echoed everywhere. Texturally, it would have been two pictures, had I not done this. Disunity would have resulted.

53

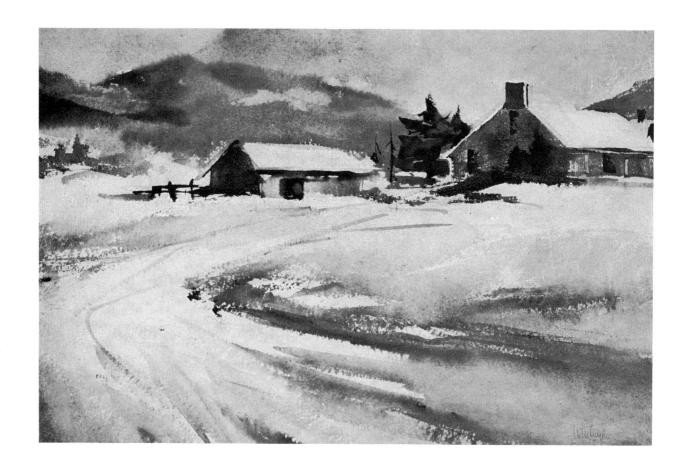

LONG ISLAND SNOW FALL

This fifteen-minute picture's virtues are in its color and value chord. It was made from a notated sketch. The reproduction is in black and white and the darks appear much lighter than in the original. Nevertheless, good space divisions, directional obliques and the tool marks of the 2-inch brush (no other tool was used) are to be seen.

Even though the sky was quiet, it helps to have some slight accent, *well placed*. The slightly darker mark above and to the right of the mountain breaks the top edge of the picture into two nicely related measures or dimensions.

There is design significance in the large, quiet areas expressing the hush of freshly fallen snow. In snow pictures, save rough brushing for foregrounds. Shadows are cool grays if you paint realistically, and the trick is slightly to modify the expanse of white for variety's sake, but still have it read as white. "Killing" the whiteness is the most frequent mistake students make, and of course, being a high key picture, the *shapes* of darks and where they are placed are all-important. Again design is the answer. There is no one note on a piano more beautiful than another. The beauty of a chord consists of right *relationships*. There is no one line, value, color, textures, shape, size or direction, the beauty of which is not contingent upon its relationship to other lines, values, colors, textures, shapes, sizes, and directions. Beauty is found in *relationships*. If you do not *develop* taste in judging them, you are rolling dice in the rectangle, and, which is worse, your ability to judge is atrophying.

4

Landscape Painting

LANDSCAPE PAINTING is one of the best means of exploiting the virtues of watercolor. The landscape terrain challenges you to use design, color, and composition in your painting and the subjects you are embracing are all bathed in nature's greatest gift to the painter: light. You will appreciate landscapes more after you have struggled to realize them in watercolor. Besides, painting outdoors is fun!

SUN ON PAPER?

There are those who differ, but it is my opinion that no one can do his best work with sunshine on his paper. You go snow blind, cannot sensitively relate values or colors, and the washes dry too fast. Contrive a shadow somehow. (Your own is the handiest.) It is not necessary to face your subject. That idea is a life class hangover. You look more intently and understand better when you look over your shoulder. All drawing (except contour drawing) is memory drawing.

TREES

Most outdoor subjects include trees. Knowledge of them, or the lack of it, will be apparent in your pictures. The bibliography includes the finest, most thorough book on drawing trees. You should own a copy. Here are general statements pertinent to painting trees in watercolor.

Each species of tree will have its characterizing silhouette which is its fastest reading label. The foliage has form which needs modeling and, having a light-absorbing texture, the value differences between planes in light and planes in shadow are close, and need exaggeration for the best form description. Observe the laws of light, including the warm light bounce from ground to under-planes of the tree.

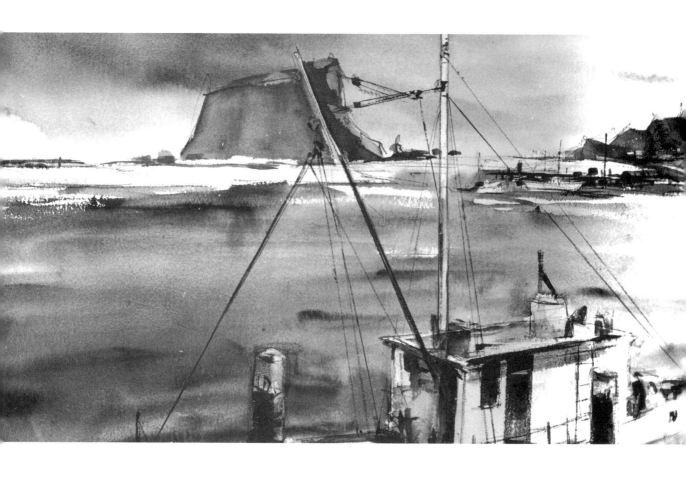

BOATS AND MONOLITH This was a full sheet imperial size
watercolor, and a failure. By judicious cropping at the bottom,
where I made the mistake of reporting detail of trivia, I have
a better job now with a few fine angles and directions. In
color it is dominantly blue with a nice repeat of white shapes,
obliquely related. Some warm oranges in the boat, repeated
in the sky, function as conflict for the dominant blue. These
enormous monoliths dotting the West Coast have decorative
potentials and can be made capital use of by the watercolorist.
Note gradation in the large washes of sky and water. Note
variety in weight of line in the "lace" of the boats' super-
structure and rigging.

The skeleton of a tree—trunk, branches, twigs—is a water system. The volume of a branch leaving the trunk must be subtracted, and the trunk above that branch must be the difference in volume.

The textures of leaves are suggested by rough brushing with an occasional extra leaf here and there. Texture is more apparent at edges and where planes in light turn into shadow.

As always, to identify locale, seize as a "label" that which happens there and nowhere else. In trees, this "best label" is a hole in the foliage with a branch seen through the hole. Holes seen through dark areas of foliage will "jump out," keyed by the darks around them, so their value must be a bit darker than the rest of the sky behind the tree. If you paint large areas of foliage and then, while they are wet, run the trunks and branches through them, you get the interlacing of foliage and branches most expediently—the brush mark of the trunk or limb striking a dry spot records limb in front of foliage. The same stroke striking a wet spot diffuses and reports foliage in front of limb.

There is no more recurrent motif in landscape painting than the lovely piece of "lace" of trunks and branches shadowed by the foliage. Seen against sky or against a piece of sunlit field which is behind them, each "thread" of the lace has a different direction and volume, and each interval between them a different shape and size. This can be the motif for a picture or a secondary interest.

WOOD INTERIOR

Do not try to paint individual trees in a wood interior. As in a rock subject, paint the elements of what happens. Shimmer is the essence of the subject, if sunlight comes through to any extent. Trunks will be cooler where they face a clearing, warmer where they reflect the forest bed. A logical sequence of steps I use is: (1) Sky area pinkish so as to key greens, carried low so whites will not "pop" later; plenty of white in the *rough brushed* sky area because of the subject's essence— shimmer. (2) Sun-struck foliage, pale greens and yellows, including foliage on the ground. (3) Pale violet distance (if distance can be seen). (4) Dark foliage in shadow, getting value and color transitions in the areas. (5) Throw water into this area (with discretion) and then tilt and jolt until the medium creates textured accidentals. (6) Now paint in trunks and branches, paler and thinner in background, warmer and larger in foreground, cutting across trees for foliage in front with wet brush. (7) Put branches in spaces in the foliage with smaller brush—this is the *symbol* for this locale, a space with a branch seen through it. (8) Knife scratch—spatter some textures in too pure areas. (9) Paint in the ground warm in the foreground and dark light oppositions, cooler and lower value contrasts in recession. (We hope you have chosen a forest floor red with needles.) (10) Cast shadows of trees all pointing directly to a point on the horizon directly under the source of light.

DUNES Distinguished space division, (great variety in sizes of pieces) is a virtue in this watercolor. The color scheme is simple. The pale yellow, lit planes of the dunes, were keyed by the large area of neutralized lavender in the shadowed planes. Neutralized blue greens in sky and water were arbitrarily repeated in the lower left. Every directional except the horizon was an oblique, *expressing* the essence of dunes, and every oblique was a different angle. All art is thematic. A theme must be imposed for the sake of unity. The challenge to one's wit is to contrive varieties in the repeats of the theme, such as the curved beach grass, a different texture from the other obliques and also a different angle. In as large an area as the shadowed planes of the dunes, gradation (which is purposeful avoidance of monotony en route) must be contrived. In this area color, value and size of textural incident change moving from left to right. This watercolor was painted in a reasoning rage immediately after a demonstration in which, too subservient to what lay before us, I got a real "stinker." The result looks nothing like what was before us, but it is an infinitely superior *expression* of, and emphasis on essences of, dunes.

58

Now close up or modify any lights you do not like. Remember that in a low-key picture the light shapes have to be beautifully designed. They make or break your picture.

BIRCHES

Give birches greater girth than they usually have so as to exploit their textural beauty. Get color into them. I usually proceed with (1) A cobalt wash, rough brushed on the light side; (2) sneak some alizarin into that, then a yellow ochre light bounce at the bottom, then Payne's gray to accent the plane change near the light; (3) with a mutilating tool—knife, heel or pencil or a brush, suggest the concentric circles using them to help describe the twisting and turning of the trunk; (4) the black marks (black flavored with burnt umber) where branches have broken off; (5) the foliage, knifing some branches through it.

SAND DUNES

When painting sand dunes, overemphasize minor differences in sand color. Avoid bisymmetric dune shapes. Usually, the prevailing wind undercuts one side, and the grass roots hold together a slightly overhanging top. There is much more color in them than a casual eye sees. Each summer at Ogunquit, Maine, I impress this fact upon classes by picking up on one small dune, red, orange, yellow, green, blue, and violet vegetation, jet black kelp and snow white clam shells. The colors are in bits of vegetation and mussel shells. It is your artist's prerogative to multiply these colors at will to achieve varities in monotonous areas.

Dune forms are not easy to "describe" because their planes change two ways at once, laterally and perpendicularly. *Do not*, after you have described the form of a dune, put the vegetation, either grass or beach plum, where it will obscure the form description. The dune usually does this; you must not.

A scuffed, rough-brushed line can describe the essential flatness of the beach, with undulations where you need a change of value and textures in the foreground. Spatter used with discretion is another interesting way to get foreground texture.

Bending grass can suggest the wind. If you make the grass tall, the dune will look small. Broken off stubble of grass is still another decorative motif.

There is no more adverse circumstance than painting on a beach if there is a wind. Sand gets into everything and on your watercolor. A large percentage of the blowing sand is in that first eight inches above ground. Prop your gear a foot above ground and you will paint in comfort.

MOONLIGHT

There are things you should know if you tackle a landscape in moonlight. Violets and reds become darker, and yellows and greens lighter. A very limited color range, in the blue and green areas, best suggests moonlight. You may use a full

value range. Key the blue greens used by putting neutralized warms in the low values, underneath things. Another characteristic of moonlight is that the moon, being a first lighting rather than a source of light, makes the light on earth a second lighting, and the bounce from that into the shadows is negligible. Hence shadows in moonlight are opaque—show no partially lit detail in them.

THE OCEAN

If there is a sun-glint of broken color on the ocean, do that first, with a fast rough brush stroke or two (the paper is still flat then). Get more of the color of water in the darks than the lights. The sea is not as blue as many painters paint it. Have strong transitions of both value and color in large areas. Though a rolling over motion can be seen in surf, do not report that linearly. The action which is more propitious for us in the pitch—toss—bounce—feel. When the incoming wave hits something and explodes into a "burst," do not forget that the burst is part of a wave. Show the rest of the wave running out of each side of the picture or behind some object. This is not only what the wave does, but it makes a finer shape. Many pictures in exhibitions have a burst of surf unconnected with the "arms." of the rest of the wave and I can scarcely resist shouting, "Thar' she blows!"

SURF

The pitch-toss nature of surf demands obliques for best expression of its movement; and remember, two or three obliques, each centered on one horizontal plane, reads as one horizontal, not three obliques.

Surf is not white. You can see forms in it, hence there must be shadows. Although it is not white, it must look white. Edges must vary but have few hard or sharp edges. Waves are soft; their edges are not sharp. After a wave breaks, it become aerated, changes color (veridian) and never again in its race up the beach is the color of the sea repeated. Be sure to vary the cool color of the aerated wave and have a horizontal transition in both value and color.

Though the surf spume and suds have a granular aspect, avoid too much rough brushing. It is monotonous texturally and looks dry, which surf is not. Each burst and wave has form, and that form must be *described* by subscription to the laws of light obtaining on any form. The surf and its bursts do not pose. When painting, watch until you see a good burst. Close your eyes and "see" the image in the retina for a moment, and then paint. If you look up several times while painting, you will come up with a characterless composite. Ignore the small and depict the larger forms of surf and waves. Too attractive edges detract from inside or third dimensional shapes and volumes.

To show force, picture the object hit (the rock) as well as the result. Get some grays into surf so the veridian will be keyed. The grays predominate in the surf explosion—almost no greens there. Change the quality of your veridian by

60

putting a bit of alizarin in it as it moves across the picture. Never have a big formless shape; insist upon third dimensional volume in both waves and burst. Make capital of wind spume at top of waves and burst and establish different plateaus in sea, especially among rocks. Get reflected light on rocks from near-waves and key the green surf by warms in rocks and sky. Spray and bursts are not as cold as you think. Sneak a pale yellow ochre into them. A big storm spume is also shot with yellow ochre—organic matter.

In the burst, vary the edge. The hard edge is the solid water going up in front. Too much detail in the white area of spray kills the power. Watch and think for a while, then figuratively turn your back and paint. Waves are splashing, tumbling, bouncing forms. Do not make them static.

ROCKS

Students have a great deal of trouble with rocks. Do not have them the same size. A sharp edge, both in silhouette and in third dimension, makes them look harder.

Do not paint them in variegated colors. Select either the mean color of rocks in that locale, or any color you like, then get variety into that color via warmer light bounce on shadowed side, but stick to the color adjective you have selected for the noun rock. Sky will reflect in up planes in shadow. Avoid green rocks. You would be using the adjective that describes other nouns—water or grass. Cracks under rocks should not look like outlines; give them chink-like shapes. Scar rock surfaces and get their textures by rough brushing or squeegeeing paint from the tops of the grain of the paper.

SNOW

If the day is sunny, very pale yellow ochre washes should be used with broken color on snow planes facing the sun; cobalt and Payne's gray in shadows. The contrast intensifies both local colors. Sunlit trees and buildings reflect on snow, especially in the shadow.

For snow on a gray day, shadows are delicate, neutral grays. White paper is very important, and you can get granular texture via dry brush, mostly in foreground where textures are more discernible. Slightly compromise remote whites. A damp cold feeling is achieved by blended edges. As in surf and cumulus clouds, more color than is actually there must be in the white areas in order to avoid boredom. Dead vegetation coming up through the snow is very warm and keys the cools of the snow.

REFLECTIONS IN WATER

This is a pure theory job, but the theory used results in realism. It does look that way. Understanding of the truth that the angle of incidence equals the angle of reflection can be obtained by placing a fair sized hand mirror on a table in front of

you, at arms length. The angle of incidence is created by the beam from your eye and the reflecting plane. The angle of reflection is the angle from the reflecting surface to the object reflected. Now, looking at your mirror on the table, it can instantly be seen that the angle of reflection can come up under a horizontal book below your eye level and enable you to see under the book, precisely as you see under a dock over water. A pencil tilted towards you reflects a greater perpendicular measure in the reflection than in the pencil, just as a pole in water will, and the pencil tilted away from you reflects much less than the pencil's length, again precisely as does a pole in water. The pencil at a 45 degree angle from the mirror plane to right or left reverses in the mirror at precisely 45 degrees.

There are your observations. Use them. Inland water is a mirror.

This law provides a perfect symbol for the essence of calm water. Its essence, flatness, is best symbolized by a horizontal. The near side of ripples, reflecting the sky, provide a light horizontal. The far sides of ripples reflect dark shores, houses, docks, or whatever, and qualify dark horizontals. So you have light and dark horizontals to express the flat plane and provide design motifs in the area. Dark values reflect in water a bit lighter, mid tones do not change in the reflection and light values reflect darker.

While on the subject of reflections, a recurrent argument among art students might be resolved. The problem: Two lights at different points on a distant shore, reflected in the intervening water. Do the lights converge to a point in the foreground at the observer's feet, or do both reflections drop perpendicularly on the picture plane? Students will insist that the reflections converge, glancing at one light and seeing it drop perpendicularly to their feet and then looking in turn to the other light and seeing the same thing happen. The truth is that you establish *two different picture planes*, the moment you turn your head slightly or even shift your eyes. Your picture has only *one* plane, hence *all reflections* drop perpendicularly.

SKIES

It has been said that the sky is the daily bread of the eyes. Certainly, being the source of light—the most beautiful thing that exists—skies are an ever-present bonanza for the watercolorist whose fresh, transparent washes over white paper are the closest approximation in visual arts to the glory of light. If the subject matter of a picture is the sky, do not have any considerable area of ground or much detail in it; make it frankly a sky picture. The reverse is also true. Do not report too much interesting detail in a sky when the point of interest is on, or in, terrain.

The essence of sky is transparency. *You* look *through* it into infinity. *Any* first wash, or effect obtained while the sky area is still saturated will not be a total failure as a sky, inasmuch as the most essential characteristic of skies will have been reported. By the same token, a sky is the most dangerous area to go back into after it is dry. You risk the "Cyrano with a a small nose" kind of failure the

62

moment a sky becomes opaque. Irrespective of incidents in them, skies on clear days are darker and warmer at the zenith and cooler and lighter at the horizon. A concept of any area helps an artist state with conviction. There are four concepts of skies to choose from: (1) A perpendicular plane or theatrical backdrop; (2) a ceiling going back to infinity; (3) you, inside of a cylindrical sky which rolls back down behind the horizon; (4) you, on the earth, at the center of a spherical sky, or the sky seen as a dome. As to technical solutions for problems presented by specific skies, be sure to study the demonstration paintings at the end of this chaper.

CLOUDS

I consider cumulus clouds the most difficult landscape subject. Casually observed, edges of cumulus clouds look sharp. They are not, so do not make them sharp. 'Treat" their edges. Clouds are soft. An edge you could shave with does not report their character—does not express them. Keep the highlight inside of the edge. With clouds as with rocks, houses, trees, or whatever, unless there is some excellent design reason, have the larger objects in the foreground. This helps recession. Larger objects more remote and the smaller ones foremost, create an unpleasant sensation. When you have varieties in size (for aesthetic reasons) and larger forms forward (for reasons of perspective) you kill two birds with one stone.

Cumulus clouds are constantly boiling and puffing. They have holes and caves in them similar to foliage. Distant cumulus clouds are, of course, smaller and also flatter at the bottom. The distant sky is colder and it keys the clouds. Always have a center of interest in the sky area, one place more aggressive visually. Exaggerate the cools and warms underneath the clouds, even in the same cloud. You will be lost if you hesitate or vacillate painting this subject; it is done rapidly, and usually on damp paper. An occasional crisp edge is advisable for the sake of variety. See masses, not outlines. Make the chief values middle tones so the lights and darks will "tell."

Good results can be obtained by flooding color in and tipping the board, especially for bottoms of clouds. Distant clouds are warmer, and cloud bottoms reflect what is under them. When a cloud is between you and the sun, paint the entire sky with graded wash, dark and warm high, and cooler, lighter low, leaving white paper where the cloud is; then paint the cloud, leaving a silver rim around the cloud—design areas of blue, soft-edged and beautifully placed between clouds.

Textural accidentals are in the clouds, not in the sky which is a smooth transition from dark warm high, to light, cold low. Carefully avoid the just blue and white aspect which the sky frequently has. Get subtle color varieties into clouds and sky. These skies *must* be quickies, like surf—a few fast strokes. It is a quickie on wet paper using dry paint, usually, but there are always more ways than one. Another way would be to paint cloud bottoms with diffusions and color changes in

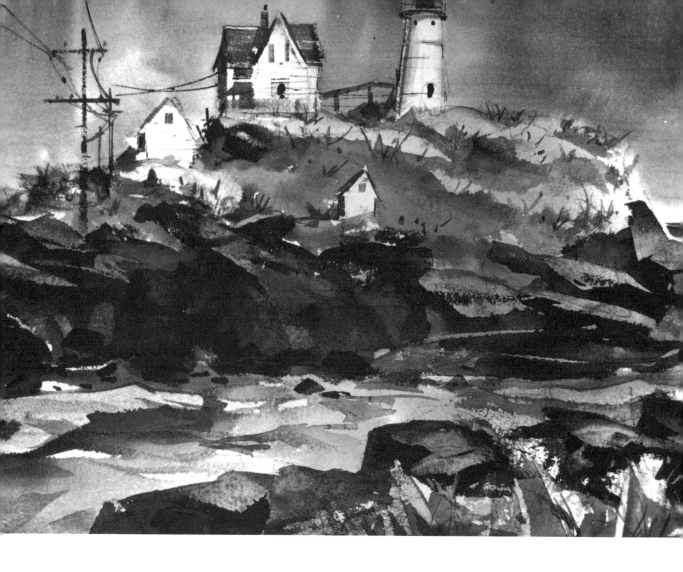

NUBBLE LIGHT The chief virtue of this watercolor is the
clarity of statement, achieved by six pieces of color and five
pieces of white, reading clearly, their visual identity carefully
preserved, *not* broken up into what Rex Brandt calls "ham-
burger." In the black and white reproduction, I'm afraid
Rex's indictment would be qualified, but in color, they were
the kind of flat, simple shapes George Post contrives. The
color achieves the important breadth of effect. Each of the
pieces or shapes in this painting was clearly identified by
almost flat color, with subordinate repeats of each color.
Sky and water were both blue. I carefully avoided having the
identical color and value adjectives for the two different
nouns. The grass is two pieces of green. The rocks are two
pieces of brown. The buildings are pieces of white, all dif-
ferent sizes and carefully allocated so that the measures and
angles between them differ.

the wet paper. When this is dry, run a wash for the sky having nice transitions and omitting the whites in the clouds; "treat" edges while wet.

FOG

Fog is a difficult subject matter in watercolor, though it would seem that it was just a question of right values. Too frequently when trying to hit a right value with a first wash the results are "thin," and have no sense of "realization." I have had fair results making values too dark and then, when dry, wetting and blotting repeatedly. I had best luck, however, with running a wash, then just as it starts to lose its glisten, atomizing clean water into areas. This stunt was born of an experience. While demonstrating one day, a fine rain—mist—started to fall. My paper was just the right degree of wetness and magically it became a successful fog picture. I immediately purchased an atomizer and now always carry one. In a fog picture *tremendously* exaggerate recession. Make every forty feet of recession approximate the recession of a quarter mile on a clear day.

OUTDOOR LIGHT

A third dimensional quality is obtained by subscribing to the laws of light. Areas become paler, cooler (clouds near horizon the one exception), and less detailed as they recede; aggression is contrived in foregrounds by using warmer, darker, more detailed areas and some violent contrasts.

Outdoor light is warm in the morning and evening. Sometimes the shade is warm also, though usually it reflects the cool sky. At midday the high source of light is cool, the cast shadows are cooler and the shade side of objects warmer and lighter.

GRAY DAYS

On gray days, objects are seen largely as *pieces* of value and color against different values and colors,. But because of the power of light, form can be ascertained. In your painting, you had better assume there is a stronger light from one side, so as to simplify the problem of form description. On gray days shadows are warmer and lights are bluish.

INTERIORS

In interiors, lights are cool and shadows are warm, as they are out of doors on a gray day. The great disparity in values between the light seen through windows or doors and the light in an interior can be appraised better if you will half close your eyes and compare them. The only way to approximate this tremendous difference in values in your painting is to skip some of the values in between. Using a value range of from white 1 to black 10, rigorously discipline your value scheme as follows:

65

If the interest is in the detail in the interior, use a 1 and a 1+ value for outside, and *no lower value*. Skip, do not use, values 2, 3 and 4 anywhere. Use values 6 and 7. Use only values 8, 9 and 10 for the interior.

If the interest is outside, use values 1, 2, 3, 4 and 5 outside. Skip, do not use, values 6 and 7. Use only values 8, 9 and 10 for the interior.

OTHER LAWS OF THREE DIMENSIONS

In addition to knowledge of light laws which enable you to give an object a third dimensional quality, study other methods of rendering a third dimension into your picture: (1) A diminishing in recession of a given measure, road, trees, figures, clouds, houses, animals, grass, *linear perspective*. (2) Overlapping planes or objects. (3) Gradation subscribing to recession laws with color, value, or both. (4) Movement in depth. As opposed to planes parallel to the picture plane, planes in linear perspective going back into the picture and creating a path for the eye. (5) Sharper value contrasts in the foreground.

UNITY

The primary principle of aesthetic order is unity. A creditable water-color must be a unit, an entity, an integration, an organism. Unity exists in visual art when some design *character* of one or more of the design elements—line, value, color, texture, shape, size or direction—is imposed upon subject matter (usually by repetition). Here are examples showing how dominance creates unity. They are abstracted from successful pictures so that dominance, and the resultant unity, will be more apparent.

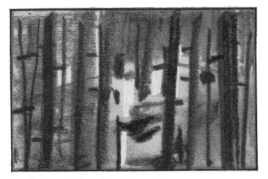
1. *Perpendiculars and horizontals* (*architectural*)

2. *Curvilinear*

3. *Perpendicular* (Rex Brandt)

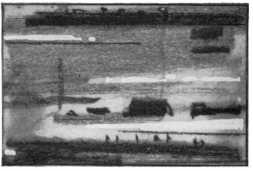
4. *Horizontal*

DESIGN CHARACTER

To emphasize design values, and to insure unity, deliberately *impose* some design character upon parts of the painting and vary the repetitions of it. Select a character that expresses your subject. Imposed characters might be Fig. 1—architectural, or right angular; Fig. 2—curvilinear; Fig. 3—perpendicular; Fig. 4—horizontal, Fig. 5—obliques; Fig. 6—angular; Fig. 7—spotted. Wit and taste are required in making some of the repeats subtle and in varying the repeats in line, value, color, texture, direction, size, and shape. Combinations of these characterful impositions are interesting. One must always be dominant for best results.

GRADATIONS

Frequently subjects will compose in such a manner that a large area must be kept less aggressive, visually, than a smaller area where there is more visual entertain-

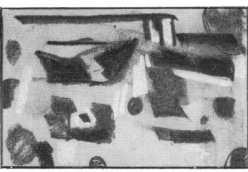

5. *Oblique (W. Emerton Heitland)*

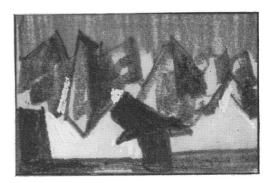

6. *Angles (Charles Comfort)*

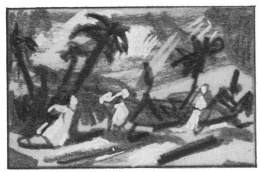

7. *Spotted (all-over pattern)*

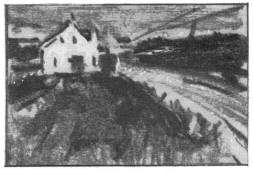

8. *Radiation, or linear subordination to a center (Andrew Wyeth)*

9. *Any combination of the foregoing, one dominant and one secondary. In this one, horizontals are dominant, spots are secondary. (Dong Kingman)*

ment. The way to solve this problem is to depend upon gradations for interest in the large area, using as many gradations as possible, so that life and movement are there but no visual clamor, inasmuch as adjacent parts of any gradation are harmonious. Get gradation in as many of the elements of design as possible.

FOREGROUNDS

A rural or suburban foreground frequently baffles students. There are two essences to be reported: (1) The terrain (usually an almost flat plane); and (2) the growth on that plane, usually grass. A linear rough brush mark describes the flat plane or rolling ground. Grass rhythms, nicely designed and diminishing in size as they recede, can well define the growth on the terrain.

There are two possible concepts of foreground: (1) We are looking *over it* at something else (work wet in wet, so diffusions occur), so that textures and things seem out of focus. (2) We are looking *at it* and because it is close, see minute textures and all detail.

RELATED FIGURES

Figures at different points on a third dimensional plane must be properly related. Draw two lines, one from the bottom and one from the top of a figure in the picture; these lines will converge to a vanishing point on the horizon. The perpendicular between those two lines at any point going back, will be the height of a figure on that horizonal anywhere in the pictue. For a head in the foreground, or parts of figures, continue the perspective lines out of the picture at the bottom or side. The figure should then be fitted into a perpendicular and a head, in right proportion to that figure, will be properly related to the figure in the picture.

EDGES

Interlock edges wherever value changes occur and vary the quality of the edge. There are three qualities possible: rough brush, blended, and sharp. Using all three qualities *at* edges puts air around objects.

Demonstration Paintings

WEST COAST SUN

The size and allocation the ocean, monoliths, buildings, sky, and rocks
were arbitrarily *designed*. Dominance of color (blue) moved towards purple
to key and complement the yellow sun. Curvilinear dominance was
imposed in the sun area and in the waves. Subordinate straights are in
the horizon, rocks and houses. A repeat of the yellow sun was
"whispered" in the lower left and in my signature.

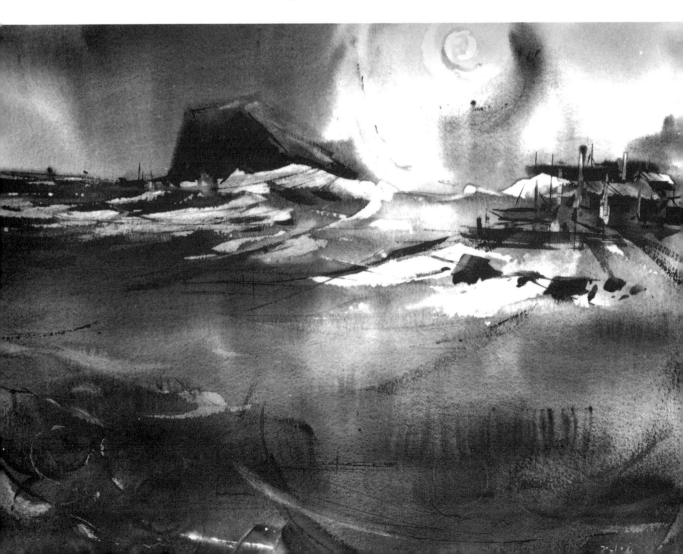

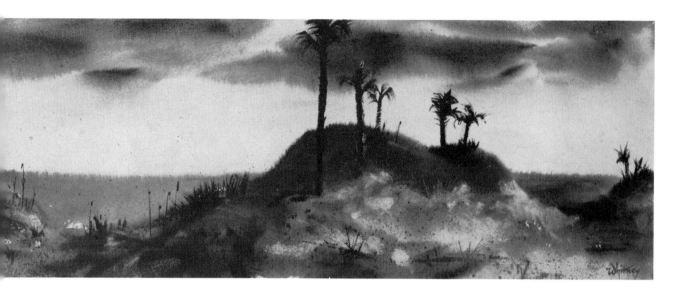

FLORIDA DUNES

This is one of the few paintings I have in which I have imposed a design motif to the extent that I want to ("Mountain Top" is another one). Note: the camera destroys unity by getting a picture that is coloristically two pictures (1) the cool sky (2) the warm earth. *Do not do that.* You must have a repeat of the sky color in the earth area and vice versa, if you are composing—designing a painting. In "Florida Dunes," I then repeated the design motif of the undulating dunes in the clouds, making the perpendicular measure of the clouds' dark area different from the dunes, and the length of the undulations shorter. (Repetition with variety).

This is an orange and blue job with soft greens here and there. I think the space division is good. I think tying the darks together with the two trees made for a fine interlocking center of interest, which is certainly well established. The broad value scheme is a piece of dark against lighter values. The key is middle major. I like this picture very much and practically no one else does. The procedure I used was: 300-lb paper, superficially wet with a sponge, then direct painting—no drawing (1) sky, (2) ocean, (3) dunes, (4) clouds, (5) trees and grass. Painting time was fifteen minutes.

70

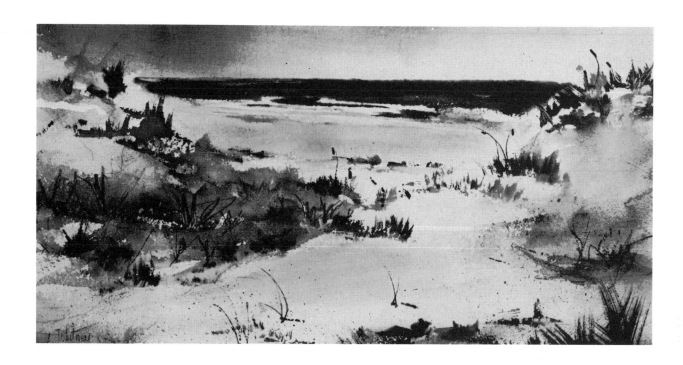

OGUNQUIT BEACH

The triangular piece of dark escapes the indictment of an unrequited wedge only because of its interlocking edges. The top and bottom angles are a "reverse repeat"—always bad. Also, this piece precisely divides the piece of white beach, another error. This piece was very rich in color, however. Again, the formula —a large piece of neutral gray, then hots and cools, one dominant—was successful. The perpendicular measures of sky, sea and beach are nicely varied.

This has a nice gradation in the sky and the gradation *works for me*, making the ocean a sharper, more demanding edge where I want you to be visually entertained by sea, surf and dune textures.

A danger in this subject is to have the edge of beach parallel the horizon, making a measure that does not change (boredom), missing the chance to get gradation in measure and making the piece of sea bisymmetric, ergo static, which it certainly is not. If there is any breeze, when painting on a beach, hoist your palette and paper about 8 inches above the sand (beer cans, logs, anything will do) or you will contend with the most adverse circumstances in outdoor painting. About 75 percent of the sand blows in that 6 inches above the beach, hence the 8-inch recommendation.

71

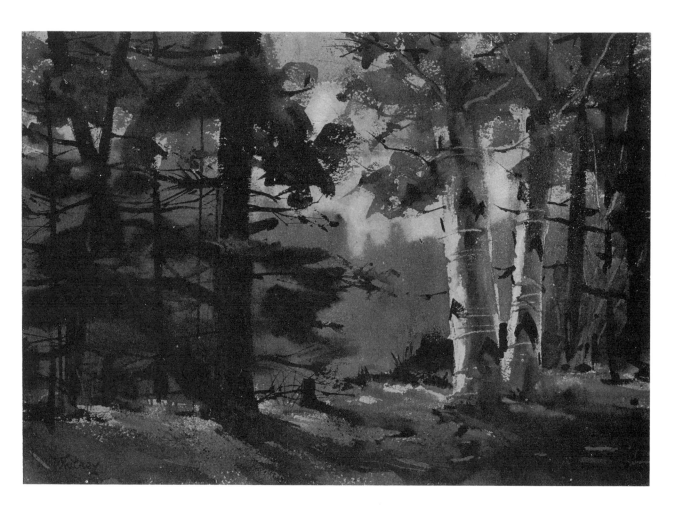

QUEECHEE FOREST BIRCH

The broad pattern scheme consists of a small light and large darks in midtones: dominances (therefore unity) in value, darks; in color, greens; in texture, rough; in direction, perpendiculars (through repetition). There is lack of unity in point of view or concept in this picture. The birches were realistic and the evergreens were more abstract. Inconsistency of this kind is always a fault. Also in a thoughtless moment, I divided the dark area of trees to the left with an almost perfect diagonal, making two almost equal areas in that subdivision of the rectangle. Edges of foliage are nicely varied as to texture—rough—blended and hard.

Procedure: (1) with pencil a rough placing of areas, drawing only the three largest trees; (2) painted the sky and distant sunlit hill; (3) the birch trees; (4) the wood interior and ground.

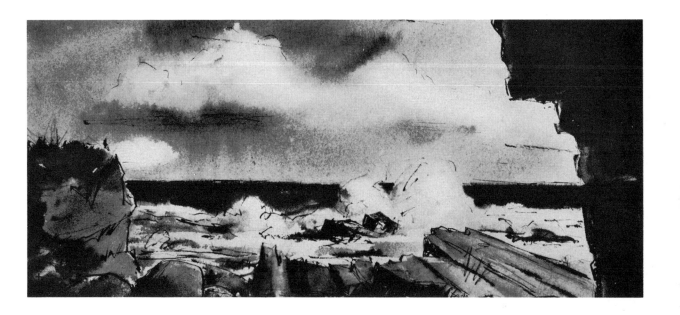

LOW SUN

I had to fight this one. I do not like the pattern, the space divisions or the value chords (though they are not as bad as they seem in this reproduction).

I first made a quill line drawing that made me happy, repeating the line texture in the sky, so as to have textural unity. I then painted a nasty, iridescent, cheap sky that made me miserable. The understand-ing of the cumulous cloud problem was there, but the color was awful. I laid the wet painting horizontal and with a fixatif blower, sprayed the picture with cadmium orange. The result magically achieved a nice modifying of the too raw blues, and a low sun effect. The cliff at the right has color varieties in it that the reproduction does not report.

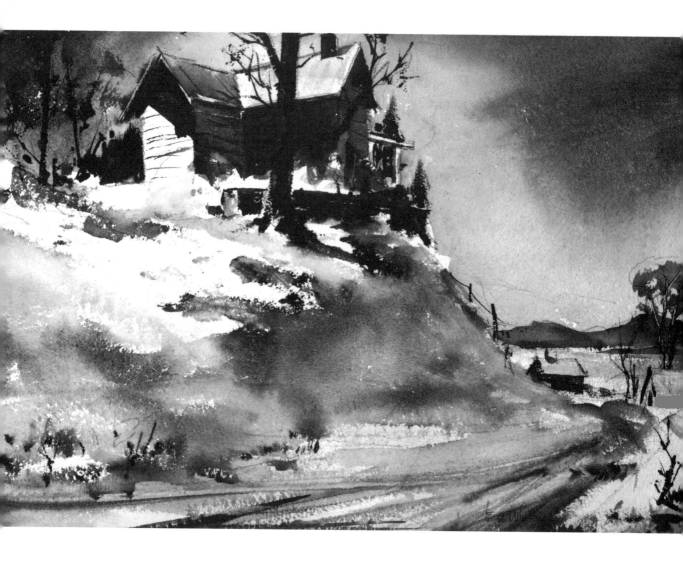

FIRST SNOW, LONG ISLAND

Snow, surf, and cumulous clouds are difficult subjects because the whites cannot be monotonously the same white. The shadowed planes, *not* white, must look white. Also color changes must be sneaked into these areas with great discretion.

In this watercolor, the academic drawing is sound. The lights, midtones and darks are readily identified, and color dominance is present. All of these components are on the credit side. On the debit side, to this painting's discredit, there is no dominant direc-tion or theme. Perpendiculars, horizontals and obliques are equal. I enjoy this criticism, assuring me that I have learned since I painted this watercolor and can say with relish "I know better now."

What a joy to believe in something. In any other investment, financial, domestic situation, friendship, you can meet disaster. When you practice a craft, you get what you pay for. No door is closed to a stubborn scholar and his greatest reward is the quality of ease that is his when he knows that he knows.

74

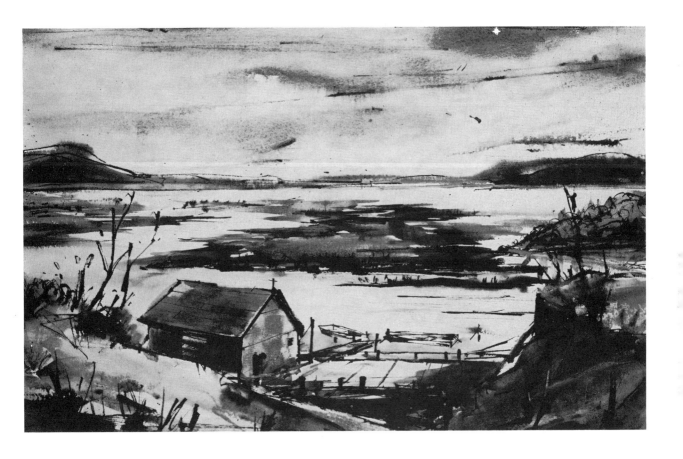

NISSEQUOGUE, L.I.

This is a goose quill, India ink drawing, with washes constituting a second partial statement. The pitfall in line and wash watercolors is in having the two partial statements balance in visual strength. The concept must be a tinted drawing or a watercolor with defini-tion helped by line. In the original, a two value in the sky keyed the water. In the reproduction they are the same value. Note that textural unity is maintained by the ink lines in the sky.

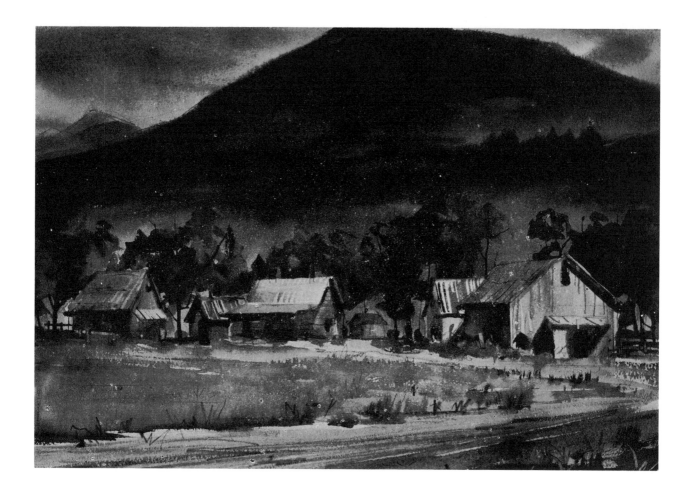

GREEN MOUNTAIN VILLAGE

The broad pattern scheme is small lights and a large dark in midtones. The picture's key is middle major; color scheme is analogous, green and yellow; mountain is green; field a yellow green; light strip forward of houses, yellow; houses and road, gray. You will rarely fail coloristically if you have a fair sized area of absolutely neutral gray and then warms and cools, *one of them definitely dominant.*

Note the device of swinging the long line (always have one) of the road back towards the point of interest, exactly the same device as used in the "Cleaves Cove" sky, chapter 3. All problems are recurrent, the same solutions are found irrespective of subject matter.

I used the following procedure: First, I made a pencil drawing, pushing the mountain out of the top to make it say high (a diminishing value as you come

down also says high and has the aesthetic virtue of change or gradation); the repeats of the motif house were varied in size and proportions and faced in different directions; cast shadows (exaggerate them on a gray day) are the fastest way of saying light. I used them in several places. The two essences of the plane in front were stated (1) it was flat, horizontal scuffing expressed that fact, (2) grass grew there, "whisker" strokes at edges of values and a few calligraphic scribbles expressed that texture . . . roads essences are rough texture, ruts, and grass at the edges. Trees were designed to be seen against the lighter area of the mountain and to make the buildings "pop." I first painted the sky, then the mountain to top of houses, foreground underwash, road, houses, textures in field and road, trees. It was a wet job on 140-lb. cold press paper.

5

Figure and Portrait Painting

I TAUGHT two subjects at Pratt Institute—pictorial design, or composition, and figure and portrait painting in watercolor. My assignment in the third year was to teach students the importance of breadth of effect and help them toward ease of handling. Both objectives are achieved most expediently through watercolor experience. Both are interdependent.

FRESHNESS, ESSENTIAL

I believe the thing to keep in mind in a watercolor portrait or figure is the nature of the medium being used. A watercolor portrait, labored over, making many changes to achieve a likeness, will not be a fine watercolor and, therefore, not a fine watercolor portrait. Let me hasten to qualify this statement. An artist of stature might have no concern about the attributes of watercolor, ignore the approximation of light in transparent aquarelle, not concern himself with the beautiful precipitations and transitions in washes and, if he were a powerful designer and draughtsman, produce an exciting portrait, but what logical answer could he give me if I asked why he didn't use casein, gouache, oil, or tempera paint?

All of the principles of design, all of the truths about treating edges for the sake of varieties, all of the value and color-chord concepts, the need for subscription to the nature of the medium, its spontaneity, wetness, transparency, immediacy, its "bloom," and its natural province of partial statement are just as valid, as inescapably essential in portraits and figures, as they are in landscape. The only difference is subject matter.

However the greater need for an honestly served apprenticeship in draughtsmanship, the absolute essential of knowledge of anatomy, and the rare quality of empathy, if likeness is to be obtained, make fine watercolor portraits very scarce

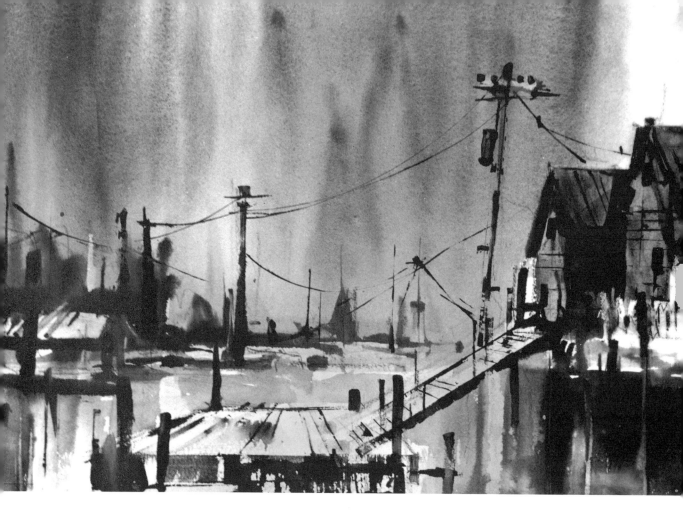

JERRY BUILT Dominance insures character. Here we have
dominance in color (yellow); in line (straights); in direction
(perpendiculars). All art is thematic. Here, the theme is
perpendiculars. The poles, the wires, and the textures in the
float and gangway were all made with a straight edge wiped in
pigment on the palette and imprinted on the paper. The
textures, therefore, have the quality all tool marks have. If
the noun sky and the noun water had different color and
value adjectives, it would be a better watercolor. It is,
however, a pretty good watercolor because it obeys design
laws. The dominances mentioned above insure unity, the
greatest single aesthetic essential. Also, it has clarity of
statement—the light shapes and the dark shapes read clearly
in the amalgam (Brandt's word) of the midtone.

78

indeed. How many do you see in the important watercolor annuals? See the chapter on drawing for the kind of experience needed.

I have a few procedures and theories which work for me and which I taught at Pratt. The twofold problem in a watercolor portrait is (1) likeness and (2) a fresh sparkling watercolor. I solve the likeness problem by making five or six paintings. By the time I get to the fourth or fifth painting I am familiar with the head architecture—which is as important as the features—and with the character of the features. With four or five studies behind me, I know which mass dominates that head—there are five masses—and the nose, eyes, and ears are familiar to me.

I solve the second problem, freshness, by flatly refusing to beat the life out of my portraits. I make them in twenty to thirty minutes. So my formula, if I may use that odious word, is paint them fast and paint six of them.

THE "PUDDLE" METHOD

I have a procedure which simplifies the watercolor figure or portrait painting problem and helps achieve breadth of effect. I mix a good sized puddle of mean flesh color, usually yellow ochre, cobalt blue, and burnt sienna. It is also a mean value. As opposed to mixing color each brushful, with the difficulty of getting reasonable flesh to read as a unit, I have instantly available a puddle of color that ties the flesh colors together, that can be "flavored" en route in my washes, warmed at the throat, ears, malar bones, chin, etc., and cooled elsewhere for reflected lights, or whatever reason. The value can also be changed at will—a lift with a thirsty brush to lighten a value; added pigment to darken. I find this puddle idea invaluable for figures, especially nudes and portraits.

Both wet and dry methods have several logical procedures. Here are some of them. I use the same procedures for figures and portraits in watercolor.

DRY METHOD A

(1) A charcoal line drawing—no large pieces of value indicated. (2) Fix the lines by going over each of them with pure water in a brush, so they will not diffuse in the washes to be applied later. Note, plain water is a fairly efficient fix. (3) Paint fast, simple washes using the puddle "flavored" or varied here and there for flesh tones, and describing forms in light value-wise.

Note: Ordinary domestic, or imported French charcoal paper takes color beautifully and does not cockle too much if you work fast.

DRY METHOD B

(1) A charcoal, Wolff pencil, or graphite outline drawing. (2) This outline fixed with a pale cobalt blue line. (3) A pale raw sienna or yellow ochre wash over the entire flesh area to avoid a snowed-on look in the light areas. (4) Paint, using puddle, flavored and modified in flesh areas. In this method the blue outline creates a nice vibration with the warm flesh washes.

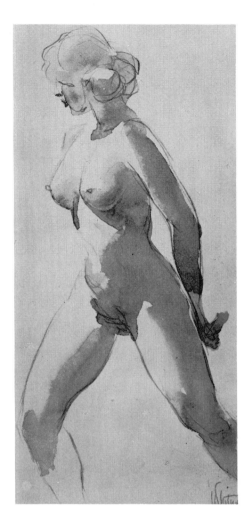

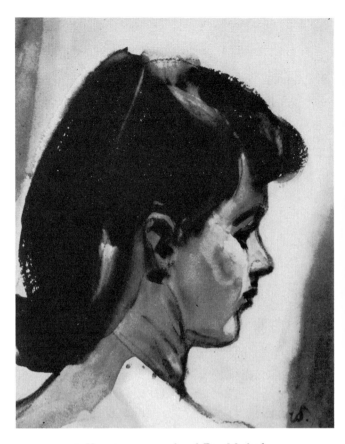

BROWN EYES Here is an example of Dry Method B, in which the paint has been applied over a fixed drawing and wash. Note the deliberate avoidance of monotony in the character of the edges. Three possible qualities were used: rough brush, hard, and blended.

PLATINUM This five minute sketch illustrates use of Dry Method A, in which the charcoal line drawing was fixed and then painted over with fast simple washes.

DRY METHOD C

(1) A graphite, Wolff pencil, or brush line drawing. (2) Fast, simple washes establishing planes and colors. This is more a colored drawing than a painting.

DRY METHOD D

(1) A dry bristle brush cobalt blue—or, if a fair model, yellow ochre—drawing, designing, drawing lines and dark areas. (2) Establish lighter tones still with bristle brush—accent plane changes where light meets dark "feeling," describing the form with brush strokes. (3) Now the big puddle washes right over the dry brush drawing with some modeling and color changes. (4) Let this dry and then treat

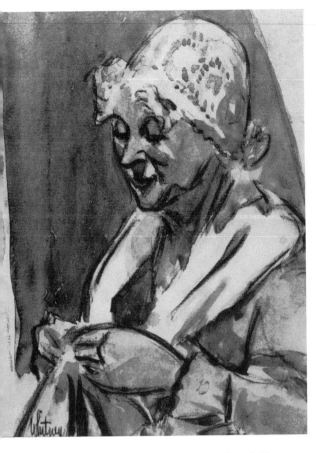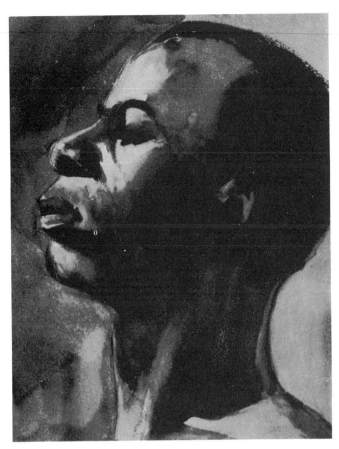

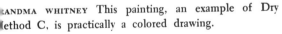
GRANDMA WHITNEY This painting, an example of Dry Method C, is practically a colored drawing.

HUNTER This painting is an example of Dry Method D. Note how the dry brush marks have described the form of the head.

edges, put in accents still needed, lighten values by wet and blot—rub with a clean rag or blotter, also qualify and relate lights. What the English call "swirling" can function now to accent plane changes and darken small areas. "Swirling" is simply dry brush marks caressing and describing the form.

In dry method A, lightweight paper may be used comfortably. In dry methods B, C and D, you will have better luck with heavier paper. In the wet method, 140-lb. paper gives the best results.

WET METHOD A

(1) Saturate both sides of the 140-lb. rough and also your Masonite board or whatever backing to which you have attached your paper. With a real sponge—a synthetic sponge is too harsh—absorb the water on top of the paper's surface until control of diffusions is possible. (2) Draw, design rapidly with a brush and any fairly neutral color—yellow ochre or Payne's gray will do. Corrections and changes

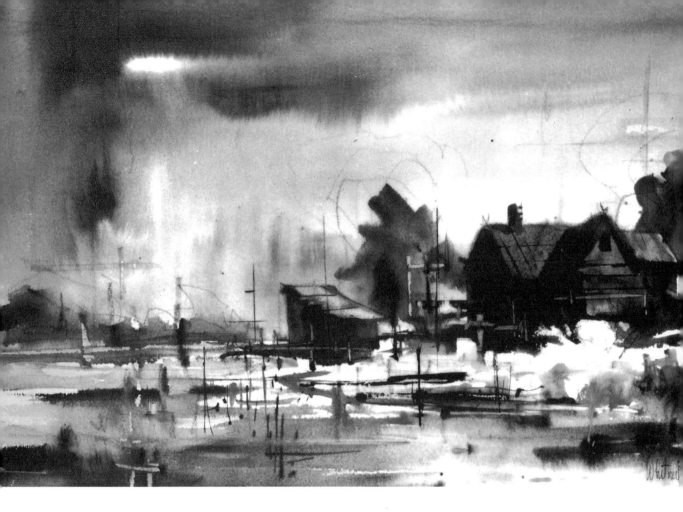

LONG ISLAND SHORE The theme here was the box (horizontals and perpendiculars). This theme is obviously and arbitrarily repeated in the sky. Without this kind of imposition of a theme, your watercolors will not have *unity*, the greatest single aesthetic essential. This is a dominantly cool watercolor. The buildings are neutral gray. The color-*less* buildings made the color-*ful* sky, vegetation and water, more beautiful.

Note again a "big piece" in this instance: the sky. The size of the interest area is in a nice relationship to the entire rectangle. I am indebted to George Post for his constant concern and appraisal.

All beauty is a question of relationships. No one line, value, color, texture, shape, size or direction—no one note on a piano is more beautiful than another. It is a relationship contrived by the artist that can be beautiful.

82

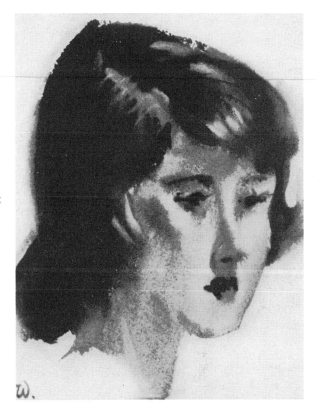

YOUNG MODEL This painting is done with Wet Method A. Chance is a big factor in this method.

in drawing or design are instantly made with a damp sponge wipe-out and redrawing with brush. This is the most plastic way to design. (3) Paint in *large* areas now in approximate colors and values. Avoid being over-careful. These relationships are to be judged and adjusted after they are there—juxtaposed. Also start to model form. Paint *freely* the big "pieces" only. Do not leave them until you like them. Keep paper wet by occasionally lifting top of paper from board and squeezing water from sponge, so that it falls between board and paper. The still damp paper distributes this water as a blotter would and stays limp and damp. (4) Now, as paper becomes dryer, work in the darks, the sharper edges, and the definition of smaller parts. Drawing can still be corrected and edges treated with a thirsty brush moved slowly.

There is a larger element of chance working this way, but a reward in painterlike quality when they do come off. Also, this method is more fun and it teaches you to see broadly. It is a freeing experience.

WET METHOD B
Draw with any tool that makes a mark, then saturate paper and proceed as in wet method A above.

In all above methods try to work in one piece at a time, stopping at logical "bridge-heads." The "piece" which is the head could stop momentarily at the

83

sternomastoid or bonnet string muscles, for instance; or one arm could be treated as a "piece" then back into the puddle color and on to the next piece. If you do not do this but go too far with an edge, you will find in going back to it that it has dried, cannot be treated, and it will be too late for value and color changes to be made without losing transparency. There will be a degree of wetness that is most propitious for the degree of diffusion you want; work in the piece of broad simple wash at that best time.

BACKGROUNDS

Backgrounds to either figures or portraits should be grayer, less intense colors. The background should not be more aggressive than it is when you look intensely at the model. And, of course, strive for fine value and color chords.

A figure, bathed in light, is just about the most exciting subject matter there is: The glory of the light, the ecstasy of flesh, the *character* to be seen manifesting itself in proportions and articulation, the *design unity* in any organism.

SEEING YOUR MODEL

No "tick-tock" trained eye and trained hand painting here with this subject, *please*. The mind aware of the values in the above paragraph, intervening between the eye and hand and conditioning the hand. A real *seeing* reported. If you cannot report in ten or fifteen minutes, it is because you do not know enough about structure. Get your nose back into your anatomy book. The more anatomy you know, and the less your work parades your knowledge, the better. Especially know skulls, joints, and tendons.

Show the precise point at which the angle of curve changes and accent it; exaggerate the angularity there. Cubes are better than cylinders as concepts, be-

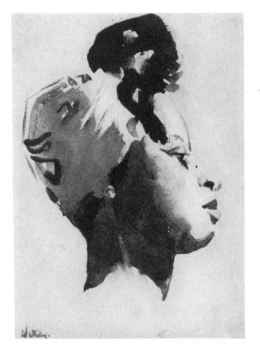

THE TURBAN In this painting —Wet Method B was employed—the drawing was made *before* the paper was saturated. The difference in the character of the right edge (lost) and the left edge (found) is a virtue. In color the turban was very dramatic.

cause it is easier to locate details on them, and they show better where dimensions change. Features are not holes in the skull, they are part of it. Shadows lie on a figure. The shape of a shadow must not overpower, nor have greater visual aggressiveness than the form it is on. Do not think of a shadow as dark, think of it as less light. Find an interest in the subject. Fix it verbally and then paint that; ask yourself, "what emotion am I painting?" Select and intensify. Lose and find forms— that puts air around them. Never a glib, smart sketch; rather a respectful study. Do not start at once, but look until you "see." Paint your emotion, not the model. You are not after the camera's "facts," you are after the essential expressive truths your trained eyes have learned to see.

Your painting is a partial statement addressed to the imagination. A thought sequence which gives a sense of being organized and putting first things first, a logical sequence, or thinking from the whole to the parts, is to (1) "feel" the pose or gesture with a fast, expressive "matchman." (2) Check the "points"—shoulders, elbows, hands, knees, feet, to modify a too melodramatic expression or add action to an understatement of it. (3) Draw forms on matchmen and establish planes in light and shade. (4) Accent plane changes. Treat—vary edges and reflect light.

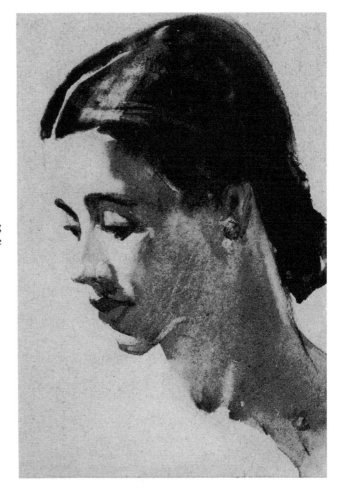

TALL GAL Here is another painting using Wet Method B. Note the quality of diffusion this method renders.

USING THE LAWS OF LIGHT

Know and report the laws of light—the six lightings on any form. (1) The local color in light; the planes receiving light. (2) The plane change accent; the plane receiving neither the first light nor the light bounce. (3) The plane in shade but not yet turning into the light bounce. (4) The reflected light in the shade. (5) The crack underneath the object or form. (6) The cast shadow.

With a definite concept of the position of the light source, any form understood—cube, cylinder, cone, sphere, hemisphere—can be described intellectually. The head is a cube, the lower arm a cone, the upper arm a cylinder, the breast a hemisphere, etc.; forms seen as their simplest geometric equivalents and *described* that way.

PAINTING MEANS WORK

A smart-aleck attitude, no matter how clever you are, is fatal. A fine antidote for slickness is drawing for a while with your left hand. Think of your drawing as an ideograph. What is in your mind and heart will be recorded; paint with compassion in your heart. Placing a highlight accurately is as important to drawing as the outline. Surround it with a value wash. Fix verbally a profoundly felt significance about the pose or model. Keep this trenchant verbal analysis in mind by frequently repeating it, or writing it to be glanced at, then emphasize any element that contributes to that concept and reject any component that does not. You will then have unity and power, every element being constructive.

The law of cause and effect is inherent. There will be some manifestation of basic character and inner integrity in the gesture. If you can, select and intensify that!

If you fail consistently in your watercolors, I doubt that it is because of stupidity. I suspect failures are the result of ignorance.

There are certainly differences in students' potentialities, but the differences are very rarely because some can and some cannot; more often they are because some *do* and some *do not*. I have seen this demonstrated in too many of my classes to doubt it. Almost without exception, the ablest student is the most studious and the most prolific. No talent can survive the blight of neglect.

Thoughtful production and sincerity will put qualities into your work which trained eyes can recognize.

I sense the cynical smiles of some, reading that statement, and I say to you: *"You have a very short memory."*

86

6

Principles of
Design

Amateurs paint pictures. Professionals
build pictures . . . with these bricks.

THERE ARE EIGHT principles and seven elements of design. Ignorance of the design significance of fifteen words—or synonyms for them—means design validities will infrequently and accidentally occur in your paintings and you will not be qualified to evaluate the accident when it happens. Understanding of the fifteen words—or synonyms for them—will enable you to fuse design values with psychological values in your watercolor paintings, and more successfully express and communicate your ideas and emotions.

Unity, conflict, dominance, repetition, alternation, balance, harmony, and gradation are design principles. You may prefer synonyms for these words. Opposition for conflict, transition in lieu of gradation, or stating the principle obversely, subordination instead of dominance.

The elements of design—the only tools you have to work with in the space arts—are line, value, color, texture, shape, size, and direction. I will discuss the elements of design more thoroughly in the next chapter. Do you want to think about, plan, organize your life, or would you rather improvise en route like a dog, turning in whichever direction smells good? Do you want cognition to contribute design values to your watercolors, or do you prefer to just "emote" and roll dice in the rectangle? You can think only with words. The fifteen words listed above are the most significant words a painter has. With them he can think, plan, build, organize, express himself, and communicate. Let us define them. *Definitions will be understood better if you refer to the reproductions with the map-like references and the text showing where these design principles pertain.* First, let us consider the

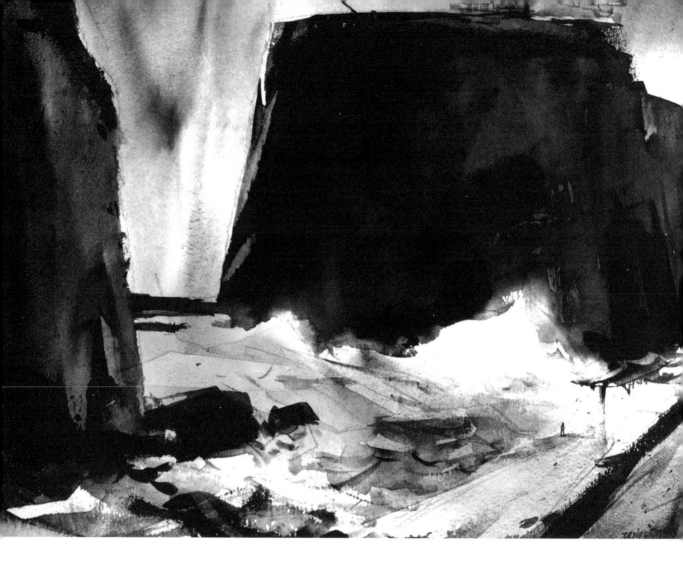

UNDAUNTED MICROCOSM This perhaps silly title occurred to me
watching the figure of the girl, microscopic compared to the
enormous rock and the raging Pacific Ocean. Something in her
stance was virile, adamant, undaunted by the macrocosm before her.
The mess at the upper right corner of the big rock does not
bother me at all. It would have distressed me a short time ago, but
happily, I find that my present preoccupation, objective and
interest is *big* pattern. If the bigs are right, small areas are
unimportant.

I am not too happy about the shape of the big rock, but there is
color and value gradation in it and several different qualities of
edge around it. I do like the surf shape and consider it expressive
and successful. This and the other paintings made on my recent ten
thousand mile painting tour encourage me by their manifest
changed objective and concepts. The dominance of straight lines
dramatizes the pitch toss of the surf. In color the neutral gray
beach makes colorful enough the not very colorful color elsewhere.

88

design principles; then the elements which are to be appraised, measured, and disciplined by these principles.

UNITY

The primary principle of aesthetic order is *unity*. A creditable watercolor must be a unit, an entity, an integration, an organism. A rabbit's tail on an elephant is wrong aesthetically. It is bad design. Your painting must be an elephant or a rabbit, or whatever it is, *all over*. Just as one bar of *St. Louis Blues* played in the middle of *Ave Maria* would destroy the unity of the musical composition—its greatest aesthetic essential—so any extraneous line, value, color, texture, shape, or direction, *not* repeated, echoed, integrated elsewhere, would compromise unity in a painting. Check through the reproduction criticisms for better understanding of the principle of unity.

Aesthetic order is contingent upon the principles of unity, conflict, and dominance, which obtain in all art forms and never change character or meaning. Being ubiquitous, their relationships—the interactions between them—must be understood.

There is static unity, passive, inert as geometric crystals of any kind, and there is kinetic unity, fluid, and in process of growth. Unity can be arrived at by association of ideas—flowers and garden tools; lovers and a moon; sailor and parrot; or by the integrity of the idea itself insisting that all elements extraneous to it be eliminated—that all elements used be consistent or subscribe to it. Unity is one definition of form, nothing can be added, nothing can be taken from it.

UNITY
It is not even suggested that Mr. Kingman worked in this sequence, but I have used a watercolor of his with an obvious horizontal dominance to show how (1) perfect unity can be a bore; (2) conflict adds interest; (3) more conflict, therefore additional interest, but disunity because no dominance; (4) dominance of horizontals (including the repetition of the bolts) has resolved conflict and regained unity.

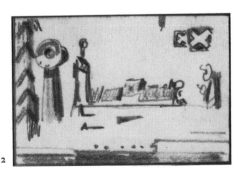

1

2

3

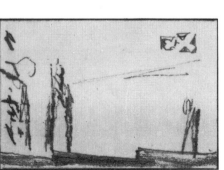

4

CONFLICT

CONFLICT OR CONTRAST
Diagrammatic examples of the design principle of conflict. See criticisms of reproductions for increased understanding of this principle.

Color conflict results when colors opposite each other in the color circle are used in equal intensity and areas.

Conflict, the tension between opposing elements, creates interest. Unity requires that tensions between visual forces be moderated, integrated, and synthesized by dominance. This dominance subordinates the visual attractiveness of the parts to a plan, a design for the whole, a sort of Gestalt philosophy, in which the whole is greater than any part and greater than the sum of its parts. Unity can be built into a rectangle in many ways. Some of them are very subtle. An artist's personal style or his character can achieve unity in his works and defy analysis. Technique can be analyzed and can unify works by repetition of the character of marks or means employed. The elephant hide allover analogy points up the principle. Check through the reproduction criticisms to understand better the principle of conflict.

1. In line: straight and curved.
2. In value: light and dark.
3. In shape: round and angular.
4. In size: large and small.

Contrast or opposition or conflict is the dynamic essence of art forms. Contrast and gradation vitalize. They put monotony to rout. Taste dictates the line of demarcation between restrained, dramatic, or melodramatic use of contrast. Contrast can be used with all seven design elements. The chord concept consciously appraises contrasting intervals and is again best for creating this contrast and degrees of it.

A design can be given character significance by degrees of contrast. The essence of a subject or the artist's emotional reaction to it can be expressed by contrasts—violent, active, or tranquil. Check through the reproduction criticisms for better understanding of the design principle of conflict.

5. In line: straight and curved;- also conflict in direction and conflict in measure: long and short.
6. In size and value.
7. In size, shape, and value.
8. In size, line, value, and direction.

DOMINANCE

Dominance resolves conflict and regains unity. The traditional and simplest way to achieve dominance is by repetition of an element, or elements, of design. The ways to use the principle of repetition are infinite in number; they can engender all kinds of emotional response and evoke any mood. A design can be coherent and discordant at the same time, if the principle of dominance has been imposed. Unity and violent conflict are not incompatible. Check through the reproduction criticisms for better understanding of the principle of dominance.

DOMINANCE

Diagrammatic examples of the design principle of dominance. See criticisms of reproductions for increased understanding of this principle. Color dominance is achieved by designing a larger area of one color (if colors are nearly the same intensity) or a very intense color in smaller areas and the larger areas in neutralized color.

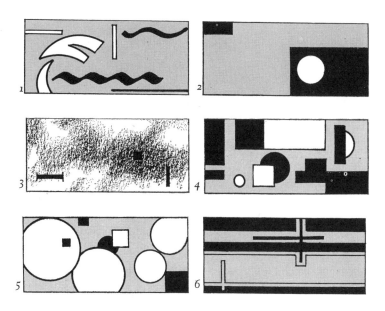

1. *In line: curved lines dominant, straight lines subordinate.*
2. *In value: the larger midtones dominated by the value contrast of the light and dark.*
3. *In texture: softs dominant, hards subordinate.*
4. *In shape: square dominant, rounds subordinate.*
5. *In size and shape: light areas and rounds dominant; squares and darks subordinate.*
6. *In direction: horizontals dominant; perpendiculars subordinate.*

REPETITION

Repetition, alternation, balance, harmony, and gradation are design principles which enable the schematic whole to dominate the parts—thus achieving unity. They function in space arts precisely as they do in the time arts, the only difference being that in art they are perceived instantaneously, and in music the time element is prolonged. The concept of a chord struck in the visual arts consisting of intervals of space, color, and shape is a logical and practical concept. Check through the reproduction criticisms for better understanding of repetition, gradation, alternation, balance, and harmony.

Design principle is a relationship law or organizational scheme combining elements to accomplish desired effects. Combinations may be (1) identical, (2) similar, or (3) totally different; results being (1) repetition, (2) harmony, or (3) discord.

Repetition is concerned with the dimension of space. Identical units can vary only in terms of their position. The intervals between them are as important a part of the design as are the units, precisely as the intervals between notes are parts of the musical composition. In two shapes identical in size, shape, hue, intensity, value, and texture, variety could be achieved only by different space intervals between them.

Repetition can be exact, alternating repeats, or it can be the happiest, most interesting of all—repetition with variety in the repeats. As a musical composer contrives variations in the repeats of his theme, so in the space arts, varying one or more of the design components of a unit, but retaining enough of the character of the unit to constitute a readily recognizable relationship in the repetitions, synthesizes two design principles—unity and conflict.

REPETITION
Diagrammatic examples of the design principle of repetition. See criticisms of reproductions for increased understanding of this principle. Color repeats can vary in value or intensity, but should be in the same hue.

1. *In line: curved and straight lines can be repeated.*
2. *In direction: this or any other direction can be repeated.*

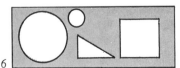

3. *In size: any kind of repetition will do.*
4. *In shape: any kinds of shape can be repeated.*

5. *In texture: any texture can be repeated.*
6. *In value: any value can be repeated.*

92

ALTERNATION

Alternation is a repeated interrelationship of sequences, rhythms in intervals between any of the design elements. It achieves unity with variety. It is a rhythmical sequence.

ALTERNATION

Diagrammatic examples of the design principle of alternation. See criticisms of reproductions for increased understanding of this principle. Color alternation can consist of intense and neutral colors; warm and cool colors; any two colors; different values of the same hue; or different intensities of the same hue.

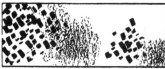

In line: straight or curved.

In value: lighter and darker.

In texture: rough and smooth.

In shape: angular and round.

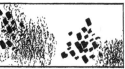

In size: smaller and larger.

In direction: oblique and perpendicular.

BALANCE

Balance is the result when forces opposing each other are equal. It can be either bisymmetric or asymmetric. Again, design can be given character significance by the use of principle. The dignity of Christ on the cross, or the symbol of the cross itself,

BALANCE

Diagrammatic examples of the design principle of balance. See criticisms of reproductions for increased understanding of this principle.

1. *Formal balance, but disunity results from no dominance.*
2. *Informal balance, and unity achieved by dominance.*

3. *Formal balance and unity achieved by dominance.*
4. *Informal balance and unity achieved by dominance.*

5. *Informal balance, but disunity results from no dominance.*
6. *Formal balance and unity in size and shape.*

93

calls for and is better expressed by bisymmetry. Expression of action or growth would be defeated in a bisymmetric design. Check through the reproduction criticisms for better understanding of the design principles of balance.

HARMONY

Harmony is achieved when two or more of a unit's components are similar. Blue and green are harmoniously related, green being half blue. Blue and yellow in full intensity would be discord. A circle and an oval are obviously more harmonious than the utterly different shapes of a circle and a triangle, which are extremes of contrast. Harmony lies between the extremes of a gamut. Harmony and unity are not synonymous. Equal areas and intensities of red and purple would be disunity though the colors are harmonious. Dominance of one color would achieve unity. The degree of harmony or discord existing between two units depends upon the number of dimensions in which similarities occur. All art structure is fundamentally a combining or a fixing of the relationships of repetition, harmony, and discord.

Harmony exists in the closer proximities between extremes. A series of straight lines starting with a perpendicular with each adjacent line changing direction only five degrees and continuing until a horizontal line is reached, would present harmonious directions en route, but oppositions at the extremes of the transition or gradation. A gradation of value or gradual change of color from hot to cold would illustrate the same truth. Juxtaposed areas in a transition from one extreme of a gamut to another are harmonious. The extremes are in violent contrast or discordant.

1. In line

2. In value

3. In texture

4. In size

5. In shape

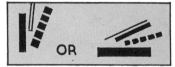

6. In direction

HARMONY
Diagrammatic examples of the design principle of harmony. See criticisms of reproductions for increased understanding of this principle. Colors harmoniously related to each other are found adjacent to each other in any small segment of the color circle.

94

The degree of discord or harmony in a design would certainly have significance in the expression of a given subject, showing either tranquility or violence, lassitude or rage, for example. Harmony may be seen in natural or traditional association of objects functionally related—small boats and fishing tackle; a book and a pipe. Literary implications or concepts are usually symbolic harmonies —liberty and a torch; justice and the scales. But harmonies are more readily seen in similarities in the seven elements of design. Check through the reproduction criticisms for better understanding of the design principle of harmony.

GRADATION

Gradation occurs in any gamut, as referred to above, or in any segment of a gamut in which there is a gradual transition from dark to light, hot to cold, smooth to rough, perpendicular to horizontal, one shape evolving into another, or a size increasing or diminishing.

Gradation or change, being movement, enlivens a dimension. It is kinetic—life; not static death. Gradation is one of the six basic value schemes to be discussed

GRADATION

Diagrammatic examples of the design principle of gradation. See criticisms of reproductions for increased understanding of this principle. Color gradation may be from one hue to another; or from one intensity to another.

1. *In line: straight to curved.*
2. *In value: light to dark.*

3. *In texture: smooth to rough.*
4. *In shape: angular to round.*

5. *In size: small to large.*
6. *In direction: perpendicular to horizontal.*

7. *In line and direction.*
8. *In mass or volume.*

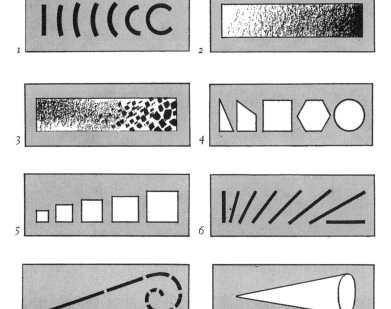

later. It is the principle of design used by Ravel in *Bolero*. This principle can discipline or be used with all seven design elements. The powerful design tool of linear convergence to a center or, obversely, radiation, frequently affords opportunity to include the additional principle of gradation in the intervals between, and the measures of, "thrusts." Gradation in all seven design elements is movement, and provides a way of getting interest into large areas without their being too aggressive visually. Check through the reproduction criticisms for a better understanding of gradation as a design principle.

A NECESSARY TOOL

Creative man strives for order, unity, everywhere and always. Nature's ecological law prevails from microcosm to macrocosm. Each unit, all organisms, all entities predisposed towards self-preservation and integrity, create conflict with competing units. This conflict can destroy unity, but dominance resolves conflict and regains unity. This cycle is endlessly repeated in all nature and in all creative endeavor. Conflict must be contrived for the sake of interest. No conflict—no plot. Unity must be achieved via dominance. A general character must be imposed upon parts by the whole. These principles must obtain, not only within the rectangle of your watercolor, but in subdivisions of the rectangle and in the use of tools employed in its production, namely, line, value, color, texture, shape, size, and direction.

EIGHT WORDS: DESIGN PRINCIPLES

An understanding of these eight words insures wiser solutions of every problem; eight verities established and having their sources in your psychobiological origins and social experience are the natural laws which enable you to breathe, feel, and think. They are basic.

FIFTEEN WORDS: PRINCIPLES AND ELEMENTS OF DESIGN

An understanding of these fifteen words, plus a modicum of wit, will give you status as a designer and a sense of strength. Your watercolors will then have the essential quality of ease. Can you afford to ignore these fifteen words?

96

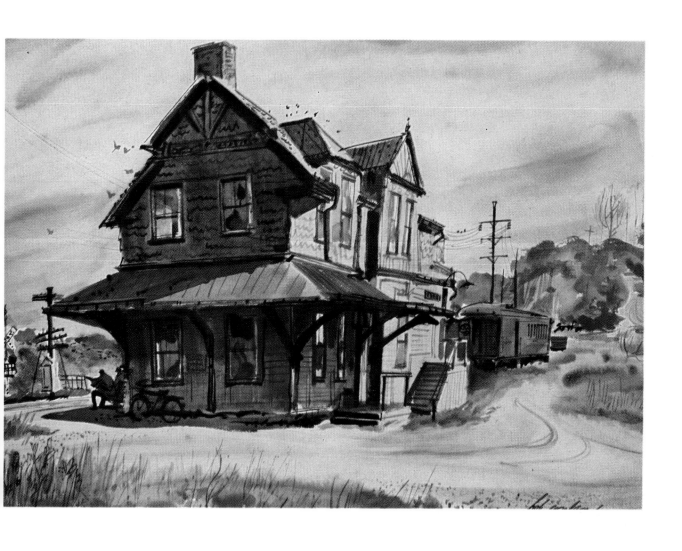

HUDSON RIVER GOTHIC BY ROBERT E. CONLAN

This is a dominantly cool watercolor, keyed by a few well placed warms. All shapes are good shapes. Conlan's easy masterful draughtsmanship is a delight to see. His more recent work has increased emphasis on design, evidence of the increased understanding this scholarly artist has earned.

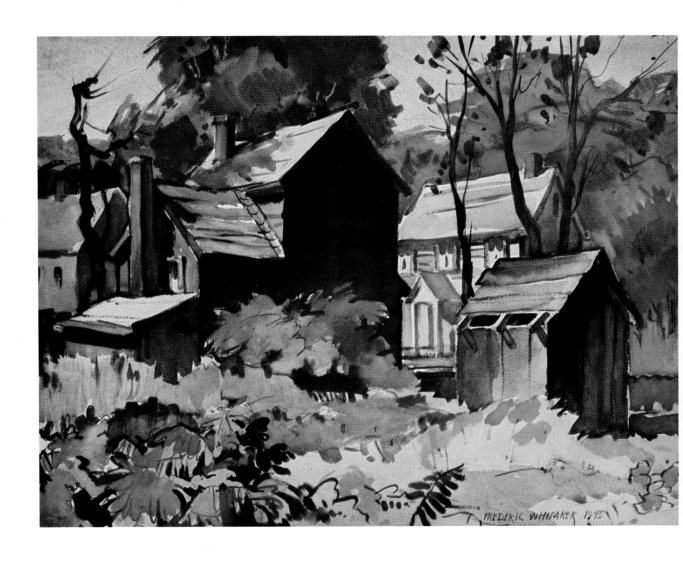

HUMBLE HOME BY FREDERIC WHITAKER
This is a successful watercolor by a master craftsman. Its
virtues are all proofs of the artist's stature and taste: a
definite design character (staccato-spotty), variety in theme,
and rich color chords.

98

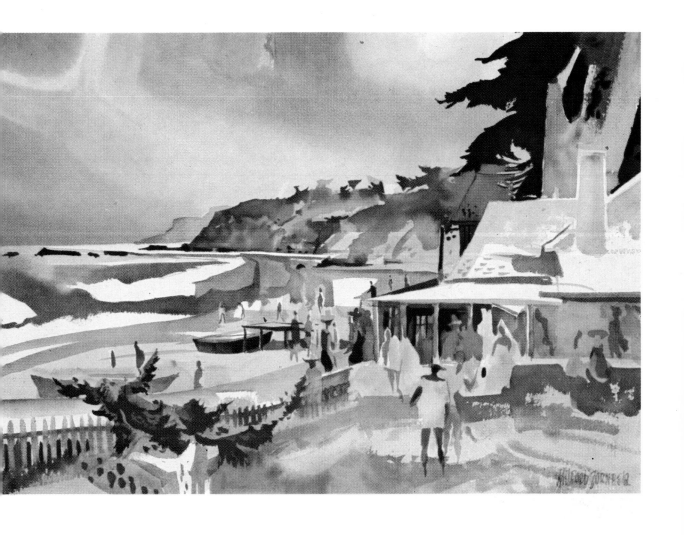

BEACH PARTY BY MILFORD ZORNES
Although this delicate, high key watercolor has no dramatic
value differences, it has carefully designed *shapes*. Appraise
and appreciate the whites and the greens in the foreground.
Also notice the variety in the intensities of colors and the
beautifully *suggested* figures.

PRINCETON BEACH BY GEORGE POST

This painting is completely realized. It is a metaphor perfectly expressing the surf's whiteness and rhythm. Notice how decoratively the darkness of the wet sand near the water is designed. Appraise the shape of the wet sand. This dynamic oblique, with a varied measure en route, interlocking edges, some gradation, change in the quality of its edge and/or change in the values behind that edge, is an intrinsically fine shape.

LOWLANDS BY ROBERT HIGGS
Here is an example of qualities achieved through observation
of design laws. Dominance of obliques and straights constitute
the *theme*. All shapes subscribe to the best formula for
shapes: a dynamic oblique, an incident en route in the edges
—or to use Rex Brandt's words, "interlocking edges." This
painting is treasured in my private collection.

In this color section, I present an original teaching device. Impatient students will be irked by the need to slow up a bit and to use carefully and thoughtfully the map-like reference method, which shows precisely where design principles have been built into the watercolors analyzed. After a few minutes' use, you will readily find the areas referred to by the letters and numbers.

It is the author's belief that this is the best teaching device. It will inform you about the use of design principles much faster than just reading text. If you are not thoroughly familiar with these principles, you will be unwise to ignore this most efficient method of acquiring an understanding of design. Unless otherwise noted, the paintings were done by me.

BOOMING SURF

Design principles present in this watercolor

UNITY is helped by dominance in line (the straights); in value (the lights) (not as obvious as it should be); in color, (the cools); in texture (the roughs); in size (the light pieces); and in direction (the horizontals).

CONFLICT for the above listed dominances is found in line, curved in the two bursts at A-3 and A-6 and B-2 plus; conflict in value at A-plus-8, C-5, 6, 7, C-1, 2, and A plus-1, 2; conflict for the cool color is meager, but is at B-2, C-4 plus and C-7; textural conflict is in the softs at B-1, B-5, and B-8, 9. There is shape conflict in the angular rocks and the curved bursts. Directional conflict for the dominant horizontals is found in the obliques at C-5, 6 and 7.

DOMINANCE. The straight lines dominate the curved lines, occurring at the tops of the two bursts and at B-2 plus. I think the lights and light midtones dominate the area of midtones and darks. The color dominance is certainly in the cools. There is a rough textural dominance. The horizontals of sky, three spots of sea, two spots of surf, the horizontal of rocks *and* the shape of the picture give a very strong horizontal dominance, expressing the sea.

REPETITION. Directional repetition with variety is in the horizontals of sky, sea, surf and rocks. Repetition of line is found in the straights everywhere but the curves in the bursts. Repetition of the curved burst tops occurs twice at B-2 plus. Repeats of the oblique thrusts of the rocks are found at A-6, not realistic at all, purposely contrived. The color repeat of C-1 to B-2 is at B-8. The purple at A plus-1 is repeated at C-6, C-7 and B-8. The yellow at C-4 plus has an echo at B-4 and in the under wash at C-8. Both echoes should have been slightly more apparent, perhaps. The two bursts are different in color but precisely the same size. Varying their size would have made a better picture.

GRADATION in value is in the rocks at the bottom edge of the painting, dark left to lighter right. Gradation in color is in the surf, green, cool at B-1, 2, 3, to blue warmer at B-5, 6.

COMMENTS. The broad pattern scheme is a piece of light against darker values. The color scheme is analogous. The key of the picture is middle major. In the other surf picture this shape "Surf, Near Nubble Light," a soft dominance was contrived. Here with the more violent surf with its bubbles and froth, I made the dominant texture rough—hard. Note how the rocks in each picture were made to contribute to the textural dominance.

102

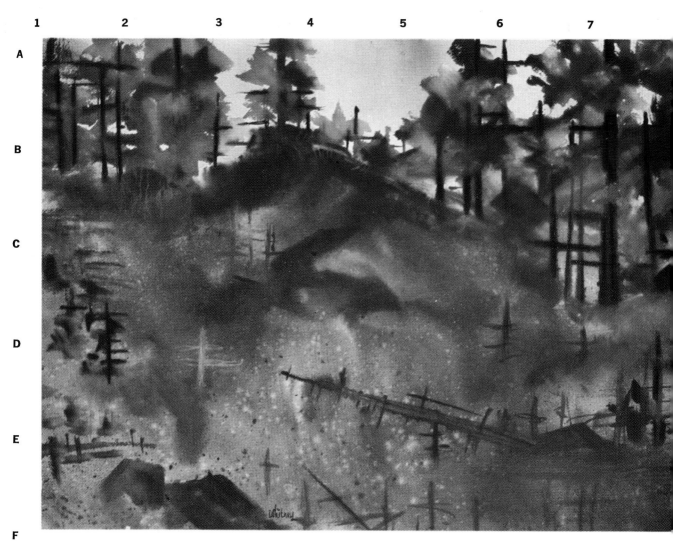

MOUNTAIN TOP

UNITY is achieved by dominance (via repetition) of the cross, and sometimes box-like, perpendiculars and horizontals. The trees really grow that way and afforded an opportunity to repeat that design motif, all over the rectangle, along the top edge of the mountain, and at D-2, at E-2 and D-3 (light marks in the dark area this time), several times in the warm area at E-4 (one time obliqued for variety), at E-6, 7, 8 and C-7 and D-6. The painting has a color dominance of green, helping achieve unity.

CONFLICT. Color conflict exists in the complementary reds and greens (too equal in visual strength in the reproduction). Textural conflict for the dominant soft diffusions is in the sharp calligraphy of trunks and trees along the top edge of the mountain, and in the hard edge of the rocks at E-plus-2.

DOMINANCE in texture is apparent in the soft diffusions (calligraphy being subordinate).

REPETITION of the warm area at E-4 is seen at A-7, C-7, E-7 and C-3. Repetition of the green area at C-2 to D-3

occurs at F-2, F-6, F-8 and A-2. Repetition of the dark value along the mountain top is at F-2 and F-7.

GRADATION in both color and value occurs, coming down and obliquely from B-3, 4, 5, and C-6 to D-4 and E-3, 4, 5, this gradation being in value from dark to light and in color from cool to warm. There is also gradation in the sky from darker and warmer at A-3-4-5 to lighter and cooler at A-6-7.

COMMENTS. This watercolor is a complementary color scheme (red and green). Its value key is low, major, expressive of a forest interior with bright sky showing through. The center of interest is established in the A-B-3, 4, 5 area. The perpendicular dominance *expresses* the growing trees. The diagonals *express* a mountain top. The close values in the forest *express* the quiet of a wood interior. In other words, there is design significance. While I painted the forest, I tried to be deeply conscious of what I heard a fine teacher (Harvey Dunn) say of a wood interior: "Make it the cathedral of God."

DEMOLITION BY CLAUS HOIE

UNITY. Color unity is achieved by the dominance of the warms. The small repeat at E-2; of the large, line, textured area at right side of rectangle helps unity. The dark repeats F-3 to F-7, and A-6 to C-6, repeating the large dark B-2-3 to D-2-4, help achieve unity as do the three windows B-2, C-2, and D-2 which repeat the large light area. Remember, repetition is a way to achieve dominance, which resolves conflict and establishes or regains unity.

CONFLICT. The color conflict for the dominant warms occurs at D-4 plus, E-5, F-3, E-7 and B-2-3. The square of the house still standing, the Gothic shape of A-6 to C-6 and the diagonal from F-3 to F-7 are all conflicts in shape, size, and direction.

DOMINANCE. Color dominance is well established in the warms. A shape dominance is fixed by the larger, box-like rectangle, which, by the way, aided by thrusts C-6 to A-6, *expresses* the architectural subject.

REPETITION. Value repetition is seen in the repeat of the large light at E-1, 2 and F-1-2-3, also in the repeat of the large dark at A-6 to C-6 and F-2 to F-7. Color repetition of the large brown B-C-D-2-3 is at A-6 to C-6, the hot red at B plus 4 is repeated at E-6-7 and F-3. Textural repetition is obvious—the E-F-2-3 area repeats the rough linear, upper right part of the picture. The smoother textured large house has its textural repeat at A-6 to C-6, and F-3 to F-7.

DIRECTION. Directional (perpendicular) repeats are numerous (establishing directional dominance); they are seen at A-8 to F-8, A-6½ to C-6½ (in line) A-6 to C-6, A-5 to C-5, the edge of dark from A plus 3 to D-3, the slit windows again from B-2 to D-2, the dark piece of the shadow side of the house, and the chimneys on the roof of the house.

COMMENTS. This watercolor, its brilliancy achieved through conflict of hot-cold, dark-light, and rough-smooth is very exciting. I do not know whether Mr. Hoie got the design principles into his watercolor via intuitive feeling or cognition. I do know positively that they are present, and that they can be recognized and appreciated by educated eyes.

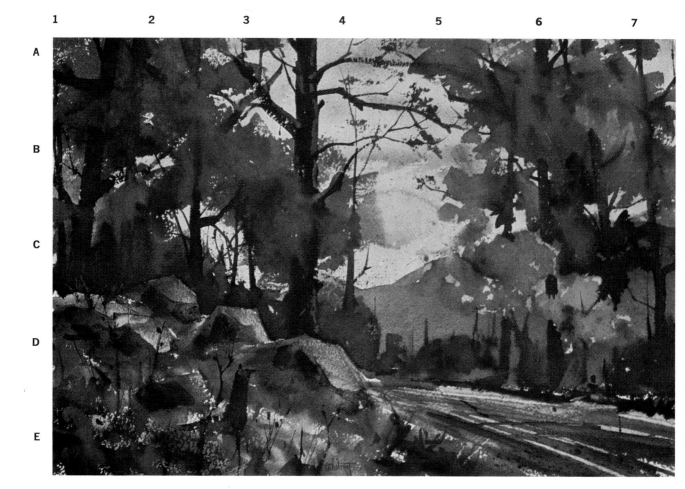

AUTUMN, QUEECHEE FOREST

UNITY is achieved largely by the color dominance of the orange fall foliage. The textural roughness everywhere but at D-5 and B-6, 7 helps unity.

CONFLICT. Linear conflict is in the straights of tree trunks and curves of foliage and road. Value conflict is mostly between the trunks and foliage and the light sky. Color conflict for the warm autumn tones is provided by the intensely cold spots at D-5, and perhaps tops of rocks at D-2, 3, 4. Directional conflict exists between the perpendiculars of trunks and the obliques of road, distant mountain, and the three rocks.

DOMINANCE. I think the curves of foliage clumps, road, and rocks dominate even the powerful straight tree (A-4 minus to D-4 minus). Value dominance is in the midtones. Color dominance is in the orange foliage. Textural dominance is rough (forest).

REPETITION. The light sky is repeated at E-3 plus, E-7 plus, and D-2. The orange foliage against the sky is repeated forward of the rocks running from D-1 to E-4.

These areas are also textural repeats. The directional repeat of perpendiculars with variety is seen in all the trunks, repeating the perpendicular of the large trunk, seen against the sky.

ALTERNATION of colorfulness and colorlessness occurs moving diagonally from E-2 warm to D-3, 4; neutral to A-1, B-2, C-3, 4; warm to A-B-C-4, 5; neutral to A-B-C-5, 6, 7 warm.

GRADATION in size is in the diminishing measure of the road, and in color from warmer to cooler in both foliage areas.

COMMENTS. This is an analogous color scheme. The broad pattern scheme is large light and small darks in midtones. It is a middle major key watercolor. My only thought was to have some interest in the small area of sky and to carry the pale wash low so that any holes left in foliage would not have to be qualified later, knowing that white paper would "jump," keyed by the dark foliage.

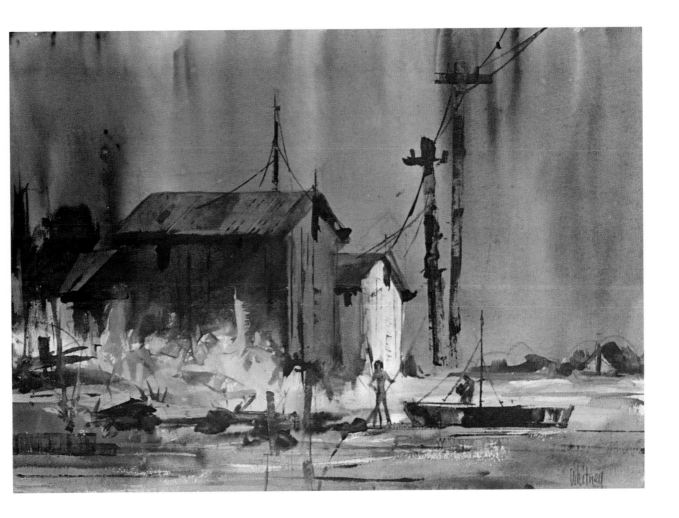

BIDDEFORD POOL

The design principle of gradation is purposeful avoidance of monotony en route. Three gradations are contrived in this watercolor. From upper left to lower right, gradation in value, color, and size insure visual entertainment. In every area, on every edge in any painting, there are but two alternatives: change or monotony. The character of this watercolor was achieved through dominance of color (green-blue), line (straights), and direction (horizontals). The latter is achieved by the distant shore, the boat, the green water at the bottom, and the light piece and the dark broken dock and rocks. The "law"—a different measure to the four edges of the paper and not too close to an edge—as to the placing of the point of interest has been obeyed. The vis-

ually aggressive piece of light in the center has variety in color and value, but does not lose its identity. The midvalue is a larger area, as it should be. The midtones are a bit too dark, giving the lights a falsely lit look. The orange and yellow, and the colorful sky and water, are neutralized by color in the larger building and the non-commital whites behind the two figures. The girl is not correct anatomically, which makes her more interesting to me. Am I saying that I do not respect more literal drawing and correct anatomy? I am not. See my nudes elsewhere in the book. What I am saying, is that I am delighted to find that my point of view and preferences have changed through the years.

SURF NEAR NUBBLE LIGHT

Design principles present in this watercolor

UNITY is achieved by the dominance of the cool colors. The directional dominance of the four horizontals (sky, A; ocean, A plus; surf B; and the two pieces of rocks constitute a horizontal thrust at C). The shape of the painting also counts as a horizontal. Size dominance is present in the largest piece, the ocean, including the surf. Surf is soft, so I expressed this by a soft dominance, even going so far as to soften rock edges in order to insure textural dominance *expressing* the subject.

CONFLICT in color is in the warm rocks; in direction, it is in the small obliques at B plus 6 and 7 plus, C-5 and B plus -2. The slightly oblique surf top, I think, counts as a horizontal. Value conflict is in the piece of surf framed by the larger areas of dark (and interlocking into them). Textural conflict is in the few hard edges at B-2, B -plus -4 plus, B plus -6 and B plus -7, 8.

DOMINANCE in value is in the darks; in color, in the cools; in the texture, in the softs; in size, in the ocean; and in direction, in the horizontals, *expressing* the ocean. (The shape of the picture helps this directional dominance.)

REPETITION in direction (and with variety) is in the horizontals—the sky, ocean, surf and rocks all being horizontals different in perpendicular measure, value and color. The green in the surf burst is repeated at C plus -9. Vague and infinitesimal as the two warm repeats of the rocks in the sky at A-2 and A-9 are, they are a purposeful echo, making for unity, a conscious subscription to this design principle of repetition.

GRADATION. Color and value gradation is to be seen in the ocean from darker and warmer at A plus -2 to lighter and colder at A plus -9. Gradation in color in the surf is from warmer at B-3 to colder at B-6. Gradation in color is in the rocks from purple at C-2 to orange at C-4 plus, to green at C-plus -9.

COMMENTS. This watercolor was completed in twelve minutes. There is no virtue in that fact except that in twelve minutes you cannot spoil the freshness of first washes—and ocean surf is fresh and sparkling. As with flowers, the essence of the ocean is freshness. A labored attempt to report botanical accuracy, or minute textures in rocks or seas, kills their essence. Such pictures are as successful as a portrait of Cyrano with a small nose would be. This is a split complementary color scheme, orange and blue, and green blue. The broad value scheme is a piece of light in darker values. The key of the picture is middle major.

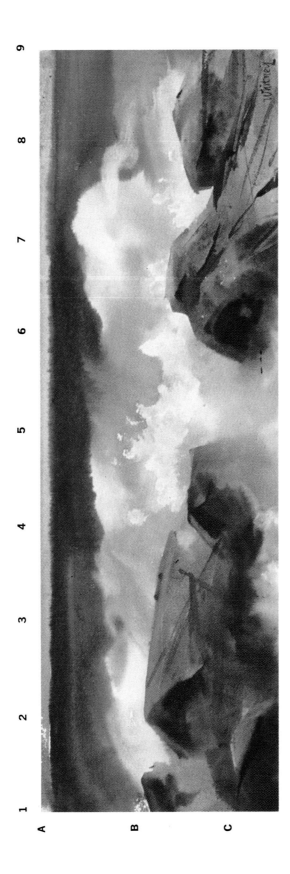

A MARINE WATERCOLOR BY JAMES BECKWITH

UNITY is achieved in this watercolor by well established color (blue), texture (soft), shape (fish is the dominant shape), and direction (the horizontals are longest and we feel the fish moving horizontally).

CONFLICT. There is, understandably, little color conflict. Underwater is cool; warms would defeat expression of this locale. Beckwith got variety via yellow at E-7 to key cools, but wisely restrained this tone. Color dominance which always insures character and unity in a watercolor is obvious here in the blue. The change in hue, avoiding monotony, was achieved by warming the blue, moving it toward purple at B-2, 3; B-6, 7; D-2; and slightly above F-2, 3.

REPETITION. Value repetition of the dark fish is in the dark "frame" near the outside edges of the watercolor, and at the dark repeat E-6. The watercolor is practically all soft diffusions as it should be to express this subject, but the textural repeats of the hard or sharp edge at D-6 can be seen at C-4, D-3 and in the wiry, calligraphic fish.

GRADATION. There is a fine use of gradation in both value and color in the rectangle of lighter value framing the large fish, from darker and warmer at B-2, C-2, D-2 to C-6 plus, D-7, E-7.

HARMONY. Value harmony is present, achieved through close values in most areas, color harmony via blue and green.

COMMENTS. This is a broad pattern of a large light and a small dark in midtone. This delightful watercolor fuses natural shapes and design values magnificently. The subject is beautifully expressed in color, texture, shapes and direction. Whether Mr. Beckwith achieved his result via intuition or by deliberately thinking about design principles does not change the fact that these principles exist.

HIDDEN VALLEY BY HENRY C. PITZ

This artist knows that art is a metaphor. The *things* are always recognizable in his works, but his preoccupation is with *design*. Here the yellows make a fine shape—the muted color being dramatized by the color-*less* areas of gray. I find straight dominances and obliques directional dominances. The works of this artist always contain shapes and textures which are never trite. The rarest and most precious kind of unity is in Mr. Pitz' work, the personal imprint of an original artist.

BROODING HOUSE BY PAUL B. REMMEY

Dominance insures character here. Notice the dominant color (green), with the subordinate conflict (purple) dramatizing the dominance. The dominant theme is rectangles. I counted twenty-two of them. These dominances make this watercolor characterful.

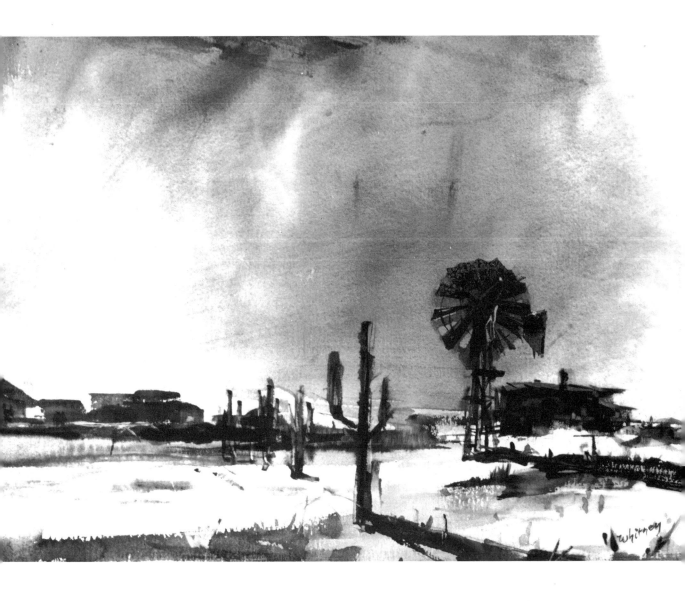

PAINTED DESERT

Distant mountains, buildings, and the windmill's cast shadow were a clue
to a horizontal dominance expressive of desert country. The mill and
the giant cactus perpendiculars became the subordinate conflict for
the expressive horizontals. In the full sheet painting, the dark in the upper
left sky challenged the point of interest at the windmill; so, most of
it was cropped.

7

Elements of Design

NOW THAT we have studied the principles of design, let us examine the elements, the seven tools we use for working in space. These elements are line, value, color, texture, shape, size, direction.

LINE

Line is the art medium that came first. It appears simple because it is the ultimate —so far as economy of means is concerned. It has no limits as a tool with which to report or express any thing, time, place, state of being, or mood. Line can be suggested by a series of objects or points. It can be unbroken or broken into parts. It can be three dimensional, going back of, or in front of, its other parts. It can describe texture and form and indicate value differences. It is an all-purpose tool except for color and it can strangely suggest color.

LINE
Lines are straight or curved. In this gradation, the adjacent lines are more harmonious; all curved lines are in harmony with each other and in contrast to the straight line.

VALUE

The importance of value (or key) in a painting must never be underestimated. Emotional reaction to value is immediate and, if it incorrectly expresses the subject

matter, constitutes two strikes against the artist. Color can augment and embellish statement or expression, but any subject can be beautifully reported, expressed, and designed with values alone.

Six general classifications of key might not be a too constricted or complicated gamut. High, middle, and low keys can exist in both major and minor relationship chords. Major chords are those with greater intervals between values, therefore stronger contrasts. Minor chords have lesser intervals—the contrasts being less in conflict, in closer harmonies, and more quiet. The uses of specific key schemes as a means of expressing subject matter are apparent. A painting of a wake or a funeral in a cheerful high key would probably be a grievous error. A minor key painting of a blast furnace in a steel mill would not be in concordance with subject matter.

1 2 3 4 5 6 7 8 9 10 *harmony* *harmony* *contrast* *contrast*

VALUE

The extremes of this value gradation, 1 and 10, would create conflict. Adjacent values would be harmonious.

Values may be used naturalistically to describe form in light, or arbitrarily allocated, as in poster designs, with no—or very modified—form description and cast shadows. In value organization, the trial and error method is profligate so far as time is concerned. Knowledge of principles constitutes the best and most reasuring critical tool. A methodical, craftsmanlike appraisal of a value scheme might consist of questioning the degree to which it (a) expresses the subject; (b) subscribes to design principles. Are the principles manifest in it? Has it unity, conflict, dominance, balance, repetition, alternation, gradation, and harmony?

It will not be an interesting rectangle if there is no variety in values. Even after a broad allocation of lights, middle tones, and darks has been roughed out, varieties *in the lights in* the middle tones and *in* the darks must be created without jeopardizing their identity, merging one into the other. This is not a simple problem. Breadth of effect you must have, but a sufficient variety in each broad piece is necessary to relieve monotony. Also, one of the areas must maintain dominance, or the result is discord.

A *value rhythm* must exist or monotony will result; therefore, value intervals that are equal can be a danger. Value intervals can function in placing emphasis on

the essence of the subject matter of the picture, or at the point of interest; they are also useful as design tools. Unequal value intervals create a more interesting rhythm than interval repeats without variety. A kind of clarity of statement can, however, be arrived at by equal intervals.

A dominant pattern creates unity. Value organization requires that value areas and value intervals be planned. They are equally important. Interest is created by unequal areas and major and minor contrasts in adjacent areas. Unity will not exist unless a dominant is present, so one value must be allocated to a dominant area. This larger area influences the key—high, low, or medium—of the picture.

The selection of a value chord is of course contingent upon the best expression of, or concordance with, the subject matter. Also, where greatest value contrasts occur, and in what volumes, must be carefully planned. Again, when seeking value varieties *in* pieces of value, breadth of effect must be maintained.

In chapter 3, I mentioned the six broad pattern schemes which make for clarity of statement: (1) A piece or shape of darker value against lighter values; (2) a shape of lighter value against, or in, darker values; (3) a small light shape and a large dark shape *in* middle values; (4) a large light shape and a small dark shape *in* middle values; (5) gradation of value in any direction, up, down, or across; (6) a less frequently used scheme which employs allover pattern, as in textile design. It can express certain subjects having no center of interest. It is essentially more decorative.

COLOR

Practical limits as to the size of my book mean sacrificing depth if breadth is to be achieved. Those interested in further research in depth need only consult the bibliography. This section on color probably suffers the most obvious condensation. This was a purposeful and, I believe, logical constriction for the reason that knowledge of color principles or color organization seems a bit more supplementary to (though remaining the basis of) taste and discrimination than the other components of visual art. Quickly, I add, "There is no knowledge that is not power." But the color facet of our activity is the most personal, "an eye for color" being comparable to "an ear for music."

All of the design principles are inherent in color organization and certainly knowledge of them helps develop taste, although they are not a substitute for it *during the process of its development.*

Among many complex color theories, the Munsell system seems most scholarly and is certainly the most accredited. It covers all of the qualities or dimensions of color. It has breadth and depth beyond the province of this textbook. A less exhaustive thinking about color organization—a synthesis of several sources that I find satisfactory—follows.

COLOR

Adjacent hues in the color circle, and hues included in any small segment of the circle, are harmonious, being related.

Colors diametrically across the circle are in conflict.

The nature of color, its vibratory relationship to sound, the frequencies of the different colors, the limits of human vision in the radiant spectrum, conjectures about Hertzian, ultraviolet, X, gamma, and cosmic rays, I leave to the scientists and painters interested enough to investigate thoroughly my bibliography. We will discuss color qualities inherent in the pigments the painter uses. I feel that the practical use of color will be significant.

Color has three properties, suspension, or characteristics: *hue, value, and intensity*. Inasmuch as a greater variety of colors can be mixed with red, yellow, and blue than with any other three pigments, a concept of these as primary colors seems reasonable, with binaries of orange, green, and purple, and tertiaries of orange-red, orange-yellow, green-yellow, green-blue, purple-blue, and purple-red. This simple designation of a color wheel or circle has merit as a basis for supporting an application of all design principles of color organization, and perhaps has advantages over concepts presenting as many as two hundred and sixty formulas for mixing colors.

Hue identifies a color in the color wheel or color gamut visible to us. Red, orange, yellow, green, blue, and purple with the intermediary tertiaries. Adjacent colors are harmonious, being related or blood brothers. Hues diametrically across the circle, opposite each other, are contrasting colors. The relationship or degree of harmony depends on the degree of proximity in the circle.

Value is the quality that differentiates between a light and a dark color of the same or different hue or hues. The gamut between white and black contains all values. Similarities in value bring different hues in closer relationship, making them more harmonious. Contrast in values, in a color or colors, results in greater conflict —increases tension.

Intensity is the degree of purity of a color—its strength—its position between full intensity and a completely neutral, colorless gray.

The three dimensional nature of color being understood, we can concern ourselves with color organization.

Color being the component of a painting in which personal preferences are most varied, few, if any, color schemes will please everyone. But there are standards by which a color scheme may be appraised, such as, does it function? Is it appropriate for its purpose? Does it subscribe to design principles—unity, conflict, and dominance? This is color organization.

Color rhythm depends upon interval relationships. These intervals will be too frequently monotonous if not consciously appraised and varieties planned into the color chord in combinations of hue, value, and intensity. Read the criticisms of reproductions for better understanding.

Unity will exist where there is dominance of one color, either in a large area or in a smaller area where the color is of great intensity; *dominance* of one interval between colors; and dominance of a strong pattern.

One way to help color dominance is to lay a wash of some color over the entire paper and then paint in that. Another way is to add a little of some chosen color to every other color and have a fairly large area of that chosen color. Try both methods.

Interest must be created by varying hues, intensities, and values, and by varying the intervals in all three. It takes experience to appraise the total area of radically different shapes, but for the sake of interest there must be variety in the size of color areas. A desired balance need not be upset by size of areas. Larger areas can be made, and usually are, less intense, balanced by smaller, more intense areas. Unity is got by dominance of one area through either size of area or intensity of it.

As with value organization, so with color organization: the large area usually dictates or fixes the hue of a picture. Therefore a hue most expressive of subject matter or mood is usually used in the largest area.

There are, broadly, five different kinds of color harmony: monochromatic, complementary, analogous, split complementary, and triadic. Study these principles carefully and put them to use.

Monochromatic harmony exists when different shades, intensities, and tints of the same hue are used.

Complementary harmony is achieved when colors used diametrically oppose each other across the color circle. Complementary schemes are usually happier than monochromatic or analogous schemes because of greater possibilities for balance, keying, variety, and contrast.

Analogous harmony is composed by using colors in close relationship to each other, any small segment of the color wheel.

Split complementary schemes are got when colors closely related to one or both complements are also used. It is a sort of synthesis of complementary and analogous schemes.

Triadic harmony is the result of using any three colors of the color wheel equidistant from each other. Harmony will be destroyed if all three are in full intensity. Usually two are very considerably grayed, or neutralized.

Colors can be related or contrasted via all three properties—hue, intensity, value.

TEXTURE

Texture challenges wit, enriches and augments, and is an antidote for monotony in too pure areas. But overemphasis is dangerous. It threatens breadth of effect and compromises emphasis on design.

Texture is not exclusively tactile. It is also visual. An icy or satin-smooth texture is readily perceived, as are the more light-absorbing, rougher surfaces.

TEXTURE
Adjacent areas in this gradation from smooth to rough are in harmony.
Extremes of rough and smooth create conflict when they are juxtaposed.

Texture gives the designer another tool with which to describe or express either himself or the subject. Design principles can also be incorporated into works by the use of textures.

SHAPE

Shapes, defined by lines in different directions, or seen as *pieces* of value or color, are identified as round, square, triangular, and modifications or combinations of these basic categories. Shapes can have different degrees of relationship, or degrees of harmony and conflict.

SHAPE
Adjacent shapes in the cycle started at Fig. 1 and turning through Fig. 8 and back to Fig. 1 are in harmony. Shapes remote from each other, such as 1 and 5, 2 and 6, 4 and 8, are in conflict.

SIZE

The measure of lines and shapes and the intervals between them may vary. They may have different degrees of relationship, or degrees of harmony and conflict.

119

SIZE

Shapes and the intervals between these squares may differ in size. The sizes and the intervals may be harmonious or in conflict. Sizes 1 and 2 and intervals A and B are all in harmony as are sizes 4 and 5 and intervals C and D. Either size 1 or interval A is in conflict with size 5 or interval D.

DIRECTION

Lines—vertical, horizontal, or oblique—engender emotional reactions. An oblique line is dynamic, personifying movement. A vertical line expresses or suggests the qualities of austerity, uprightness, and balance. A horizontal's quiet, tranquility, and repose have obvious uses in expressive design.

DIRECTION

There are perpendicular, oblique, and horizontal thrusts or directions. Any of these, adjacent to each other, are harmonious. The extremes of A and H are in conflict. Any of the dotted lines at a 90-degree angle from the attached obliques are in conflict with those obliques, as are the A and H lines.

USING THESE ELEMENTS

The obvious and surprising neglect of line, value, color, texture, shape, size, and direction organization precepts in most watercolor production is the result of sloth, usually. Objects are tangible, seeable things. The relationship between the objects or things is intangible, subtle, obscured, and has to be thought about. Too many painters avoid thinking as a pestilence. Thinking is hard work. You have a legal right to avoid it, but you cannot avoid the consequences, which are poor, weak,

120

insignificant pictures and personal frustration. In time the sentence you have passed upon yourself will be irrevocable.

I do not contend that knowledge alone can produce fine works. I do, and I do not. Art expresses humanity, but is not humanity. A wit, an inventive faculty, is required for successful, creative expression. This wit, this inventive quality, cannot be taught, but it will never be found in the ignorant. New combinations of old forms require both wit in contriving the new and knowledge of the forms to be reassembled. The character and nature of the forms or units of the new design *can* be taught. The character and nature of the principles and elements can be violated *only* by an artist who understands them. The rules cannot be broken through ignorance, but if drawing and painting require some gift, some predisposition for the activity beyond what can be learned—what might be clues to appraisal of potentialities—one clue would be whether or not you have a subject and whether or not you have information about that subject. Your commodity is inextricably bound up with facts. The *things* in the world and the truths about them must be your passion to the degree that you have greater knowledge of them than others have. If not excited about the world and what is in it, and not sufficiently interested to store a heart and head full of facts about it, then vegetate somewhere else, not in the world of art.

BOTH ARTIST AND CRITIC

Another clue which might indicate potentialities is a sense of duality, a sense of being at all times both artist and critic—the critic ever alert even in the fever heat of inspiration with its empathetic concentration—the painter must be the actor and the audience both and at all times, if communication is to be achieved, and without communication there is no art. Art *is* communication.

Ability to fuse emotional content and technical knowledge is also a necessary bridge between artist and audience. Both must simultaneously receive all the implications of a work or it fails its function. An interest in, and knowledge of, other paintings past and contemporary are essential if for no other reason than to avoid that which was indigenous in other times or minds and for that reason better done. Self-knowledge is contingent upon a sense of relationship too, and *must* precede self-expression. You cannot fully express what you have only partial knowledge of without revealing your ignorance.

Another difficult thing the painter must learn is that the values and significances of his time *as he sees them* must not be influenced by his culture's self-appraisal. Above all, the painter must know art and nature are two different things and therefore not the same thing. Art is concerned with the truth of a thing, not the fact of it. Art is a manner of understanding nature that no school or teacher can teach. The use of the tools used for the expression of the understanding is the teacher's province, and the most important tools are *design principles and elements*.

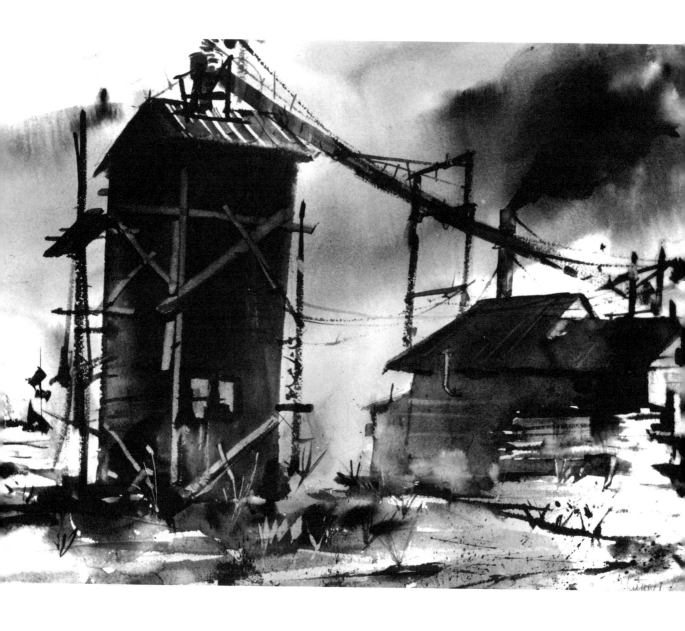

SAWMILL

This industrial subject called for straight dominance in line. The blowpipe's slight curve functions as a *conflict*. All *dominances* are made more dramatic and their character is emphasized by a subordinate *conflict*. A neutral gray area, lower right, makes the color "sing" elsewhere. Being aware of the possible monotony of the dark blowpipe, scaffold, and edge of buildings, I changed the values *behind* these edges en route.

122

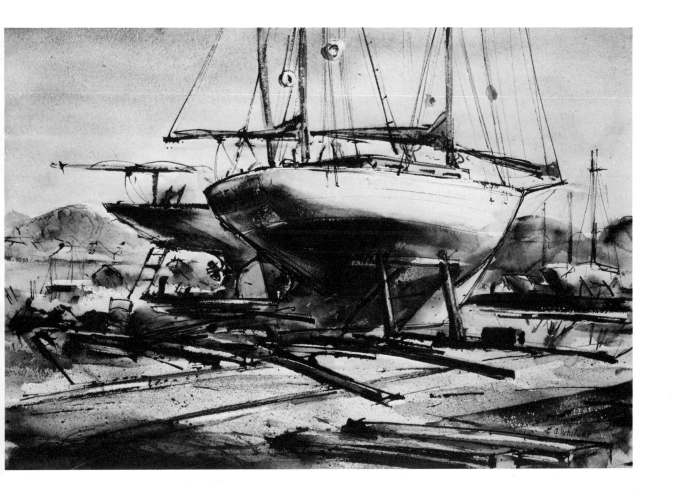

HIGH AND DRY

The first question to ask in any painting project is, "What am I trying to say?" Make this answer, or "telegram to yourself," succinct. The telegram here, was "boatyard." The second question should be "What is the best way to say it?" The answer to the second question is found by observing and expressing the characteristics found *only* in that locale. So, where else are you able to see *under* a boat? Where else is debris so abundant? Both of these essences, expressed, shout "boatyard."

The rigging and masts of this ship became the "lace," "grill," or "trellis" professionals search for and capitalize upon when they find it, as I did. Note the variety in the weight of line in the masts and rigging, and the variety in the measures between the lines. This painting is done with line and wash. The drawing was made with a goose quill and waterproof ink; then the wash was added.

8

Drawing

*Drawing is the language that enables men of the Ice Age,
in the caves at Altamira in Spain and Lascaux in France, to
speak to us, today, and to the men of the hundredth century,
with perfect clarity. Drawing is the universal language.
Draughtsmen communicate instantly and effectively with
anyone, anywhere in any time.*

THE LAST ADMONITION I gave to my students at Pratt Institute, I made as dramatic as possible so as to make it memorable. High on the front wall of the classroom, with chalk, I letter the word "D R A W." Then, underlining that word down the wall to the floor, across the floor to the opposite wall and up that wall as high as I can reach, I say, "good luck, good-bye."

DRAWING IS THE FOUNDATION

I put this much emphasis upon the importance of drawing because it is the *foundation* of visual art. Without fine draughtsmanship—the discipline endured and the mastery achieved—your work will have limited content. You will be aware of this lack, and it will affect your morale. You will not have the essential quality of ease and the sense of power.

The way to learn to draw is to *draw everything, everywhere*. In the life class, in your sketchbooks, *draw*. What the psychologists call canalization then takes place in the mind. It is best achieved—the canal is made deeper, hence the thinking faster, and more facility is achieved—by increasing the *frequency* of the experience. Ten minutes, ten times daily, is better than six hours once a week.

Great draughtsmen are eliminators, stating essentials only. What the essentials are and what can be eliminated are learned in the sketchbook. The limited time teaches you what is important, and what is not. You learn that detail slows up

action and that the fast "matchman" emotionally charged interpretation of the pose or action is the vital essential. This can be "developed" a bit later, if need be. The constant observation of recurrent forms is the way to *understanding*, which, plus your feeling, is what you draw. The same thing happens to a dress every time a woman sits down. The same thing happens mechanically in a sleeve whenever an arm bends and, in sketching, you learn what it is that happens. Any gesture can be emotionally expressed in five seconds by a draughtsman who has been faithful with his sketchbook.

UNDERSTANDING THE FIGURE

In a life class, where more prolonged or sustained studies are made, knowledge of the figure must be obtained. You must know the origin, insertion, and function of surface muscles, the bone structure and the proportions of the human figure. You must be a good student of anatomy. You must then, in a sense, forget all you know, because no one is interested in anatomical diagrams. Nor are any but a backward few interested in academic drawings which are purely illustrative, however correct, if they are *not* fused with a sense of design, well related directional thrusts, pieces of value, and fine shapes. The more prolonged, studied drawings, in life class or anywhere else, when carried further than the sketch, become a more complex problem and as such need breaking down into a number of logical steps which can be disposed of one by one. This not only insures better results, but gives a reassuring sense of being organized.

I have found the following breakdown successful. (1) A long look to find something about the pose or action that is interesting. It might be an over-all rhythm, a shape, the color of the model, or a pattern of light and shade, or the character of the model—squat—tall—slender—obese—alert—lethargic. (2) A fast "matchman" emotionally charged "feel" about the pose or action. (3) A checking of "points"—head, shoulders, elbows, hands, knees, feet, etc.—to modify a too melodramatic interpretation, or to put more movement in it if action is understated. (4) Establishing planes in shadow. (5) Accenting plane change and "treating" edges. I used this sequence most frequently in figure and portrait demonstrations in watercolor at Pratt Institute.

USING PRINCIPLES

In more considered line drawings, principles to be subscribed to are: *Principality* —a dominant dark and its "echo" somewhere; a dominant light shape, and its repeat and a gray area, functioning also in helping to establish greatest value opposition at the center of interest; *Variety*—transition, i.e., no "dead" areas, and also variety in character and weight of line; *Breadth of effect*—values counting broadly, not too cut into patches, a few big pieces and a few fine angles, pieces

locked into each other insuring unity, concern about too much gray or "hay" without compensating pieces of solid black. Large light areas are necessary due to the medium's need for eliminations; reliance on one of the several broad value schemes: (1) black and white in a gray area, (2) principle black in a gray area, (3) black separating (in between) gray area and white area, (4) gradation in any direction. Design is an inseparable component of fine drawing.

DRAWING EVERYWHERE

At present, with my heavy teaching schedule, driving everywhere, I have to rely on sketches made while the traffic light is red to help me retain the "seeing," thinking, feeling I learned years ago, spending several evenings a week from 7:00 p.m. to 2:00 a.m. in hotel lobbies, bus terminals, railroad waiting rooms, and restaurants.

Discipline yourself until drawing everywhere and at all times always becomes a *habit*. Carry a book too large to fit into your pocket, so it will never be there. Every three minutes, waiting for a train or bus, and during the ride in either, DRAW. At first the curious, looking over your shoulder, will embarrass you. Ignore them. Later when the facility is yours, you will find you are childish enough to enjoy their admiration of your skill. In your sketchbooks, the drawings being for you only and therefore not inhibited, you make your longest strides towards your ultimate personal style.

VARY YOUR DRAWINGS

Avoid boredom by varying the size of your sketches and the size and character of the tool used. Learn that good drawings are "written." Know that variations in the quality of a line are infinite. A line can be apathetic, alive, tender, harsh, nervous, arrogant, feminine, masculine, wiry, soft—any adjective you can name. Your line will be what *you are* when you make it. A line is instantly creative, for there is no line in nature. It is a sensitizing joy. Empathy is involved. When you draw an animal, a person, or an object, you literally embrace them. Be so aware of their texture, volume, temperature, and weight that it is a physical sensation closely akin to touching them. You *do* touch them with your pencil. They become extensions of yourself. I remember Harvey Dunn saying, "Sufficiently identify yourself with an object and it draws itself."

In drawing one learns that a "soft" curve with no variety in its changing angle is characterless. It has no virility. Always exaggerate the high spot on a curve. It proves you know where the change occurs and gives variety and virility to the changing angle (a little thing, but the little things in the aggregate make the difference).

In even the simplest vignette, think—feel some design into it, relate directional thrusts and darks; the quality of *fusion* of illustrative and design values should be in the simplest sketch. A design value almost inevitable if speed is achieved, is a rhythmic quality.

126

Gain experience relating figures to still life and objects in proper scale. Lack of this experience will show in your finshed drawings. Suggest groups of figures for the same reason. Relate figures to each other at every opportunity.

VARY YOUR TOOLS

Use many papers to find out which you like, but I warn you that some of your sketches will be very precious to you, and you will regret having made them on cheap wood pulp paper which will turn yellow and crack. I use a good bond paper.

A Wolff pencil, say 2-B, is a splendid tool. It does not reflect light as graphite does nor is it as "slippery" when drawing. Its drag or bite feels good. Pressed charcoal in a visualizer's pencil is a tool of different size. The felt tip pen is another. In order to achieve variety of line easily, use a fountain pen with the most flexible nib you can get, and fill it with Higgins Eternal black writing ink. This is preferable to the "artists' pens" filled with India ink. These corrode and are "stiff." The wet pen line rubbed with a finger creates values for modeling and indications of local color, adding interest to the sketch. A 6-B carpenter's pencil is a splendid sketch tool. Pieces of value can be indicated with one stroke. Also, the large or heavy line mechanically eliminates and disciplines the inclination to report too much detail. It leaves the mind only the large shapes and gestures to think about, and imposes a kind of accidental tool mark.

PENCIL DRAWING This was drawn with a Wolff pencil. I enjoy using this pencil because it is not slippery and doesn't reflect light. The sketch took ten minutes to draw.

127

Eric, a fine draughtsman, got this accidental quality by dipping paper matches into India ink and drawing directly with them. Low, the English cartoonist and illustrator, used wooden matches dipped in ink. Among steel pens made by Gillot, Esterbrook, and Spencerian, the pen draughtsman can find those that suit him.

One of the finest tools for drawing is a goose-quill. A twist of the fingers changes the mark from a line so fine as to be almost invisible to a bold line ¼-inch in width, or, twisted and held at a different angle, a double line. It can be pushed, dragged, slid in any direction. It never sticks into the paper. Its accidentals are magnificent (mostly). Do not split the quill as all books tell you to do. First make a 45-degree diagonal cut at the end. Sharpen the point a bit with a scissors. Insert one inch of curved watch spring (any jeweler will give you a broken mainspring) to function as an inkwell, so you do not have to dip too often. Draw, changing the angle and twisting the quill for different weight and character of line.

For line drawing in ink, I prefer the goose-quill first, and a very flexible gold fountain pen nib second; both for the same reasons: (1) Variety in weight and character of line; (2) they do not stick into the paper when "pushed." You move them at will in any direction.

Brushes, with their inimitable character, should be used until you are so familiar with them you are unconscious of them. Dry brush and split brush are effective, useful subdivisions of brush drawing. When you draw with a round brush, hold the brush at a right angle to the plane of the paper.

Lithographic crayon is another drawing tool. Both the pencils and the crayon sticks have their personal techniques which we learn by experimenting with them.

Know that facility with, and understanding of the potentials of, each tool or medium will come only after a reasonable apprenticeship. Do not hastily reject a medium because of ignorance and unfamiliarity.

SEEING VOLUME

Good drawing is 80 percent "seeing." Not seeing structure—you must *know* that— but seeing a decorative shape or thrust, and the significant, dramatic essence of a

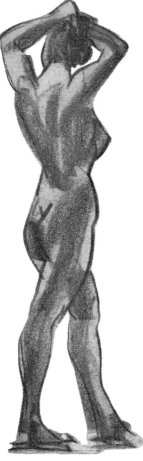

CRAYON DRAWING I drew these one minute action sketches with a lithographic crayon.

128

pose or action, character, place, or whatever. Again, the sketchbook is the answer. The "quickie" educates you here as no life class can. Learn to "see" and describe form in the most elementary possible terms. There are only four basic volumes: cubes (length and breadth can be different—actually a right-angled parallelopiped —but let's save time and call it a cube), cylinders, cones, and spheres. Your head is a cube. Your upper arm is a cylinder. Your lower arms and legs are cones. Your breasts or buttocks are hemispheres. An automobile is two modified cubes.

Do not think line as you draw. Think—feel—be conscious of—describe— *volume*. Learn to see all volumes in terms of their simplest geometric equivalents —the four mentioned above. You will be amazed when you discover how little need be added to the big forms simply "described." I once complimented Herb Noxon, head sketch man at McCann-Erickson, on his draughtsmanship. His answer was, "Hell, anyone can draw boxes and barrels!"

VARY THE LINES

Quality of line is like social aplomb. If you worry about it, you do not have it. Later you can check back and where a line is monotonous, get variety into it, thickening it, crossing, or breaking it somewhere. If a line in any area seems hard or wiry, add another line close to it. Two lines are less aggressive visually than one, because the white black white black white are merged by the eye and become a gray tone, as opposed to the bull's-eyed single black line. Differentiate between line "nouns" and "adjectives." The heavier nouns indicate the structural lines of an object. The adjectives with less weight or thickness express textures, qualify surfaces or veil them in tones, or values. Never have adjectives more forceful than nouns, except for design reasons.

DRAWING WITH ALL THE SENSES

Draw with all five senses alert. The eye, however, is the organ by or through which the other senses are stimulated and made aware *through knowledge previously gained*. You can only draw from your experiences. A drawing of a ship by a sailor, however inept technically, will have authority in it that the landlubber's drawing will not have. Knowledge used in drawing is born mostly of the sense of touch. An object handled in the dark is readily "seen."

CONTOUR DRAWING

To understand better the dual approach to fine draughtsmanship practice each component separately. What is called contour drawing is one qualifying experience you should have. The exercise consists of looking at the model intensely until, in imagination, you are touching her with your pencil point, which is on the paper and not looked at, then moving your eyes very slowly along the contours of the model, co-ordinating the visual experience and the tactile experience of the pencil point. If

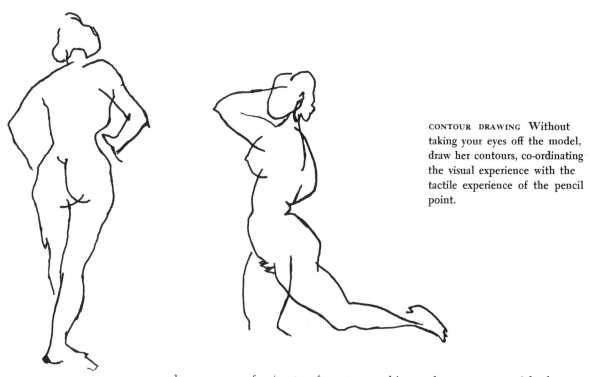

CONTOUR DRAWING Without taking your eyes off the model, draw her contours, co-ordinating the visual experience with the tactile experience of the pencil point.

you have a sense of going too far astray making ends meet, one quick glance at the paper authorizes a fresh starting place.

Be convinced that the drawing tool actually touches the model. The whole purpose is to develop sensitivity. Fragmentary drawings are okay. Stop the moment you have "lost touch." This experience is also profitable in drawing objects. Draw forms within the outline—nose, eyes, etc. Affectionate, demonstrative people who have always enjoyed touching other people have a preconditioning for this exercise. Others will have more difficulty contriving the essential sensual awareness they have been missing.

GESTURE DRAWING

The other component quality and qualifying drawing experience is sensual also. It has to do with gesture. Again empathy is involved. You must feel a gesture so vividly that muscles actually contract.

In the longer studies, the objective is to gain knowledge of structure and the laws of light. In the contour and gesture drawings, the objective is to "become" the model or object.

130

The contour drawing contrives physical contact slowly and carefully. The gesture-action drawing pace is the opposite. The greatest possible speed is essential for the reason that truly *intense sharing* of the gesture or action can last only a very short time. Muscular fatigue or an awareness of the fact that the experience is vicarious or analytical faculties step in and the emotional intensity sags.

Another virtue in the action drawings is speed—ten seconds can be enough. You are forced to think from the whole to the parts, and not having time for the parts, find that a fine, rhythmic selectivity can be sufficient. If big things are right,

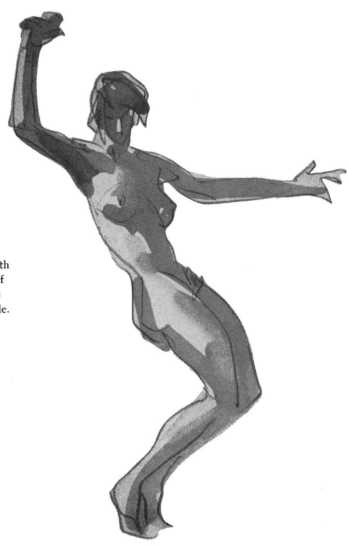

GESTURE DRAWING This is a five minute "written" drawing, seven inches high, which I completed with a fast wash. Sharing the action of your model—intensely sharing the action—can only last a short while. So draw fast!

131

little things are unimportant. The difference between finish and superficial finish is discovered. Your subject is the action. You will find that lines and proportions can be very wrong in an academic or literal sense and very right in another more important sense. You will observe also that detail slows up action. My "red-light" sketches exemplify the virtues of this discipline. Incidentally, *just* the gesture "seen" and emphasized makes a collaborator of one who looks at your sketch. "They" finish the partial statement. They enjoy that.

THE EXPERIENCE

Remember, you are not after results. The drawings are not important. The *experience* is. But remembering the "by-product" theory, some of the sketches will be fine because your state of being as you made them was interested, excited, curious, and sensitized. The only metaphysical experience I have knowledge of is that your state of being, your emotional content, and the degree of your understanding leak through the pencil or brush on to the paper as the stroke is made.

STUDY THE LIGHTING

If a drawing is modeled, you are involved with the laws of light which obtain regardless of the form occurring in the light. Never copy the shape of lit and shadowed areas on a volume. This I call tick-tock drawing, often seen in life class. Heads lifted up to look, down to draw, endlessly using eyes and hands without the intervention of the mind. Look at a volume until you *understand* it. See it in terms of simplest geometric equivalents. Then with a definite, fixed concept of where the light source is, you *explain* or *describe* on the paper the form you *understand*.

There are six lightings on any object: (1) The local color in light; (2) the plane change accent as the plane turns into shade but has not yet turned into the

GESTURE DRAWING This drawing—made with a Wolff pencil—was completed in ten minutes. Speed is the essential element in gesture drawing.

132

light bounce; (3) the local color in shade; (4) the reflected light in the shade; (5) the crack underneath; (6) the cast shadow.

A plane, if not a polished or reflecting one, is lightest when precisely at right angles to the source of light. As the plane turns away from the light, it gets progressively darker; when it is a bit beyond the same plane as light source to object, it is darkest in shadow. This is where the "plane change accent" occurs. As the plane continues to turn away from the light, it turns *into* the "light bounce," which is the reflected light from nearby planes facing the light. The light bounce is lightest on the plane which is at right angles to the reflecting surface or, if there are none very close, on the plane parallel to the plane taking the first light.

A meticulous report of the precise relationship between the values is not necessary, but the proper *sequence* is. First, direct light; second, the plane receiving neither the light nor the reflected light, which is the dark plane change accent; then, the reflected light, never as light as the first light.

Your drawings will be more third dimensional, and you will have more fun making them, if you *describe* form this way, as opposed to copying shapes of light and shadow. Any form may be intellectually described or reported. To prove light and color reflect or bounce, look into a mirror. Look under your chin. Then move a card, your hand, or any plane closer to and away from your chin. Light and colors "bounce." Aviators flying in the South Pacific were instructed, "If you get lost at sea, look for a cloud with a warm bottom. It will be over an island." (O'Hara)

LIGHTING The light coming from the right hand side of the drawing determines the relationship of the values: direct light, reflected light, and dark planes.

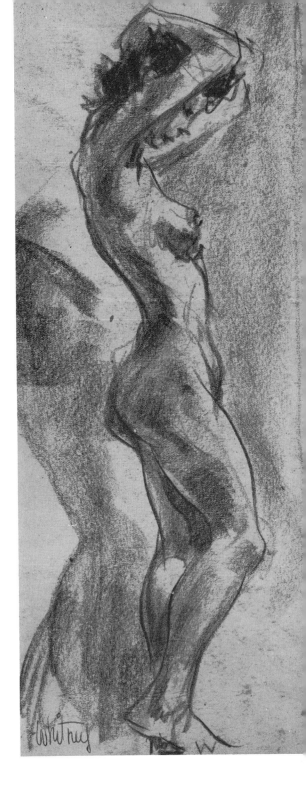

CAST SHADOWS

Cast shadows help describe form, give a sense of reality, and are valuable as design thrusts. A cast shadow is on a direct line from the light through the object casting the shadow. In landscape, if you drop a perpendicular from the real or imagined source of light to the horizon, or eye level, every cast shadow will point to that intersection. (If the light source is behind you, the shadows will converge at an imagined point.) Another way of saying it is: all shadows on the horizontal plane converge to one point. The shadow will of course run up and down over forms and describe them. Cast shadows are darker in value close to the object casting them and sharper at edges near the object.

DRAPERY

The simplest statement regarding the nature of drapes is that folds radiate from the nearest tension point, and can be simplified into a few planes, expressing this mechanical truth. Reasonable results can be got if you have drawn enough, and

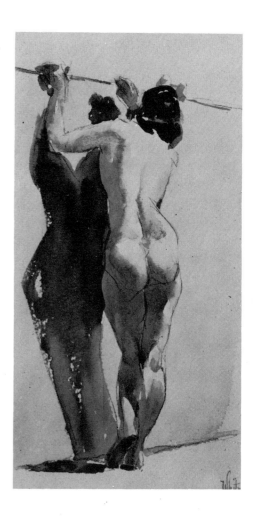

MODEL AND SCREEN Note that the three masses (head, chest cage, and pelvis) are all on different planes. This insures a nice rhythmic pose. The cast shadow is more aggressive visually than the figure. It should not be. Cast shadows help describe form, but should not overpower the form.

134

understand light laws. Gravity, of course, has an effect on drapes that is readily understood. Again, seeing simply is important. A dozen folds radiating from a knee or shoulder need not be reported. Three or four report the mechanics involved, slow up action less, and show which line or mass "passes" in front of, or behind, which. The different character of folds have been designated as pipe or drop, zigzag spiral, diaper, lock, flying, etc. Knowledge of each is contingent upon observation. The problems they present are readily solved by draughtsmen. (See Bibliography for augmentation of the above.)

SOLID FORMS

There are four simple methods of modeling solid forms with line: (1) Across the direction of the light rays. (2) By horizontal sections of the form. (3) By lines parallel with the rays of light. (4) By vertical sections of the form. There are also combinations of any of the foregoing.

Form is described by the spaces or shapes it occupies and by its interception of light.

Line expresses the limits and directions rather than the local color and tonal subtleties.

SHADE AND SHADOW

Know the difference between shade and shadow. Standing in light some of my planes are in shade. The area of the floor and wall I keep the light from is shadow. Shadows are darker than shade, because less light is reflected into them.

PERSPECTIVE

There are many available treatises on perspective. It is not proposed to go into that subject in this textbook more than to state the rule from which all other rules are deduced. The vanishing point of any line coincides with that point at which a parallel ray from the eye meets the picture plane. The *line* is the drawn line in the picture but seemingly at say a 30-degree angle from the picture plane. The *ray* from the eye is at the same angle from the picture plane.

LOCAL COLOR VALUE

Local color value in a drawing has to accept the limitations of the medium. Select only a few of the most obvious ones. Do not attempt the whole range. Brilliance and vivacity suffer if limitations of the medium are not acknowledged. The significant "key" of a subject can be expressed readily—a Negro and an albino, for instance, in a low key or a high key drawing.

FRESHNESS

Directness and freshness are as important in line as other media. Aim bravely at

finality. "Overpower" a first line with a second line, rather than erase. Also the eye will find a mean between two "tries."

STRUCTURE

If your 5-10-15 minute figure drawings are failures, it is because of ignorance of structure. Get your nose into your anatomy book. (See Bibliography.) Gain a knowledge of skulls—joints and tendons. Cubes are better concept than cylinders. Speed, yes, but respectful study also. Know what the other side of the figure is doing. Get variety in weight of lines. Feel your own body for understanding. Draw your emotional reaction, not the pose as is; if it's "right" it's wrong. Don't compete with the camera, which has no opinion and can only report facts; truth, not facts, is what you are after. Think of the *character* and you will get finer drawings. The masses of head, rib cage, and pelvis are practically fixed, the action takes place *between* them. See simplest geometric equivalents. Study respectfully. You are right now doing the greatest single thing you can do to insure emotional and economic security in the future. Your drawing should be an ideograph. What is in your mind will show; will be clearly recorded. Spontaneity, yes, but don't let your smart hand put your mind to sleep.

DRAUGHTSMAN'S MISCELLANY

With pencil, pen, or brush in your hand, you become a god, an authority unto yourself . . . striving for realization solves all the technical problems . . . no matter how inept and fumbling, results can be got through simple sincerity . . . draw with compassion in your heart and we will know it . . . test your knowledge and gain more by drawing the pose from the far side or any angle different from where you sit, including a worm's and an eagle's eye view . . . the expression of the gesture is infinitely more important than accurate outlines of parts of the figure . . . the discipline of a straight line helps any drawing . . . don't worry about a drawing. Fill your mind with an eager, zestful curiosity about, and examination of, it . . . a part or a piece or a line where it feels good rather than where it is . . . right for the camera is very wrong for a drawing. The man who draws by measuring and not by "touch" is not yet a draughtsman.

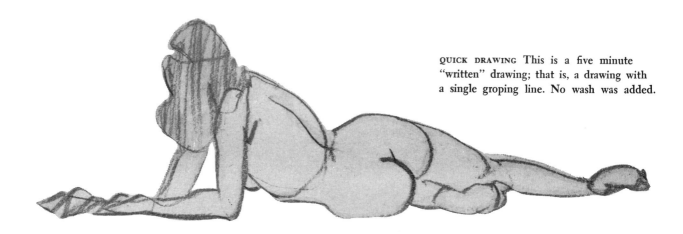

QUICK DRAWING This is a five minute "written" drawing; that is, a drawing with a single groping line. No wash was added.

BE BOLD

Too great an exaggeration of character or essence, bespeaking energetic expressiveness, is preferable to understatement or factual reporting. If it looks *exactly* as the model or the action looked, it is a failure.

DRAW CONTINUOUSLY

In regards to drawing continuously, some of you—confronted by the demands on your time and energy—the inexorable demand for payment for goods received—will shrug off this obligation to yourself and join the category of those who *"do not."* At any stage of your growth, or your development of taste, questioning, faltering, remember that is the point at which thousands quit, incapable of grace under pressure.

> *"On the plains of hesitation*
> *bleach the bones of countless*
> *millions who, at the dawn of*
> *victory sat down to rest, and*
> *resting, died. . . ."*
>
> *Author unknown*

And now I revert to my first paragraph in this chapter, dramatizing the word *draw.*

If somewhere, sometime later I see a student on a subway platform, in a restaurant, in a hotel lobby, slouched in a corner, hat brim pulled low, sketchbook on lap, I will exult. My seed will have prospered. My hook has struck. He is being nourished by the eternals, the infinite. He is learning to draw. He is bypassing the mathematician-scientist who goes around, while he takes the short cut to, realities. He is on his way to finding significance in infinity and he is discovering validities automation knows nothing of.

Matting,
Framing,
and Selling

SIGN YOUR PICTURE with one of the tools you used making it, using a color used elsewhere, where it functions, not too conspicuously, as part of the design.

MATTING

The last thing you can do about the pattern of your watercolor is to mat it to best advantage. Cut a large old mat through horizontally from the upper right-hand corner of the inside aperture, to the outside edge. Cut it also horizontally, from the lower left-hand corner of the aperture to the outside edge. You now have two right angles of mat board. By moving these right angles horizontally and perpendicularly over your watercolor you can change the design and proportions. After shifting the two mat right angles, and deciding where they belong, you employ the same device to help your decision as to width of mat, but this time your two right angles are black cardboard. The mat width should be the same at tops and sides, and slightly wider at the bottom because optical center is slightly higher than actual center. The location of the center of interest in the picture influences this decision. If the center of interest is low, make the mat wider at the bottom; if high, the bottom width can be the same as top and sides. Pencil lightly where the mat is to be cut.

If your hands and eyes are trustworthy, cutting a mat from mat board is easily and quickly done. I do not even use a straight edge. The free hand cut can have slight irregularities, as in handmade pottery. If you need a straight edge, make the first stroke lightly so that a guiding groove is straight and clean. Then increase pressure each successive stroke. If you put pressure into the first strokes inexperi-

enced hands will wobble. Your wobbles will not be coincident and you will have to smooth them out with sandpaper.

Use 2-inch gummed paper tape to fasten painting to mat in the back *across the top only*; if you fasten it all around, the changes in the weather, affecting mat and paper differently, make the picture cockle. The mat can be hinged with tape to another piece of mat board for additional "dress-up" and stiffness.

The buff, gray or white pebble board or linen mat should be chosen carefully. Taste is your only guide here. Taste guided by reason, that is. Many students and a fellow-teacher criticized matting of a picture I had in the 1957 National Academy and Philadelphia Watercolor Shows. The white mat they recommended would have established the greatest visual attractiveness via value contrast at a place at the picture's edge where there was no visual entertainment. By using a gray linen mat only slightly different in value from the edge of the picture, the greatest visual strength or center of interest was where the visual entertainment was. In planning your mat and frame, you are still *designing*.

FRAMING

If only someone could devise a way to keep dry watercolors looking as they do when saturated! Slide any "stinker" under a few inches of water. It has the same light reflecting glory as has an inked litho stone or a wet pebble on the beach. Glazing slightly recaptures this saturated look and protects a painting. The commercial holder that binds your picture to the glass is one way of getting these advantages, the other way is glass in a frame. If you live in a metropolis, find a professional framer with taste; he probably is a painter himself. Trust him. There are many materials used for frames. Consult your framer as to which suits your taste and purse.

You might enjoy making your own frames; consulting a good book is the wise procedure (*see* Bibliography). Have fun experimenting with orthodox materials and your own improvisations.

PRICING

Interest in selling one's production of watercolors will vary with temperaments and the need for some compensation for time or materials. Many students ask me how to price their pictures. My answer is always the same. It seems to me there is only one practical and ethical way to fix the price of a picture. *What is it worth to you*, plus a small profit. Ask yourself, "Would I rather have fifty dollars or this picture? Seventy-five or the picture? One hundred?" When you are not sure of the answer, add five or ten dollars. Make that the price. One virtue of this procedure is that, not being too greatly concerned about selling, you easily and naturally contrive the "soft sell" which sells more pictures. The trick is to be honest with yourself in answering the question, "What is it worth to me?"

The above procedure is recommended for amateurs. The professional has a different problem. He has hundreds of pictures, most of which have lost interest for him. They have in them, however, his hard-earned professional excellence and inasmuch as they can be an embellishing focal point in a room for say, two hundred years, they have very real intrinsic value. To a lesser degree this is true of students' work. I always point out the long-time value of watercolors when students underrate some record of sensitive seeing. It is reasonable also to price paintings according to the law of supply and demand. In other words, the price of anything is the amount you can get for it. Of course, your taste and experience function in pricing. Establish three or four categories of excellence and have a mean price for each. Discard utter failures as good ethical practice. The supply and demand law will dictate occasional revisions in these mean prices, and prices will vary in different localities, but never haggle or cut the price of a specific picture.

If you have an agent or agents, he rates one-third of the selling price as commission, and earns it by finding and dealing with purchasers, and acquainting them with your background and status, exhibiting, reviews, etc. He can do this more gracefully than you can. Finding agents should not be difficult if your work has merit. An appraisal of possible agents is important. Is he centrally located? What kind of and how many people does he have access to? Do not have a narrow or fixed concept of the social status of possible purchasers of pictures—the gamut is greater than you think.

Galleries are not the only places in which you can show and sell. Bookstores have sales people qualified by cultural status to present creditable watercolors intelligently. The space problem they have is solved by displaying one or two of your efforts and a further selection kept in racks or portfolios. Print shops and gift shops are other possibilities, avoiding those in the lower taste brackets. Department stores sell many pictures in conjunction with their framing departments. Furniture stores frequently display pictures as part of the problem of interior decoration.

With all of the above, your paintings are placed on consignment. A written agreement should exist precisely stating terms governing all sales.

If your watercolor production and your wish to sell part of that production warrants consideration of the foregoing text, know that you can sell pictures by being absolutely free of any buyer's opinion as you paint and then practical minded enough to price work realistically.

10
A Craft
Philosophy and
Art Today

COMBINING the two subjects of a craft philosophy and art today in one chapter—viewing the two extremes of the gamut—rational communication at one end and contemporary nonobjective or the new American abstract expressionist academy at the other—might help the reader to place himself. Striving for an exact preconception of your ultimate style is not recommended; however, an investigation leading to a concept of what you are, and *what really interests you*, discovering where in the gamut you feel at home, and an understanding of your character and temperament, plus absolute honesty, should result in good and original works.

YOUR EMOTIONS

The most precious single thing you can possess is emotional security. Emotional security is contingent upon two things: (1) affection; (2) a skill. We all possess the first requirement to some degree because of, and despite, our faults. The second basic need, a skill, is an infinitely rarer possession for the reason that it has to be earned, and also because it presupposes sufficient intelligence to see that man is a skill-hungry animal. He either acquires a skill, and with it a sense of fulfillment, or he does not acquire a skill and becomes a neurotic frustrate. Henry Thoreau has said, "Most men lead lives of quiet desperation." Since he said it, the picture has changed. Men have grown more desperate and less quiet. Why?

At a Columbia University faculty symposium, it was agreed that our two cultural poisons were materialism and mechanization. It was also agreed that the only antidote was a craft activity. In colonial days a man could win the respect of his community and himself by doing a fine job as blacksmith, wheelwright, farmer, shipbuilder, gunsmith, etc. Man is a hand—*homo faber*.

Today the cold machine depletes craft activities. Men too rarely experience creative emotions and pride in workmanship. We have a mechanized humanity.

Man's human and spiritual arts are threatened with aridity, and fail to develop equally with machine techniques. We may well become scientific supermen and aesthetic idiots. The difficulty of reconciling the mechanical and the personal is apparent, but the effort must be made to establish a working relationship between the objective and subjective. The tragedy is that mechanization is a cumulative thing. It can no longer be stopped. The machine eats into our lives, devouring all that is human and lovable in us. We obey the dictates of radio and TV. A vast network of mechanical forces, now beyond our control, anesthetizes us to human warmth and values, as evidenced in contemporary painting, replete with what Lewis Mumford calls "dehumanized nightmares." He states, "The great problem of our time is to restore man's balance and wholeness, to give him the capacity to command the machine he has created, instead of becoming its helpless accomplice and passive victim."

A CRAFT PHILOSOPHY

The best way to balance our one-sided mechanical triumph is through a craft philosophy. A craft philosophy helps us make constructive efforts to acquire the power to produce something beautiful. This is the only power which does not corrupt.

The artist-craftsman, seeing the inevitable choice each of us must make between pain and boredom, chooses the ego frustration, the travail, of creative work —appreciation always being one jump ahead of ability to produce—over the boredom of invalid preoccupations, and, he, enduring a discipline, achieves mastery. He discovers that life's values are both extrinsic and intrinsic. Observing that one's personal temperament or point of view is "fixed" to a considerable degree, he sees that behavior is caused, and learns tolerance. He also learns that will cannot change him, but understanding can. The artist practicing his craft sometimes understands the most profound truth of all: results are unimportant. The value is in the activity. Are these things the craftsman learns worth knowing?

The practice of a craft is the one exception to the law of compensation—the one gain without a loss. You can invest in a domestic situation, in a friendship, in stocks and bonds, and get a swift kick in the teeth, be gypped. But rarely has anyone invested one hour or one dollar in a craft activity without profiting from it.

No apology is made for carrying coals to Newcastle in the preceding text. You, reading this book, are one of the saved. You have seen the light or you would not read here. But restatement of the truth that there are values in craft activity other than the monetary compensations for it, aids, abets, and confirms our faith.

PAINTING TODAY

Certainly today's artist-craftsman is concerned with his world *today*. I will try to make my comments *tolerant*, thereby avoiding the fatal philosophic mistake made

142

by the current abstract, nonobjective academy. The abstract nonobjective academy is decorative and subjective, therefore it can be indicted for being fragmentary and frightened. Rejecting the world as it is, it becomes idealistic. Webster defines ideal as "existing only in the mind as an image, fancy, or concept."

Lionel Trilling, lecturing at Columbia University, interested me when he said, "The idealist is on the road to corruption." Asked by a student to amplify his statement, Mr. Trilling said, "The lover inept through idealism." Now Lewis Mumford and many other fine minds have defined art as essentially an expression of love. Ergo, the artist is a lover. Mumford's breakdown of the artist's development into three stages is noteworthy: (1) The self-enclosed, infantile, stage, "Look at me." (2) The social or adolescent stage, exhibitionism passing into *communication*, "I have something to show you." (3) The mature stage, art transcending needs of person or community, becoming an independent force. The final stage, producing the widest *range of universality*—self-love and exhibitionism outgrown —"Let us share this gift together." Hold the three stages of growth in mind for a moment while we look at Webster's definition of subjectivity—"Concern with only one's own thoughts and feelings." Now into which of Mumford's three stages of growth does the definition of subjectivity allocate the too subjective artist?

The best test of a good mind is its capacity for being objective. The best proof of twisted narcissism is subjectivity. Arnold Toynbee put it well, "The nemesis of creativity is idolization of an ephemeral self." The subjective lyricist is a bore. What is the difference between a man refusing to talk about anything but himself and a man refusing to paint about anything but himself? And having subjectively painted oneself a half dozen times with all possible brilliance and subtlely, how does one then avoid the worst kind of plagiarism—self-plagiarism? Another quote —this one from Aldous Huxley: "Love casts out fear; but conversely fear casts out love. Fear also casts out intelligence, casts out goodness, casts out all thought of beauty and truth. What remains is the dumb or studiedly jocular desperation of one who is aware of the obscene Presence in the room and knows the door is locked and there aren't any windows . . . for in the end fear casts out even man's humanity." What a pitiful fate, and how blessed we are if we are not that way.

Subjectivity is fear. Man's ego has suffered three terrific blows. Darwin, Freud, and the 100-inch telescope. The frightened whimper in paint, and produce —art today—neurotic, infantile in symbolism, regressing to formless scrawls or geometry. Why can't frightened people see that the dignity they feel deprived of consists of being part of nature?

Jacques Barzun in *Romanticism and the Modern Ego*, recognizing the inevitability of man's egotistical partiality to himself, finds self-consciousness rather than self-awareness rampant today—the fear of being wrong, ridiculous, or being taken in. Rejecting all principles and standards—they have none. Barzun quotes T. S. Eliot as saying that the result of modern culture has been to obscure "what we

really are and feel, what we really want, what really excites our interest." This is mistrust, this is fear, the curse of the modern artist. He hides his fright under an affectation of toughness—the smart aleck—look Ma, no hands!

"To admire false values is a bad thing, but to admire nothing at all for fear of being duped is a progressive disease of the spirit." (Barzun) Let's avoid this disease by admiring the principles which are the consensus of all good minds preceding ours, plus intelligence and sensivity wherever we find them.

WHAT IS ART?

Now, as opposed to other times, we have stress and strain and wider discrepancies of opinions as to what art is. The primary concern of each artist is to find a place in the chaos that affords him the greatest opportunity for personal integrity and self-expression. He searches out that area of the gamut where he may discover the greatest values, *for him*, and where significance for our culture may be found. Do self-styled judges, critics, experts, making and breaking reputations and establishing hierarchies have access to wisdom that artists who paint do not have? Is the absence of professional ability a liability or an asset? We can only re-live, re-experience, re-create from our culture with taste born of study of design principles.

Color Demonstrations

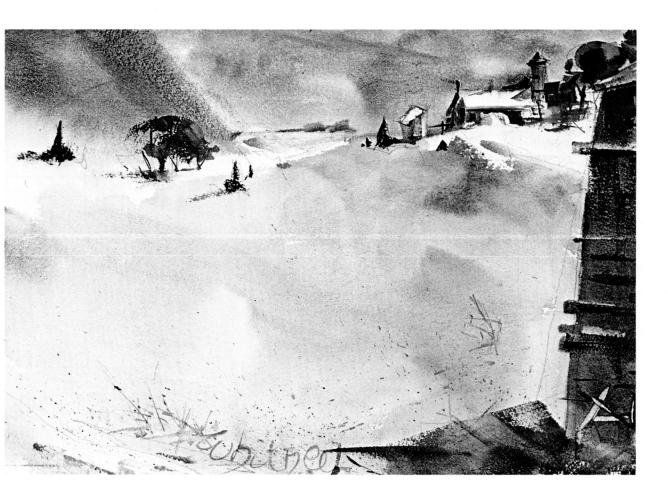

COLD AND QUIET

For this watercolor, I sketched first. I made my subject, snow, an enormous part of the painting. When considering divisions of space in a painting, the greater the difference in the size of the divisions, the more distinguished they become. Leaving the white areas until last, I did the horizontal at the top which includes sky, mountain, buildings, and trees.

Next I painted the field of snow. As in surf and cumulus clouds, such white areas as snow are tough to paint inasmuch as the shadowed areas must not be white, but must look white. This calls for discrimination. Never forget to accent the change in planes on all forms—darkest near the light. If you do not do this, you lose the illusion of third dimension. In an area as large as this, there must be both color and value nuances. When

running the snow wash, I did not try to stop it exactly at the edge of the barn. That would have slowed it, but I made sure that the wash in the area of the house had soft edges. Such edges would not show through the darker wash which I applied later.

Last, I tackled the foreground piece of barn and its cast shadow. Note the gradation of both value and color in the barn: colorless and dark at the top, lighter value and warm at the bottom. Also the knifed boards and their cast shadows helped to enliven this large foreground shape. The roughbrushed edge of the shadow expresses the granular character of close-up snow. The very few warm-colored grasses—they turn a warm color when they die—are a slight but important repeat of the warm colors on the barn and silo.

145

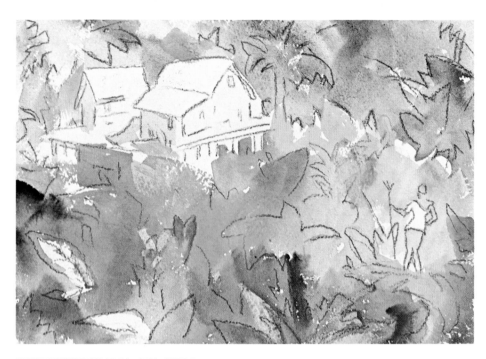

IN THE MOUNTAINS OF JAMAICA, STEP 1

Art is emphasis on essence, or characterization. The essence of Jamaica is its colorful foliage and its abundance of curves: the banana leaves, the palm trees, and the curvaceous natives. These essences, when exaggerated, *express* the locale and insure unity in a painting. A change in value and color around the edges of figures prevents them from looking superimposed on the painting's background.

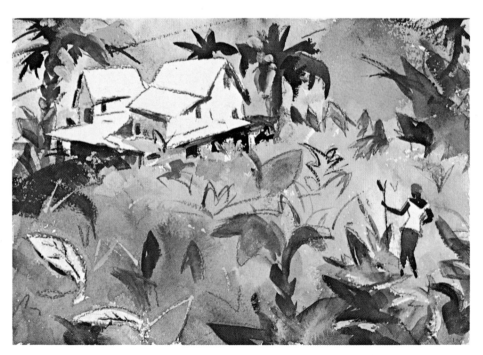

IN THE MOUNTAINS OF JAMAICA, STEP 2

I apply the darks next—always after the midtones. For the shadows on the curving banana leaves, I use phthalo green, alizarin crimson and burnt umber. I introduce a touch of bright red for accent in the front of the house and on the figure's turban. Notice that the white areas framing the house and figure's blouse are still untouched.

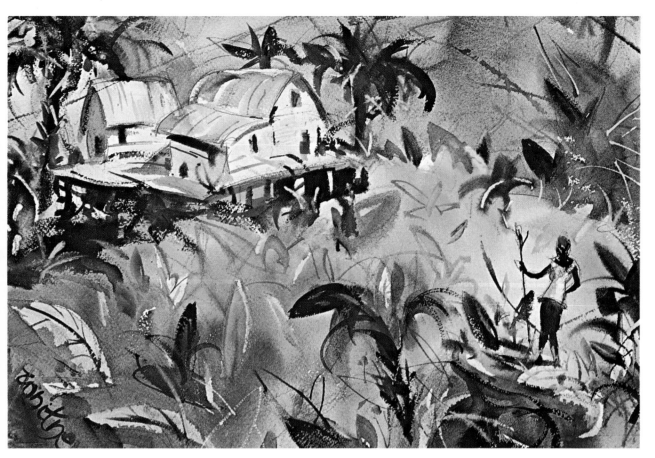

IN THE MOUNTAINS OF JAMAICA, STEP 3

Now I qualify the whites. Then I add calligraphy. This accomplishes three jobs: (1) helping definition; (2) decorating areas; and (3) connecting darks for the sake of larger, more generous and more interesting shapes.

In this painting there is an emphasis on design, a theme. All art is thematic. What you think about and have knowledge of will be apparent in your painting. If you think "design," it will manifest itself in your works. If your objective is facsimile—reporting facts instead of symbolically expressing truths—there will be no evidence of a trained mind functioning in your paintings.

147

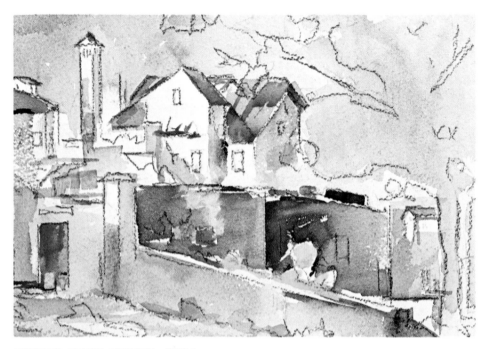

BUILDINGS, NAZARE, PORTUGAL, STEP 1

I have painted all the midtones first, so that the white areas can be evaluated. Now I can see the whites as individual shapes. The sum, or total, shape of the whites should obey the "fine-shape" law. Shapes are identified by value, color, and texture. Here the white areas are related and the warm areas of color are also carefully related. Portugal is colorful, and this essence is expressed by this colorful watercolor.

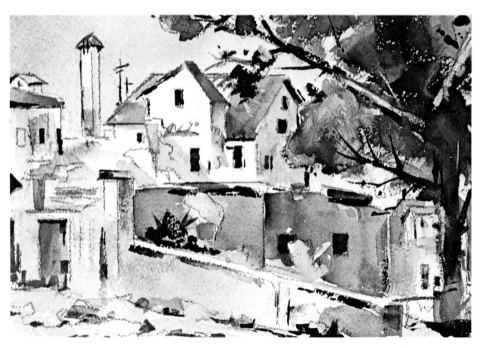

BUILDINGS, NAZARE, PORTUGAL, STEP 2

Now I establish darks. These areas contain gradations of both color and value. Keep in mind that the sum of these darks must be different from that of the whites, and very subordinate to the larger midtone. For the roofs and doors I use cadmium red light, with burnt sienna and alizarin crimson for variations in the red.

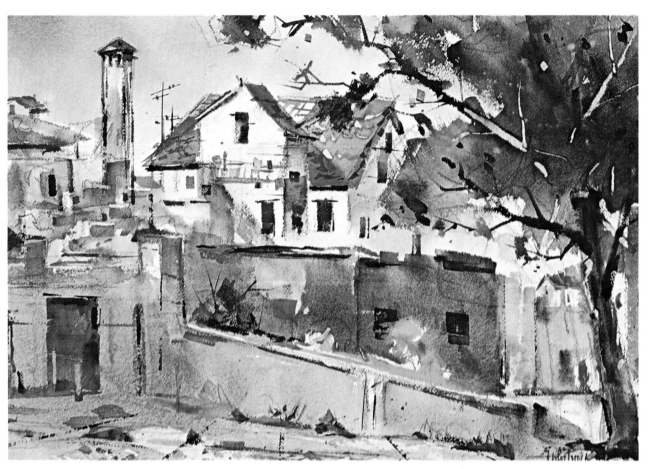

BUILDINGS, NAZARE, PORTUGAL, STEP 3

Now the whites are qualified and value changes are made to effect a better "chord." That aesthetic value, a fine "chord," is what Charles W. Hawthorne had in mind when he said "a fine watercolor is an accident." Hawthorne knew the value chord changes as the watercolor dries. This "chord," by the way, is the only aesthetic value for which I cannot give you a specific, precise law. It is the one component of a good job in which, to a degree, you must roll dice. If your watercolor looks—if it feels—right wet, it will dry *wrong*. Do not leave an area until you are sure it is a bit too dark.

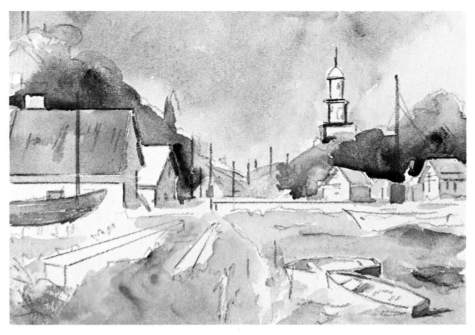

MAINE TIDE RIVER, STEP 1

First, I sketch my subject. The drawing must be fairly explicit because of this busy subject. Then I paint all middle values. I leave pure white paper for the lights, so that they read clearly. Concern yourself with color dominance. Will the painting be warm or cool? I paint the sky with diluted ivory black. While wet, I add to it Prussian blue and alizarin.

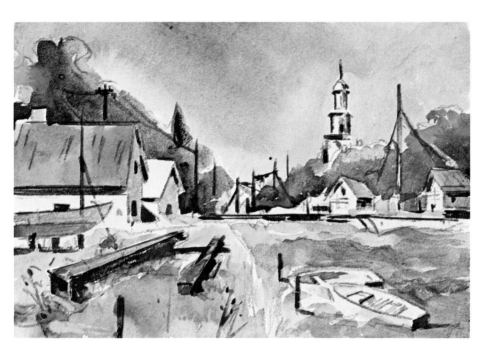

MAINE TIDE RIVER, STEP 2

At this stage, I am still concerned about value and color relationships. The intensity of color shouldn't be the same throughout the painting. I check for gradation of color in the large areas: sky, water, foliage and land. At this point, I add the dark, shadow areas to the picture. For them, I use ivory black, phthalo green, alizarin, and burnt umber.

150

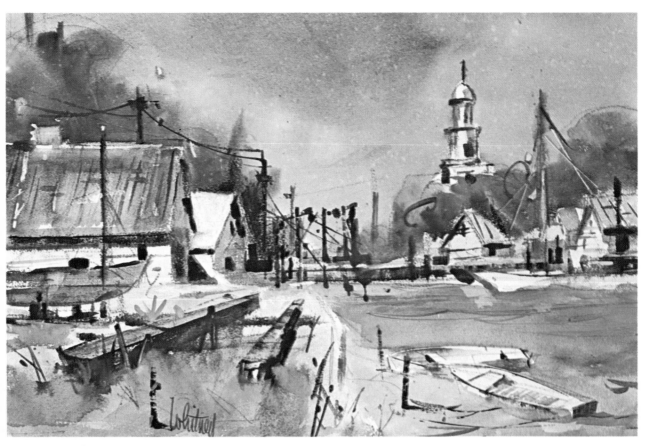

MAINE TIDE RIVER, STEP 3

Now I check for accents where planes change. Be sure you have variety in the darks. I wet-blot to lighten areas, and use a rough-brush technique to darken others. Lastly, I qualify light areas, being careful not to have any of them join the midtones. What you think about will be obvious in your painting. You must decide whether you want to be a "what-is-it," or a "where-is-it" artist. Incidentally, I agree with Jacob Epstein, who said "to construct and relate natural forms may call for a greater sensibility and a more subtle understanding of design than the use of abstract formulae."

These reproductions are all of demonstrations done during my classes, and I talked and taught as I did them.

151

JAMAICA, STEP 1

This subject is ideal for what I consider the best watercolor procedure: first, drawing all of the shapes in pencil; next painting in all middle value washes, carefully saving the white areas. The background, or sky wash, is Prussian blue, cobalt blue, and burnt sienna. The perpendicular in the upper left-hand corner is cadmium yellow pale.

JAMAICA, STEP 2

Here the darks are my concern. Their shapes (no lollipops), their sizes, values, and colors are all different. All these dark areas are painted so that their relationships are oblique. The total shape made by them obeys the shape law, "two different dimensions, oblique and interlocking edges." For these darks I use alizarin and phthalo green, which is as dark as black but livelier.

152

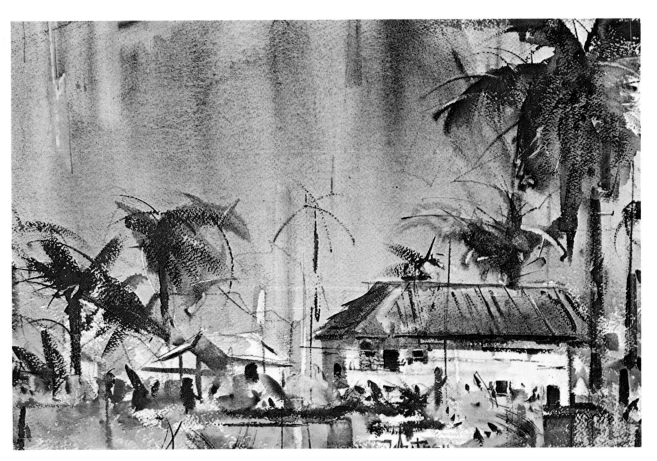

JAMAICA, STEP 3

Last, as usual, I qualify the white areas, getting gradation of tone in them. I strengthen the darks via drybrushing. In this painting, I have to do a dangerous thing. I add a fast second wash over the sky. This should be avoided, if possible, because a second wash threatens the essence of sky, which is transparency. Then, as always, my last tool is calligraphy. This calligraphic brush-handling helps definition, decorates areas, and changes and connects dark shapes, so that they will be larger and more generous. Dissatisfied with the quality of my work (everyone should be), I was reassured by reading Rex Brandt's statement that one in fifty exhibited paintings was painted outdoors. All but one of the reproductions in this book were demonstrations, done outdoors, while talking to my class.

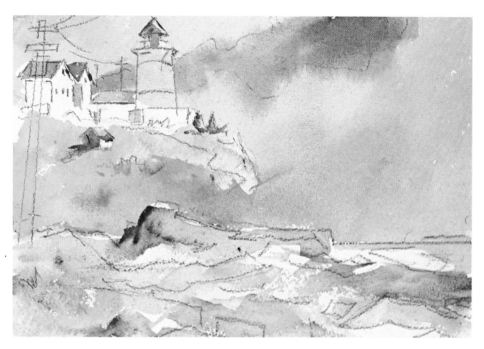

MAINE COAST, STEP 1

The midtone always comes first in my procedures, leaving whites unmolested. This makes it easier to judge the shapes and relationships of these whites. Any other procedure threatens the best shaping and relating of these visually aggressive whites. In the upper left of the sky I use cadmium yellow pale. The sky and the ground above the rocks is yellow ochre and burnt sienna.

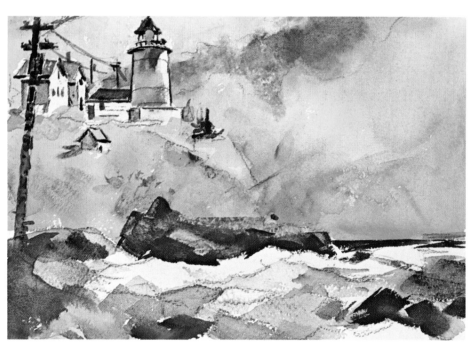

MAINE COAST, STEP 2

Now, I add the darks, carefully obeying the shape *law*. I purposefully avoid the conflict of cool colors challenging the dominance of warm ones. They should dramatize the warm dominance, but must never challenge it. In the rock areas the darks are painted with burnt umber and ivory black, as well as the telegraph pole. The clouds are a diluted Prussian blue and burnt umber, applied while the sky was still wet.

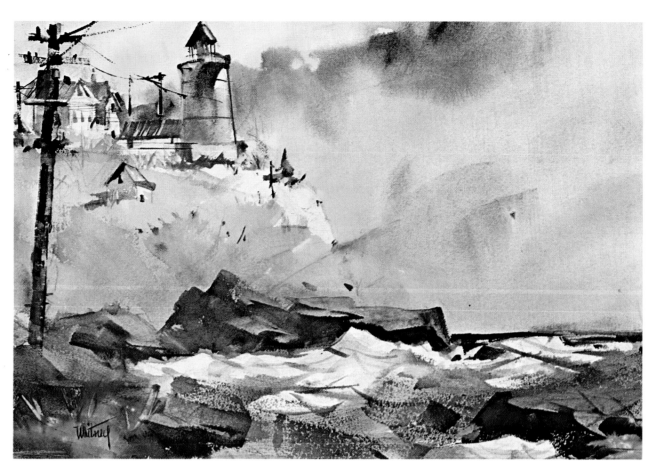

MAINE COAST, STEP 3

Now, I qualify, or model, the white areas. It requires a deft, trained hand to do this last, but the priceless saving of the most visually aggressive value, white, in the embracing amalgam (Brandt's phrase) of the midtones, makes the training essential. Note: any hand can be trained. Also, at this stage I add the "lace" of grasses, telephone wires, and my signature. Notice how I have modified the burnt sienna tone above the rocks in the painting's center. I do this by wetting the area and blotting it with a tissue.

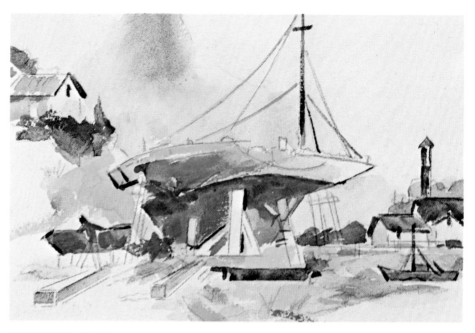

THE RED KEEL, STEP 1

This watercolor is a vignette, which has design laws of its own. A vignette must be a well placed, defined shape of middle value with fine shapes of dark nicely related in that middle value range. The four untouched corners of the paper should differ in size and shape. The hull and keel below the water line are cadmium red light.

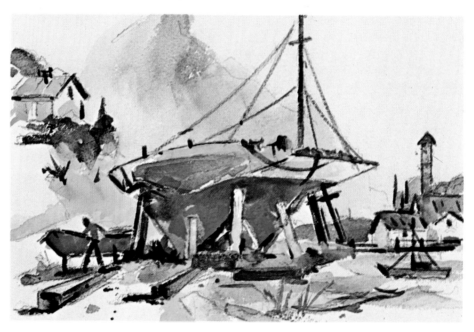

THE RED KEEL, STEP 2

The vignette sells well because the untouched white corners sparkle. In this step, I establish the "grill" or lacy character of the subject. I also develop more gradation or interest in the color washes. The red keel is the center of interest, so I have delineated it well by connecting it to the small red boat and the figure's shirt.

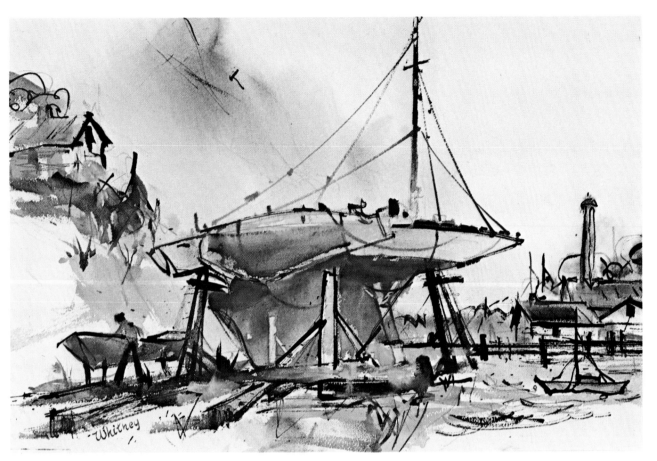

THE RED KEEL, STEP 3

I decide that the painting does not express the vitality characteristic of a boatyard. So I add
dark accents with India ink and a goosequill line. This stronger, linear gill seems right for the
job of holding up the boat, and the very dark values created by the India ink make a finer
value chord. It is a successful watercolor because I force you to focus on a shape that obeys
the laws governing a fine shape.

157

SURF, STEP 1

Students have trouble describing the form of a subject that is essentially white, such as snow, cumulus clouds, and surf. The white planes of such white objects in shadow can not be *painted* white, but must *look* white. The cool gray that you use for such shadows must be precisely the right value. Surf is the only subject in which I model the white areas first.

SURF, STEP 2

Now, I start to add the darks. I keep the ocean cool and not too dark. I also strive for soft edges so that darker, warmer, more detailed rocks will come forward. Note gradation of color and value, even in the smaller shape. I always present the total piece of surf obliquely to portray its activity.

158

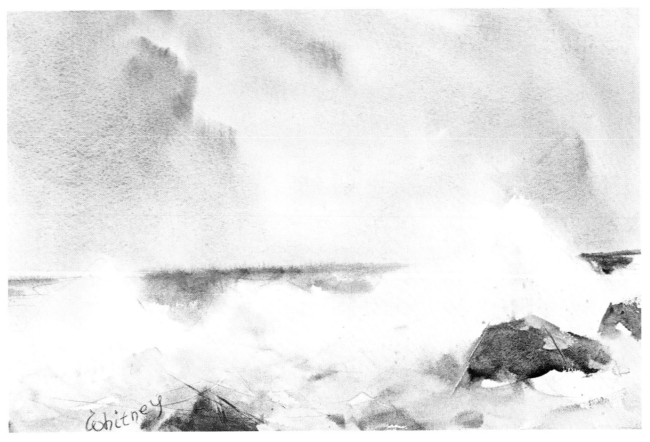

SURF, STEP 3

Now I paint the foreground rocks. I see to it that there is a "mama, baby, and papa size" sequence (or the reverse). An increasingly larger sequence is not as good aesthetically as a varied one. Why? Perhaps because "down-down" is less varied than "down-up." Note the great difference in measures between the three rocks. Note, also, that they are obliquely related, expressing the surf's movement. The oblique line of the rocks is not parallel to the oblique line of the surf. These minor relationships do not seem important to many, but tiny "minuses" and microscopic "pluses" in the aggregate promote or demote watercolors. Note the variety of color in the rocks and in the qualities of their edges—soft, drybrushed, and hard. Seaweed at the water's edge (in yellow ochre) helps enliven that area.

THE ABSOLUTES OF DESIGN

The only thing I am afraid of is a limited gamut of appreciation, or understanding. A fine musical composition is a number of sounds, related by an artist to please the ear. A fine composition in art is a number of values, colors, directions, and textures related by an artist to please the eye. Music may have, but does not need, lyrics. Paintings may have, but do not need, objects. The knowledgeable use of design principles—structure —makes a realistic, abstract, or non-objective painting credible.

Knowledge and integrity rate respect in any art form. All the laws of design are in this watercolor. There are two different measures for variety: oblique and, there-

fore, dynamic; and color dominance, giving character. There is conflict dramatized by the dominant color; there is gradation to avoid monotony as the eye travels, and variety in the quality of the edges, again avoiding monotony. The three warm spots are rightly different in size, but wrongly equidistant. The curves are dominant, the straights subordinate. All of these principles were thought into this watercolor in seven minutes. I asked an audience in Cincinnati to time this postscript, after a realistic demonstration. If you, too, fear limited appreciation and understanding, remember that great music does not need lyrics, and fine painting does not need content, if it has form.

160

Notes

MY NOTEBOOKS, used as reference for this text, are the result of many years of student note-taking—seldom verbatim—and my own findings, theories, and conjectures. I no longer know which is which. Where it was noted or where my memory serves, I have given credit to lecturers, teachers, and authors. Where omissions occur they are not willful. Are these "capsules" a collection of bromides, clichés, adages, and axioms? They are. Tell me a truth that isn't. I drag into my book, when pertinent to subject matter, findings of Leonardo, Epstein, Hartley, Hopper, *et al.* These men are artists and thinkers, and all are articulate. If *they* cannot help us towards understanding, we are incapable of being helped.

⋅⋅⋅ TO ENLIVEN social intercourse we express our innermost thoughts honestly, with editing, but no expurgation. This instantly vitalizes conversation. The same principle or technique applied to painting has the same result. It is not easy to avoid other people's preconceptions as to what you should say. It isn't easy to eschew other people's ideas as to what you should paint. But if you do not, your painting is a fake. It is a counterfeit. André Gide most perceptively expressed this truth:

> "What another would have done as well as you, do not do it.
> What another would have said as well as you, do not say it; written as well, do not write it. Be faithful to that which exists nowhere but in yourself—and thus make yourself indispensable."

⋅⋅⋅ IN MANY places in this book, I doubtless indicate a bias in favor of method—the logical, orderly, approach of the craftsman—as opposed to that of the poet, achieving results or sensing values intuitively. I state with all possible emphasis

here and now that all "ways" are valid provided sincerity is there; no *pose*. Right for one man or artist is wrong for another.

◄§ IT IS very easy to paint a painting which is difficult to understand, and vice versa.

◄§ WHETHER A painting is modern or not depends upon the following: The degree to which design is seen as subject matter and improvisation is used as method; in the measure that it has equalized surface tension, or, in other words, refused to destroy the *flat* surface covered with pain. Jean Cocteau put it this way, "A picture is not a window." Indication of depth can be made, but surface unity must not be destroyed by holes.

◄§ "IN ITS limited sense, modern art would seem to concern itself with the technical innovations of the period. In its larger and, to me, irrevocable sense, it is the art of all time; of definite personalities that remain forever modern by the fundamental truth that is in them. It makes Molière at his greatest as new as Ibsen, or Giotto as modern as Cézanne."—Edward Hopper.

◄§ "INTUITION IN art is actually the result of prolonged tuition."—Ben Shahn

◄§ IF YOUR objectives, your preoccupations, your concerns, are precisely what they were five years ago, the only growth being technical virtuosity, you really have something to worry about.

◄§ ONLY ONE kind of success interests a good mind. It is really freedom achieved, freedom to live fully and give uninhibited full play to enjoyment of one's faculties. No need of any power except the only power which does not corrupt, the power to make something beautiful. No need of *things*. No great need of, not too much concern about, other people's opinion.

◄§ ALWAYS THE inescapable paradox: In both life and art, if you play safe, you achieve a degree of security. Having security you become bored and disinterested. Being disinterested, your works lack the most essential quality. Producing work of lesser merit, you are no longer safe. Or, obversely; boldly taking chances, via technical experimentation, refusing to live or work by fiat, you learn, develop, grow. Growing steadily you one day inevitably achieve undeniable stature, and are safe.

◄§ THERE ARE scholarly students and nonstudents. The second group may coast on a "flair" or preconditioning of some sort, for a while, but they tire of the limited menu of their own guts and deteriorate through apathy or jump out of

windows. The first group, appetites stimulated by the vitamins available in the ideas of other minds, continue to grow, and growth, or increasing one's power, is happiness.

⊸§ "TO CONSTRUCT and relate natural forms may call for a greater sensibility and a more subtle understanding of design than the use of abstract formulae."
—Jacob Epstein

⊸§ I HAD a teacher who insisted that taste in space divisions and color was congenital. He was wrong. Taste in our activity is learned, precisely as tasteful, gracious living and good manners are learned. No baby ever had them.

⊸§ "THE ARTIST creates through his sensitiveness and his power to impose form. Form is not tradition. It alters from generation to generation. Artists always seek a new technique, and will continue to do so as long as their work excites them. But form of some kind is imperative. It is the surface crust of the internal harmony, it is the outward evidence of order."—E. M. Forster

⊸§ LEO STEIN, in his book *Appreciation*, concerned with unity or *wholeness*, tells of remarking to an international beauty that the way her eyebrows were stuck into her skin, and the disagreeable contrast of hair and forehead, were "ugly in the disparity of their texture," and that "one advantage of art in representing them was the unity of the material." He continues, "The work of art if successful is always a whole." And he uses the phrase "an incorruptible unity." Stein is right. The artist-designer's creative job is to impose that unity upon natural phenomena.

⊸§ HIDDEN FROM ignorance, in the most trite material, are the distinguished space divisions—color and value chords, and other compositional beauties perceived by trained designers.

⊸§ THE DRAUGHTSMAN selects and intensifies.

⊸§ WHEN YOU work from the whole to the parts, expressing the large gesture first, you frequently find when you get to the parts that the subconscious has beautifully suggested the details.

⊸§ DO NOT draw till you have a "vision," then hold to that trying to recapture it always.

⊸§ IT WAS agreed by a group of pre-eminent illustrators that fine drawing was eighty percent "seeing" and twenty percent understanding structure.

ᵉᵍ IN THE very fast report (after the "seeing"), or for that matter without it, the intensity of the emotional realization as a stroke is made is the important thing. Obviously a greater intensity can be held for thirty seconds than can be held for minutes, so—the stroke becomes more charged.

ᵉᵍ "WITH US, as with the masters, drawing alone will supply the framework and the key to express the truth of our vision. I can think of few other tasks more absorbing than the one of teaching of the art of drawing, whatever few facts and laws I happen to know."—Rico Lebrun

ᵉᵍ "THAT IRREGULAR and intimate quality of things made entirely by the human hand."—Willa Cather

ᵉᵍ THE AMATEUR is afraid of boldness; the professional is afraid of timidity.

ᵉᵍ ONE REWARD for sketching is that you learn to "see." This gives you a very rich source of entertainment for the rest of your life.

ᵉᵍ "WHO PAINTS a figure, if he cannot be it, cannot draw it."—Dante

ᵉᵍ DRAWING IS in one sense greater than painting. It records perfectly, more simply and directly the personality of the artist.

ᵉᵍ THE ARTIST's quest is self-discovery. The sketchbook is the shortest route to that objective.

ᵉᵍ AN IMPORTANT work of art can be considered, edited, reconstructed, changed, tried again and again. An important work of art can also result from a flash of insight and be executed at great speed in a very short time. Mozart composed the overture for "Don Giovanni" in a few hours before its last rehearsal.

ᵉᵍ A SKETCH can have greatness in it.

ᵉᵍ SKETCHING, frequently use a large tool, a litho crayon, a 6-B pencil, a carpenter's pencil, or one of the felt pens—draw figures, say, three or four inches high. The big tool makes small detail impossible and disciplines "seeing"—teaches you to see only large shapes and thrusts—to see simply.

ᵉᵍ DRAWING from memory is an enormous aid to powerful draughtsmanship. The old illustrators developed by journalistic reporting before the advent of the camera were superior draughtsmen because of their daily experience, going to the scene of

164

a fire, a murder, the trials in court, and then going to the studio to draw. Draw from memory frequently.

➤ YOU CAN BE a master draughtsman in the sense of eye and hand perfectly trained, but if you do not learn to see and stress beautiful rhythms and shapes and intensify human character and its expression in articulation, your drawing will be uninteresting.

➤ THE WIT of a sketch need not be superficial. It can have the selectivity, the significance, the power of suggestion, that a Shakespearian couplet has.

➤ MAKE FINE distinction between freely "written" drawings and sloppy draughts-manship—or, you may lose critical ability.

➤ "THE UNREADABLE will shortly be unread."—Jacques Barzun

➤ THE ARTIST's difficult task is to keep a boy's heart and gain a man's head.

➤ "NOTHING is so poor and melancholy as an art that is interested in itself and not in its subject."—Santayana

➤ "ART CONVEYS what the artist knows about feelings, which is knowledge."
—Suzanne Langer

➤ THE SENSE of style is in all sincere work, simply because it is sincere. Tempera-ment, constitution, and understanding being different in any two people, their report of the simplest incident will never be the same, yet each will be truth, pro-vided the artist limits himself to truth as he sees and understands it.

➤ SIMPLICITY and naturalness always have been, are, and always will be the concomitants of greatness.

➤ THERE ARE no gimmicks in the learning process. You sweat, digging deep, or your knowledge is superficial.

➤ "NEVER REMAIN too long at one point, forever repeating the too familiar."
—Konstantin Stanislavsky

➤ THE ARTIST's concern has three subdivisions: (1) perception (2) conception (3) craft. All are subject to development.

➤ "THE MERIT of originality is not novelty, it is sincerity."—Carlyle

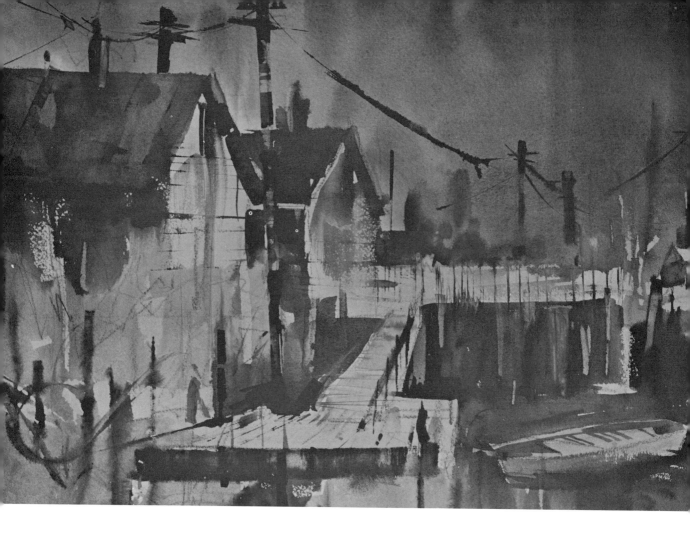

HOUSES, FENCE AND FLOAT

The sophisticated objective in space art is to present beautiful shapes.
Shapes are identified by color, value, and sometimes texture. The light shape
in this watercolor obeys the law for good shapes: "two different
measures, a dynamic oblique and interlocking edges." The *size* of this
white piece, however, is too close to the size of the midtones, which
should be dominant. The darks are scattered, and difficult to find, which
hurts clarity of statement. I started this painting with the objective
of perpendiculars as a "theme" because of the many poles. The
horizontal lights being larger (hence more aggressive visually than the
smaller darks) took over. The design theme is now horizontal, the
subordinate perpendiculars become a "second movement" conflicting with,
ergo complementing, the horizontal theme.

166

꧁ SCHOLARSHIP, yes, but deliberately avoid the mind imprisoned by what it has been taught, its refusal to think for itself.

꧁ "A WORK OF ART we all agree is a unique product, but why? It is unique not because it is clever or noble or beautiful or enlightened or original or sincere or idealistic or useful or educational. It may embody any of those qualities—but because it is the only material object in the universe which may possess internal harmony. All others have been pressed into shape from outside, and when the mold is removed they collapse. The work of art stands up by itself, and nothing else does."—E. M. Forster

꧁ ". . . FOR LOVE of anything is the offspring of knowledge, love being more fervent in proportion as knowledge is more certain."—Leonardo da Vinci

꧁ "THROUGH a natural development all great poets eventually become critics. I pity those poets guided by instinct alone; for they seem incomplete to me. In the spiritual life of the former, infallibly there comes about a crisis that makes them want to *reason out their art* to discover the obscure laws by virtue of which, they have created, to draw from this study a series of precepts whose divine aim is infallibility . . ."—Baudelaire

꧁ "THE MAN who would emancipate art from discipline and reason is trying to elude rationality, not merely in art but in all existence. He is vexed at conditions of excellence that make him conscious of his own incompetence and failure. Rather than consider his function, he proclaims his self-sufficiency. A way foolishness has of revenging itself, is to excommunicate the world."—George Santayana

Conclusion

THE FUTURE? My hope is in man's proven unpredictability. My congenital and reasoned optimism flatly refuses to accept prognostications of larger laundry tickets and new prophets disdaining outmoded paint-throwing in favor of hose-squirting. I give no credence to the first genius who will contrive a paint pipeline from Sherwin-Williams' factory into his studio. The future will decide whether or not composition *as subject matter* requires eight-foot paintings. The future will fix the taste status of the artist who thinks it does.

Will art schools have gymnasiums equipped with dumbbells as necessary conditioning for throwing larger buckets of paint farther and more "furiously"? Will cross-country running be added to art school curriculums, so that paintings, ever larger, can be finished with dispatch? The future will tell us.

I expect escapists will continue to throw paint, and subjective lyricists will struggle to *outsize* each other, and I know large circulation magazines will continue to advertise them for their shock value and because they are *clinically* interesting to the public.

We may grow tired of improvisation eulogized as method, and find solace in the fact that artists must paint *from* the world they live in, though they do not paint *about* it. No one knows the kind of world we will paint from or about, but we have design principles as a means of appraising changes and familiar unchanging human motivations. Man, his tools, and environment will continue to be important subject matter to fuse with, and be conditioned by, increased emphasis on design.

I believe that a public that will spend billions on education will achieve a better understanding of art and artists. I believe that our taste will improve. I

believe that painters will find a wider gamut of subject matter than personal tensions. I believe man's sense of humor will prevail and negate contemporary delusions of grandeur. I believe that the genuine hunger for education, which I find in my eight weekly classes, qualifies my faith in art with content to come. I believe the shorter working hours presage an art renaissance. I believe that the contemporary, non-objective academy is victim of a basic illusion and is in a blind alley. But it is rightly free to create its own laws of color and form, is correct when it contends that art is more than imitation and must not strive for the illusion of reality, nor be *scientifically* true to anatomy or perspective.

I believe that the future will be different, yet still maintain a continuity with the past. There will be natural warmth in some artists, some will be less fortunate. I think both should be encouraged to express and report themselves with paint. There will be movements, schools, causes—hated, eulogized, and considered with compassion and objectivity. There will be sensitive people trying to live creatively who are not interested in reputation. There will be people who want power and prestige and will get it and will never discover the sweet uses of anonymity. There will be artists courting success successfully and those who have success thrust upon them. And they will both, then, have a vested interest and their objective thinking will be compromised.

I believe that to the question, "Why be analytical about art?" there will never be a more satisfactory answer than "Because we want to." We usually make a poor job of it. So long as we have this compulsion to analyze, why not do it efficiently. Artists *naturally* feel and think. The thinking is qualified by knowledge (previous thinking), or it is not qualified. We cannot help but have preconceptions about our activity and surely subjecting them to careful analytical scrutiny must end in increased appreciation and understanding. The artist's conception of art has never been in greater need of discipline and conditioning by aesthetic theory than it is today. The statement that taste—discrimination—has to be educated into the artist, even if it were wrong, would not negate the fact that congential endowment of these qualities is augmented by knowledge of principles which are teachable, and which are the most powerful tools with which to express one's self.

The human spirit and intelligence, despite the threat of the H-bomb, will continue to create. To the statement "force is the ultimate reality," artists will answer, as always, "Is it?" and go right on creating and loving, constituting an aristocracy in the best sense of the word—the epitome of the best in human tradition. There will always be that kind of person. There will always be increased understanding as a reward for scholarship. There will always be the validity of design . . . and these things are enough to keep the watercolorist interested, edified, and happy in his craft activity.

Epilogue

AREN'T WE ARTISTS LUCKY! Steinmetz and Edison knew things that Newton never dreamt of but Leonard Bernstein does not know one damned thing that Beethoven didn't know!

My friend, Robert Taylor, questioned me one evening in Texas, "Ed," he said, "the scientist knows that there is, beyond what he knows, a vast area of knowledge not yet available. He may have been scholarly and gained much understanding. Then comes an Einstein whose experiments and discoveries make other scientists' arduously gained knowledge old hat, passé, relegated to the wastebasket. Is art that way?"

Art is not that way. The difference between science and art is quite sharp. The *uses* of the principles of art change with successive cultures. The *principles* remain absolute, inviolate, and ubiquitous. They do not change.

Without unity a musical composition, a literary effort, choreography, architecture, movie direction, or a painting has always been, is, and always will be inferior. The means by which unity is achieved do not change.

Unity, conflict, harmony, alternation, repetition, gradation, and balance exist in varying degrees in any art, in any time—realistic, abstract, or nonobjective—if the work is superior.

I give you an analogy. One of man's oldest ideas is the wheel. The first crude wheel was a sorry thing compared with the modern, tapered, roller bearing, steel belted, radial-tired wheels which whisk us hither and thither today. But the *principle* of the wheel has not changed. Automobiles of any future date will have wheels, or they will not function.

Paintings of any future date will have structure achieved by adherence to the laws of design, or they will have no aesthetic merit.

Here is another analogy. Social decorum, proper behavior, have as many forms as there are ethnic groups and social hierarchies. But the principle of good manners —*concern about the other guy, first*—does that change? Anywhere? Ever? Neither do design laws.

Within the gamut prescribed by design principles, the ways to speak with one's own voice are infinite. Design laws do not constrict originality, which Carlyle defines as sincerity. You are totally free to express things pregnant with meaning for your trained eyes. The understandings you worked and paid for are yours, and true—*forever*.

Leonard Bernstein doesn't know one damned thing that Beethoven didn't know! Aren't we artists lucky!

Bibliography

Barzun, Jacques. *Energies of Art, The*. New York: Harper & Brothers, 1956.

Barzun, Jacques. *Romanticism and the Modern Ego*. Boston: Little, Brown & Company, 1943.

Blesh, Rudi. *Modern Art U.S.A*. New York: Alfred A. Knopf, 1956.

Brandt, Rex. *Composition of Landscape Painting, The*. The Press of the Rex Brandt School, 1959.

Brandt, Rex. *Watercolor Landscape*. Corona del Mar, Calif.: Published by Rex Brandt, 1953.

Brandt, Rex. *Watercolor Technique*. Corona del Mar, Calif.: Published by Rex Brandt, 1950.

Bridgman, George B. *Constructive Anatomy*. Pelham, N.Y.: Edward C. Bridgman, 1920.

Bridgman, George B. *Seven Laws of Folds, The*. Pelham, N.Y.: Bridgman Publishers, 1942.

Cheney, Sheldon. *Primer of Modern Art, A*. New York: Horace Liveright, 1924.

Collingwood, R. G. *Principles of Art, The*. London: Oxford University Press, 1969.

Coomaraswamy, Ananda K. *Christian and Oriental Philosophy of Art*. New York: Dover Publications, Inc., 1956.

Dehn, Adolph. *Watercolor Painting*. New York: The Studio Publications, Inc., 1957.

Dunlop, James M. *Anatomical Diagrams*. London: G. Bell & Sons, Ltd., 1915.

Edman, Irwin. *Arts and the Man*. New York: W. W. Norton & Company, Inc., 1928.

The Encyclopedia Britannica Collection. *Contemporary American Painting*. New York: Duell, Sloane and Pearce, 1945.

Ennis, George Pearse. *Making a Watercolor*. New York: Studio Publications Inc., 1933.

Feibleman, James K. *Quiet Rebellion, The*. New York: Horizon Press, 1973.

Flanagan, George A. *How to Understand Modern Art*. New York: Thomas Y. Crowell, 1951.

Goldwater and Treves. *Artists on Art*. New York: Pantheon Books, 1945.

Graves, Maitland. *Art of Color and Design, The*. New York: McGraw-Hill Book Company, Inc., 1951.

Graves, Maitland. *Color Fundamentals*. New York: McGraw-Hill Book Company, Inc., 1952.

Grosser, Maurice. *Painting in Public*. New York: Alfred A. Knopf, 1948.

Grosser, Maurice. *Painter's Eye, The*. New York: Rhinehart & Company, Inc., 1951.

Harris, Kenneth. *How to Make a Living as a Painter*. New York: Watson-Guptill Publications, 1964.

Henri, Robert. *Art Spirit, The*. Philadelphia and London: J. B. Lippincott Company, 1923.

Kent, Norman, edited by. *Watercolor Methods.* New York: Watson-Guptill Publications, 1955.

Krutch, Joseph Wood. *Modern Temper, The.* New York: Harcourt-Brace & Company, 1929.

Kent, Norman, edited by. *Seascapes and Landscapes in Watercolor.* New York: Watson-Guptill Publications, 1956.

Langer, Suzanne K. *Feeling and Form.* New York: Charles Scribner's Sons, 1953.

Langer, Suzanne K. *Philosophy in a New Key.* Cambridge: Harvard University Press, 1942.

Maginnis, Charles D. *Pen Drawing.* Boston: Bates and Guild Company, 1921.

Maritain, Jacques. *Creative Intuition in Art and Poetry.* New York: Noonday Press, 1955.

Mumford, Lewis. *Art and Technics.* New York: Columbia University Press, 1952.

Nicolaides, Kimon. *Natural Way to Draw, The.* Boston: Houghton-Mifflin Company, 1941.

O'Hara, Eliot. *Art Teacher's Primer.* New York: Minton, Balch & Company, 1939.

Ortega y Gasset, José. *Dehumanization of Art.* Garden City, New York: Doubleday & Company, 1956.

Pitz, Henry C. *Drawing Trees.* New York: Watson-Guptill Publications, 1956.

Rand, Ayn. *Romantic Manifesto, The.* New York: The New American Library, 1971.

Read, Herbert. *Education Through Art.* London: Faber & Faber, 1943.

Read, Herbert. *Innocent Eye, The.* New York: Henry Holt & Company, 1947.

Reid, Louis Arnaud. *Study in Aesthetics, A.* London: George Allen & Unwin, Ltd., 1931.

Sloan, John. *Gist of Art.* New York: American Artists Group, Inc., 1939.

Smith, Jacob Getlar. *Watercolor Painting for the Beginner.* New York: Watson-Guptill Publications, Inc., 1959.

Sullivan, Edmund J. *Line.* New York: Charles Scribner's Sons, 1923.

Taubes, Frederic. *Better Frames for Your Pictures.* New York: Studio Publications, Inc., 1952.

Taubes, Frederic. *You Don't Know What You Like.* New York: Dodd-Mead & Company, 1944.

Teachers College, Columbia University. *Readings in the Foundations of Education.* New York, 1941.

Viereck, Peter. *Conservatism Revisited.* New York: Charles Scribner's Sons, 1949.

Watson, Ernest W. and Kent, Norman. *Watercolor Demonstrated.* New York: Watson-Guptill Publications, 1945.

Whitaker, Frederic. *Whitaker on Watercolor.* New York: Reinhold Publishing Corporation, 1963.

Wind, Edgar. *Art and Anarchy.* New York: Alfred A. Knopf, 1964.

Index